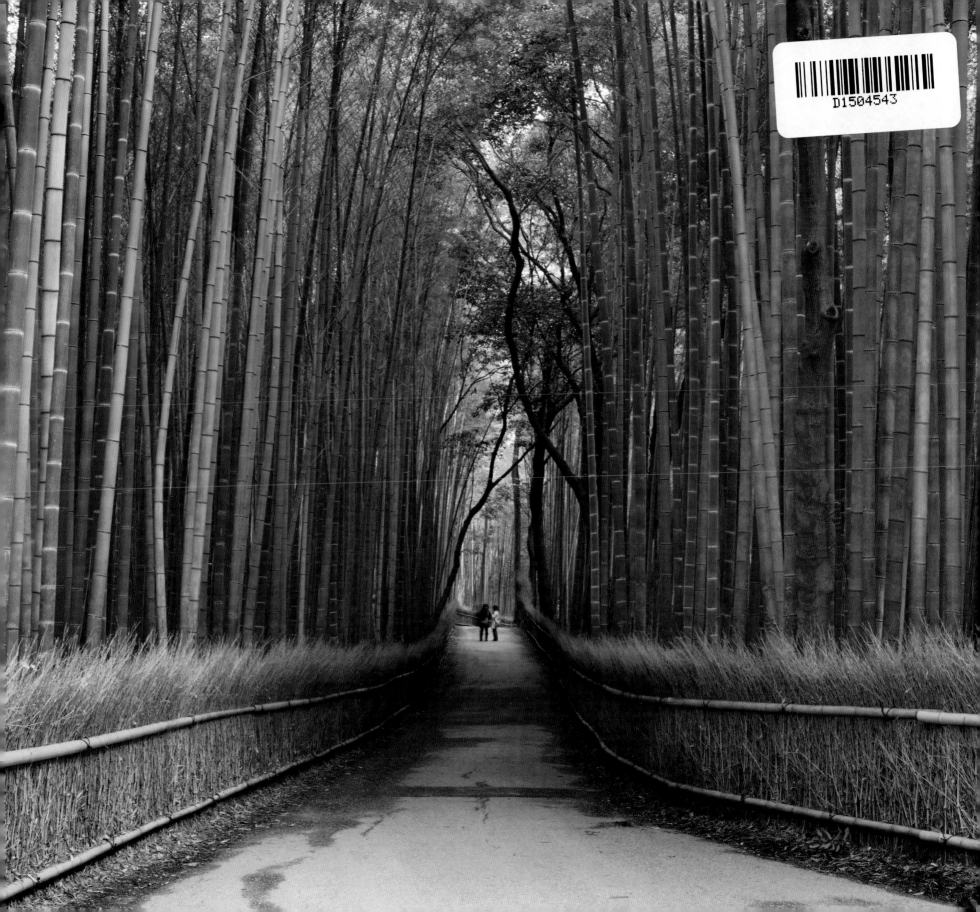

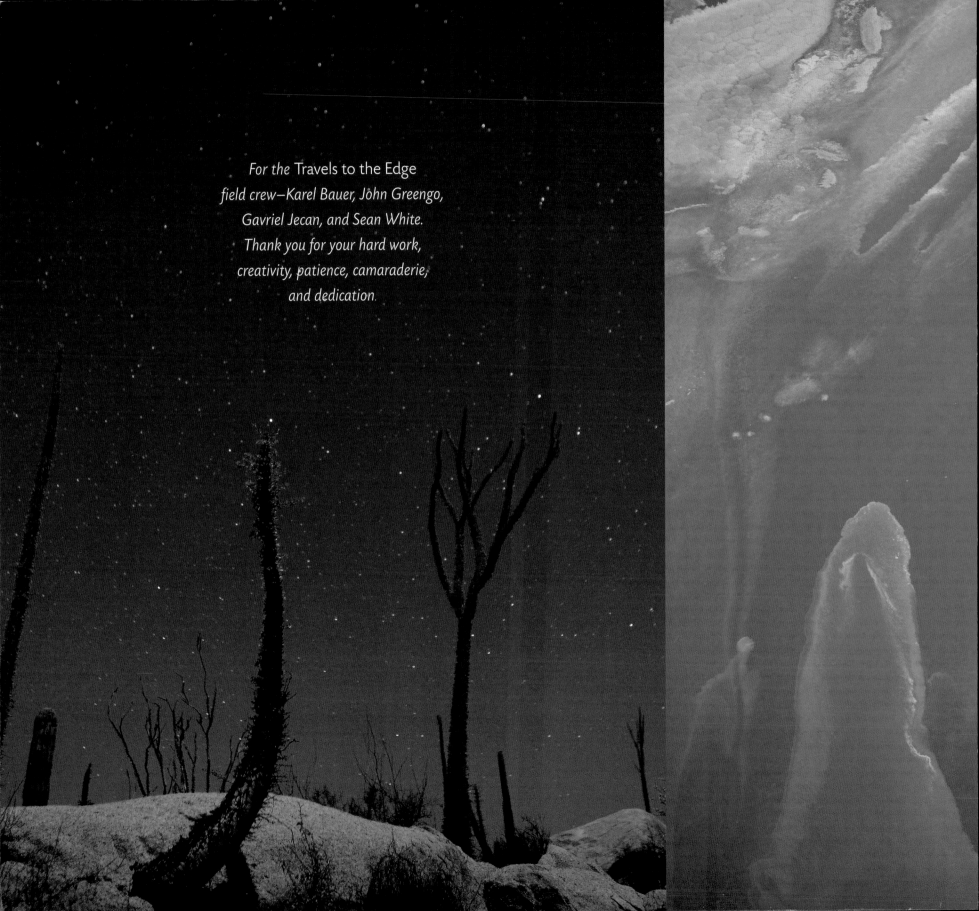

For the Travels to the Edge
field crew—Karel Bauer, John Greengo,
Gavriel Jecan, and Sean White.
Thank you for your hard work,
creativity, patience, camaraderie,
and dedication.

ART WOLFE

TRAVELS TO THE EDGE

A PHOTO ODYSSEY

ITINERARY

Alaska
ARCTIC NATIONAL WILDLIFE REFUGE

Alaska
KATMAI COAST

Alaska
GLACIER BAY

The American Southwest
ZION NATIONAL PARK AND CANYON DE CHELLY

Mexico
BAJA

Peru
MANU

Bolivia
THE ALTIPLANO

Brazil
THE PANTANAL

Patagonia
MOUNT FITZ ROY AND CERRO TORRE

Patagonia
TORRES DEL PAINE

Antarctica and
The Falkland Islands

The Southern Ocean
SOUTH GEORGIA ISLAND

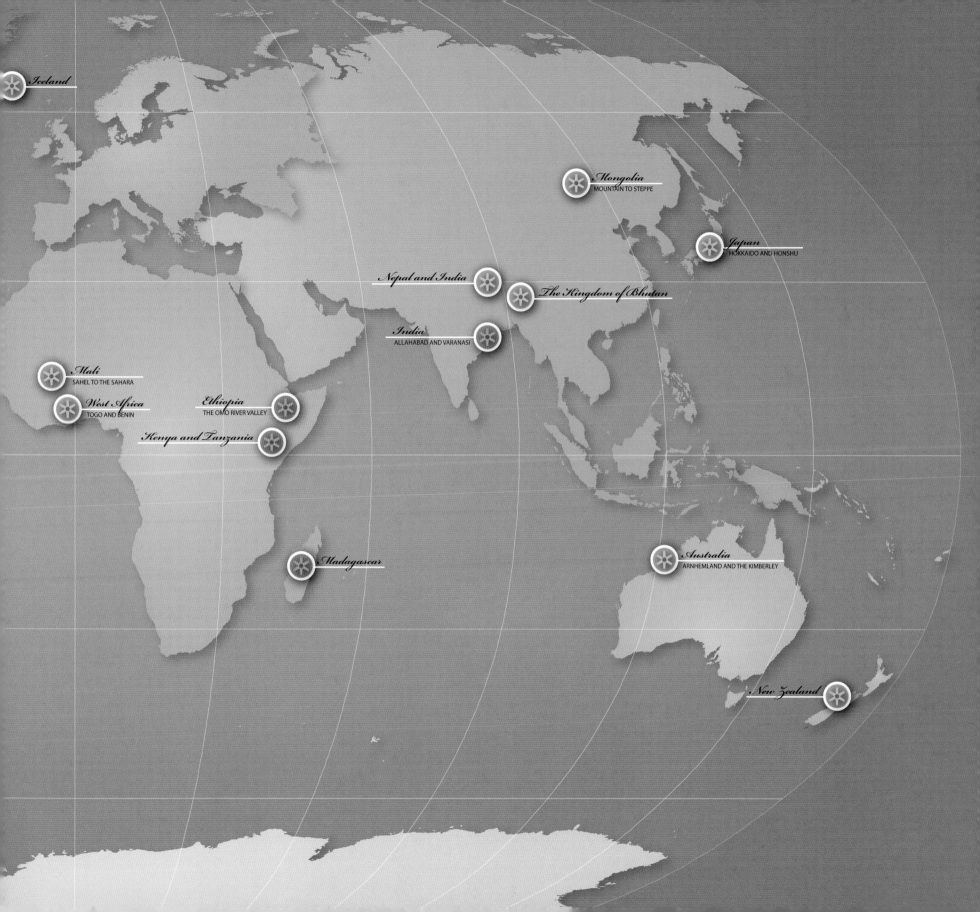

Iceland

Mongolia
MOUNTAIN TO STEPPE

Japan
HOKKAIDO AND HONSHU

Nepal and India

The Kingdom of Bhutan

India
ALLAHABAD AND VARANASI

Mali
SAHEL TO THE SAHARA

West Africa
TOGO AND BENIN

Ethiopia
THE OMO RIVER VALLEY

Kenya and Tanzania

Madagascar

Australia
ARNHEMLAND AND THE KIMBERLEY

New Zealand

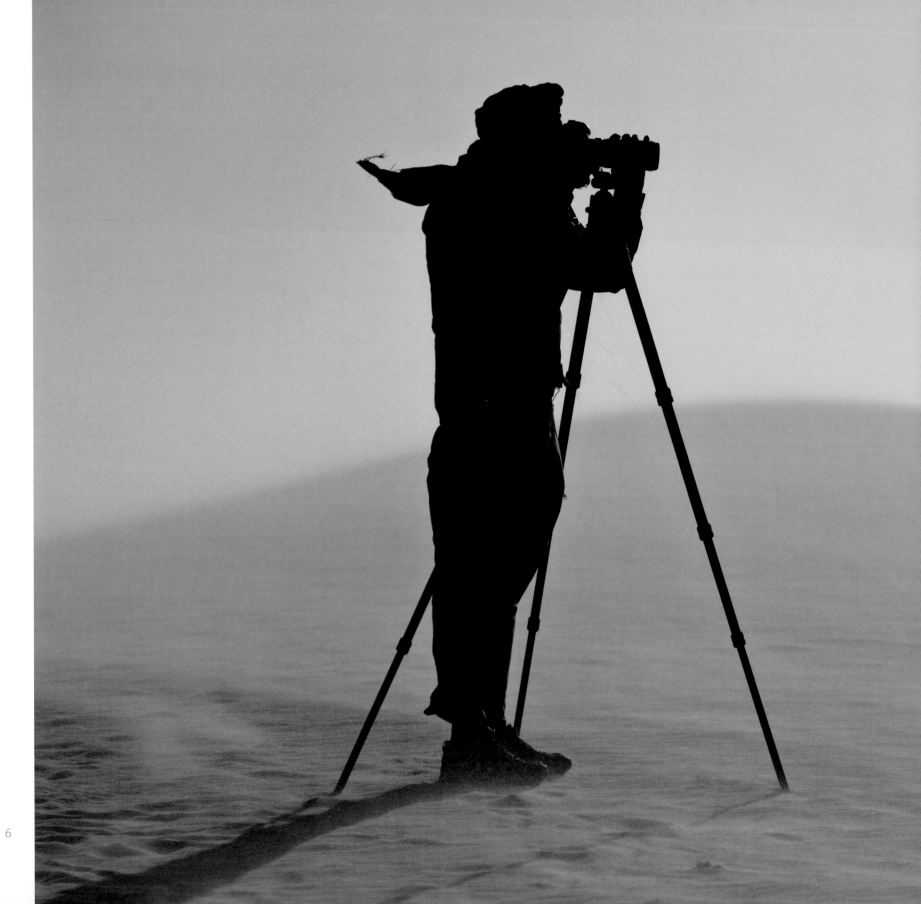

INTRODUCTION

I began exploring the world as a kid in Seattle, Washington, mounting expeditions into the woods behind my parents' house. Even then I wanted to keep going, to see what was over the next ridge or beyond Puget Sound. Later, camera in hand, I devoted myself to photographing the beauty of the North Cascades as I embarked on my career as a photographer.

My life changed when I was invited to be the photographer for the Ultima Thule Expedition to the Tibetan side of Mount Everest in 1984, years before the mountain was tamed by commercial guides, and lattes became available at base camp. I encountered people who had never seen Westerners before, photographed mountains of incomprehensible scale, caught glimpses of rare wildlife. This experience inspired me to spend my life wandering the planet to capture images of the wild world.

For thirty years I traveled constantly, chasing the light from continent to continent. At first I was driven to develop my skills and vision, but over time I felt compelled to expand my mission to include the preservation of wildlife and wild places, to document and advocate for tribal people under threat from civilization's encroachments. This intrusion threatens to obliterate the last wild places and the wondrous animals that live there, which would impoverish our planet for as long as humans persist.

To bring the beauty and plight of these places, people, and wildlife to a wider audience, I decided to create a television program to add my voice to the chorus of governments, artists, nongovernmental organizations, foundations, and corporations striving to protect our wild heritage. This led to the public television program *Art Wolfe's Travels to the Edge*. American Public Television and Oregon Public Television got on board and Microsoft Corporation, Canon USA, and Conservation International agreed to underwrite the program. Over the next two years my crew and I worked in the Sahara and Himalaya, Australia and Antarctica, in the crush of a Hindu festival, and on uninhabited islands.

My team and I have been fortunate, meeting wonderful people, documenting amazing wildlife behavior, and capturing moments when light and landscape produce a startling image. We hiked to a rocky prominence in Patagonia, hoping to photograph a condor, but we found only empty sky. Then, at the summit, one condor and another and another soared around us, circling, passing close enough for us to hear their wings tearing the air, the sound of ripping cloth. On the same trip, we hiked and skied to the west side of Cerro Torre on the Patagonian Ice Cap. Patagonia is renowned for brutal weather and even in fine weather clouds build up in the afternoon. On our only day in position, we were blessed with pink light on the high, snow-fringed peaks. Within days hundred-mile-per-hour winds would scour the ice cap and snow would stream off the spires like vapor trails, but we were granted that moment.

On South Georgia Island, my favorite location on the planet, I was photographing elephant seal pups inches from my wide angle lens. Curious, they inched their way toward me, and eventually I had to wipe away nose prints. As I spoke to our cameraman, one affectionate fellow crawled up on my back uninvited, assuming a position that could be used as evidence in a divorce proceeding.

In Ethiopia, we witnessed the Karo tribe dance after sunset during a harvest festival. After shooting, I downloaded the images to my computer and ran an impromptu slide show. All the children in the village crowded around me, eager to see themselves on the screen; except for the unfamiliar patter, I could have been with a group of kids anywhere in the world.

We started down this path with an eye toward opening a window to the world. The experience provided that opportunity and many more: we live on a beautiful planet and it holds astonishing secrets that we stumbled upon almost every day. Wildlife has always delighted me, but the adaptations found across the animal kingdom are often unbelievably elegant or odd. Scientists agree that we are in the midst of the largest extinction in sixty-five million years and it tears my heart out even as I record the wonders I find.

Wildlife has often been my focus, but equally important are the similarities I've found in people across the planet. The barriers between us are matters of assumption, habit, and groundless fear. A mother living in a leaf shelter in the Congo wants the same for her child as a mother in the United States: shelter, food, clothing, and happiness. I hope this project can help bind us all together in some small measure.

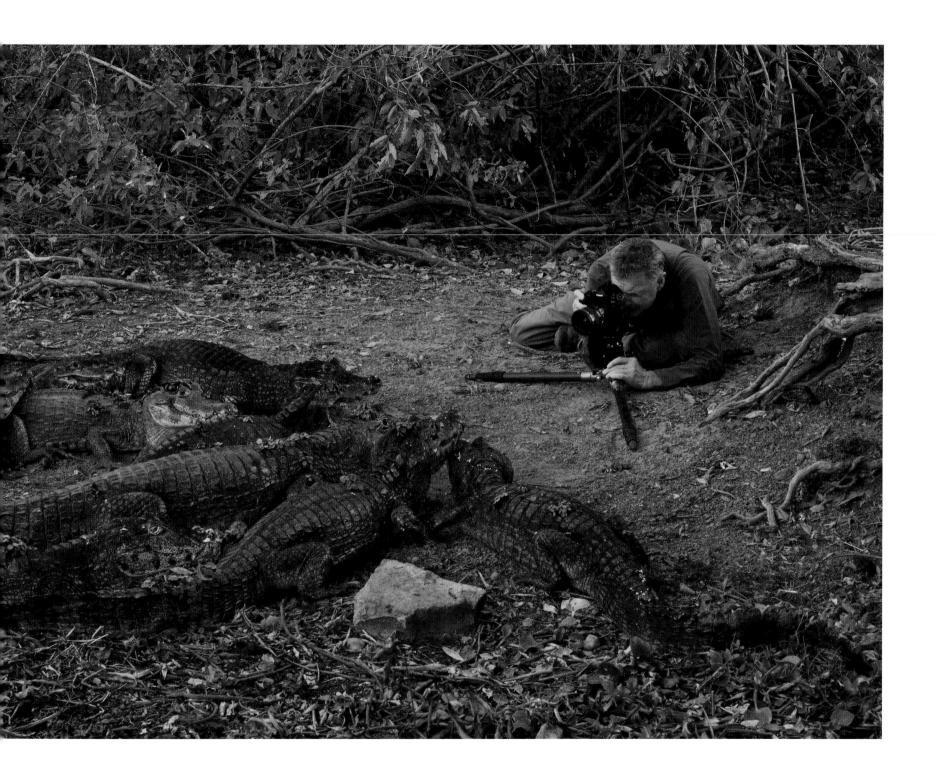

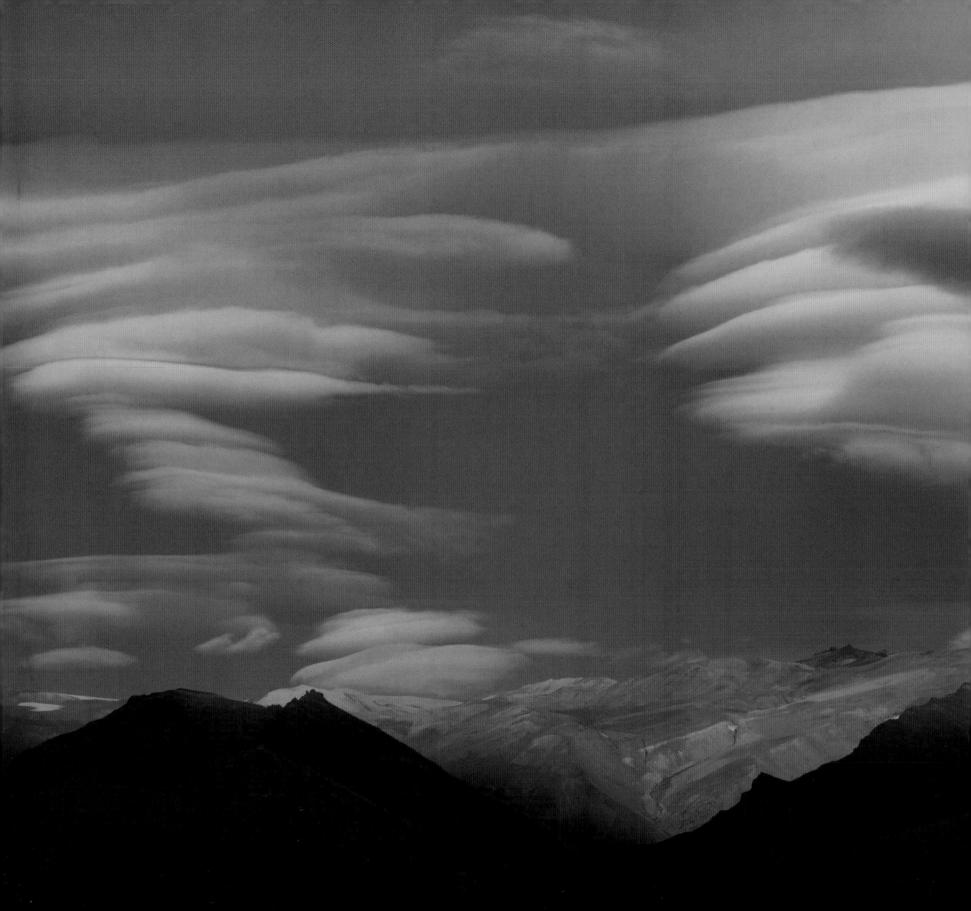

TORRES DEL PAINE, PATAGONIA

Patagonia is the treasure of the southern Andes. Straddling Chile and
Argentina, this region is known for its majestic granite peaks, including the
famous Torres del Paine. The winds wheel around the Southern Ocean,
unimpeded by land until they cross the tip of South America, sometimes
reaching speeds of more than one hundred miles per hour.

A herd of guanacos, a wild relative to llama, fixates on me as storm clouds build above the pampas to the east of the Andean crest. Chile's Torres del Paine National Park is famous for its beautiful granite spires, high winds, and magnificent wildlife viewing. I used a wide-angle lens and a neutral density filter to regulate the wide-open, bright sky and to capture the guanacos in the foreground.

In lovely sunrise light, dynamic lenticular clouds, a hallmark of the region, pass over the Cuernos Towers of Torres del Paine National Park in Patagonia. This compact group of mountains rises abruptly over the flat pampas of neighboring Argentina.

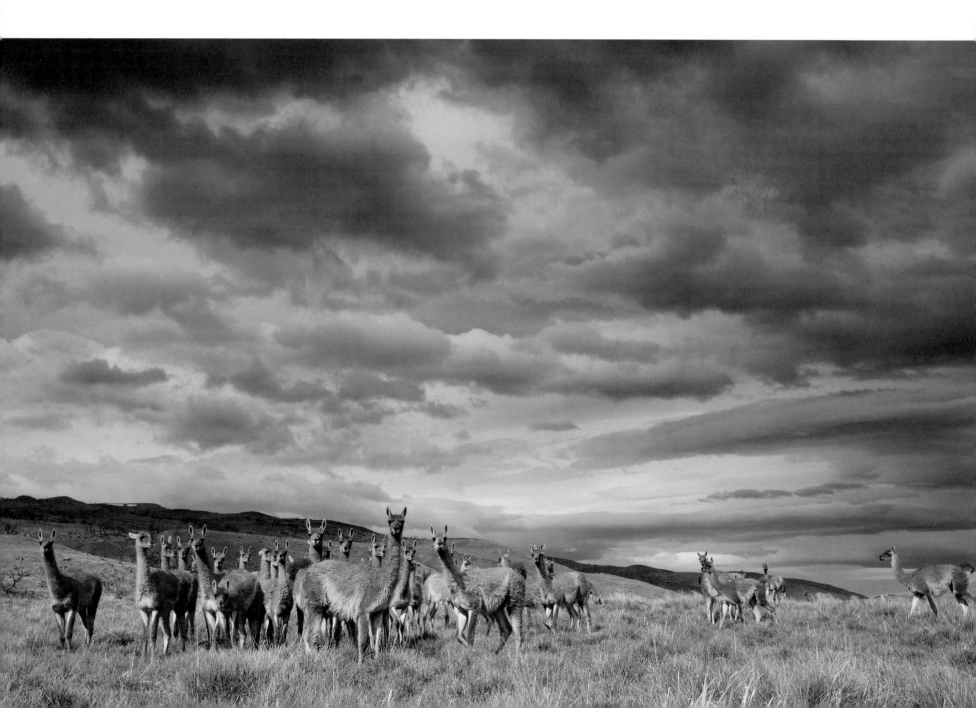

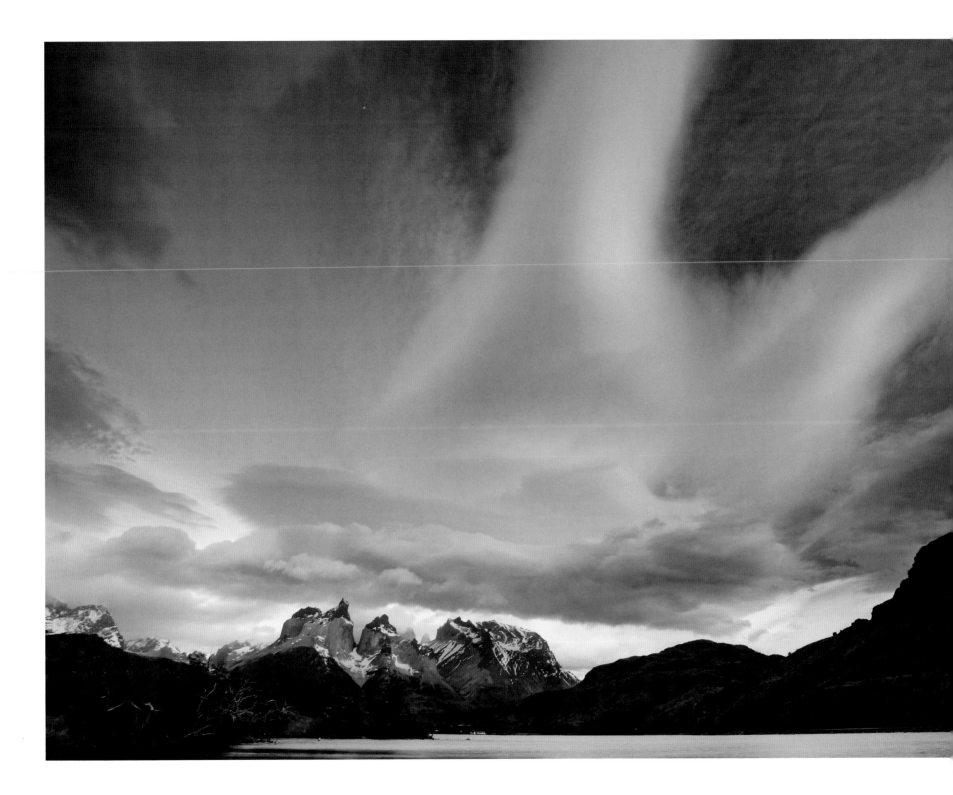

A silhouetted trekker surveys the raw, wild landscape as the setting sun reaches these smooth rock faces at an oblique angle. I found this vantage point, directly north of Mount Fitz Roy and Cerro Torre, as our team hiked around the massif.

The last rays of the setting sun illuminate the rock spires of Mount Fitz Roy and Cerro Torre in Los Glaciares National Park in southern Argentina. This viewpoint, from the largest ice cap outside of the polar regions, was the highlight of our eight-day circumnavigation of these two famous mountains.

MOUNT FITZ ROY AND CERRO TORRE, PATAGONIA

Photographers and climbers alike revere Patagonia for its stunning granite peaks, including the great spires of Mount Fitz Roy and Cerro Torre. A guide, a lifelong friend, the crew, and I traversed forest, valley, and glacier to capture rare and distinct views of these two iconic peaks. We climbed to the Patagonian Ice Cap to gain a view of the western flank of Fitz Roy; we were lucky enough to shoot on a clear day, rare in a place known for its savage weather.

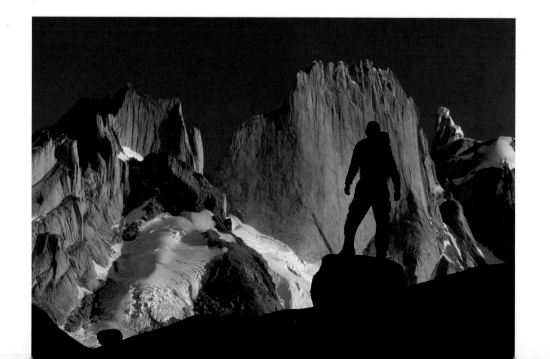

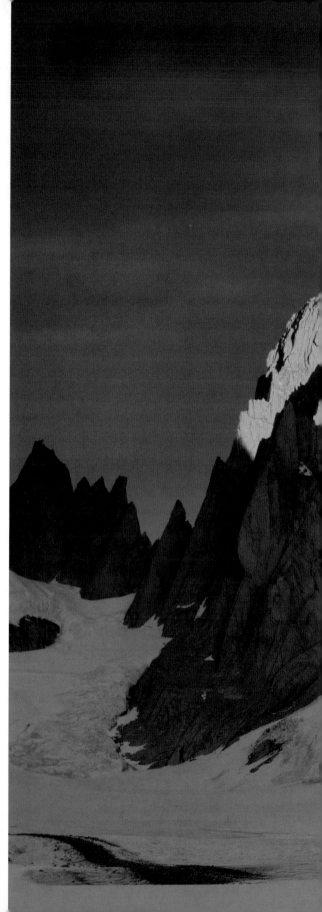

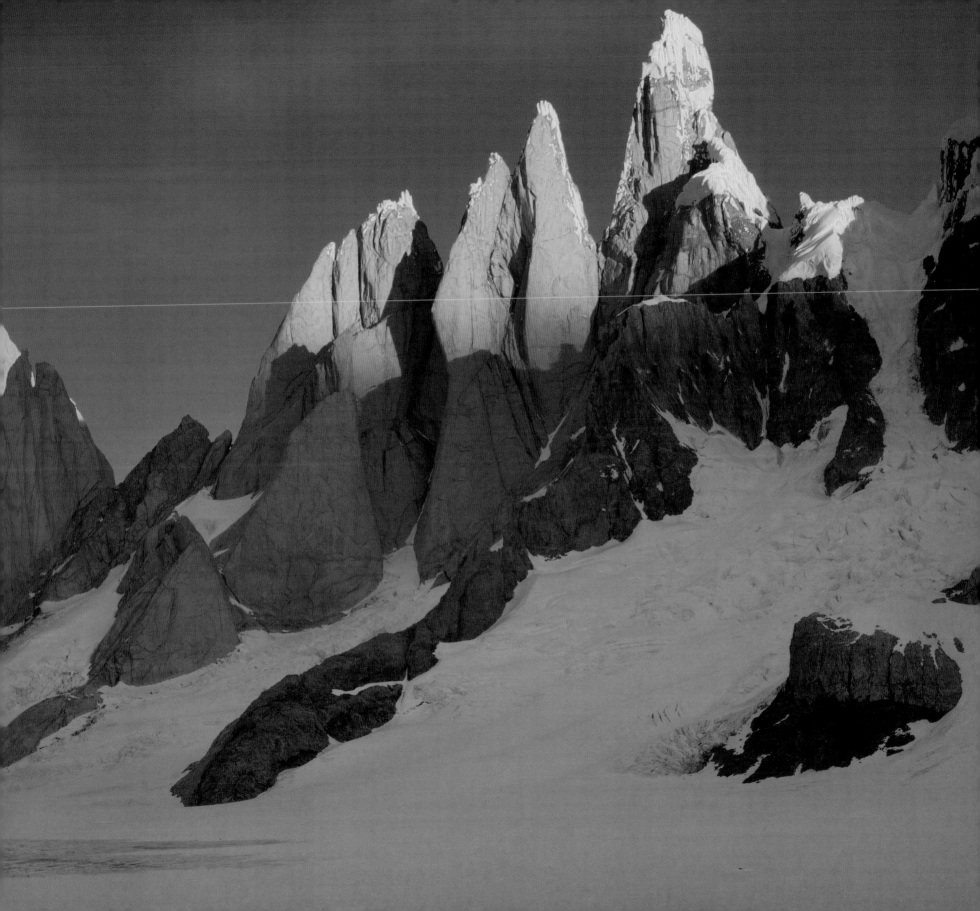

As in the soda lakes of East Africa, Andean flamingos feeding in the salt lakes of the Altiplano turn pink from eating brine shrimp.

THE ALTIPLANO, BOLIVIA

The high plain of the Andes represents a mosaic of surreal landscapes dotted with wildlife. Altiplano dreamscapes include cacti silhouetted against a time lapse of star trails, geysers bubbling mud and steam, abstract reflections split by the distant horizon, and a man-made series of perfectly conical salt mounds.

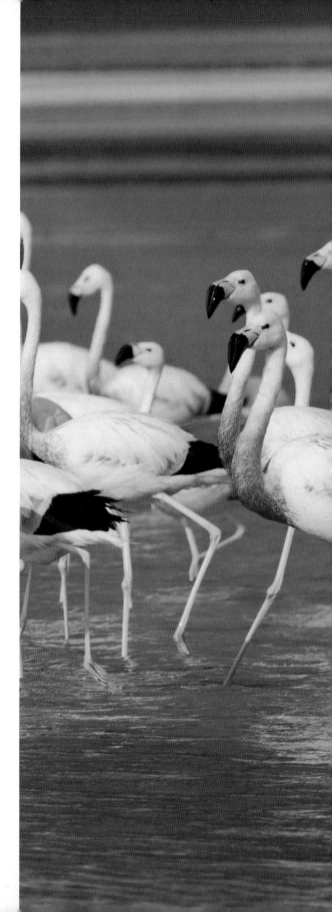

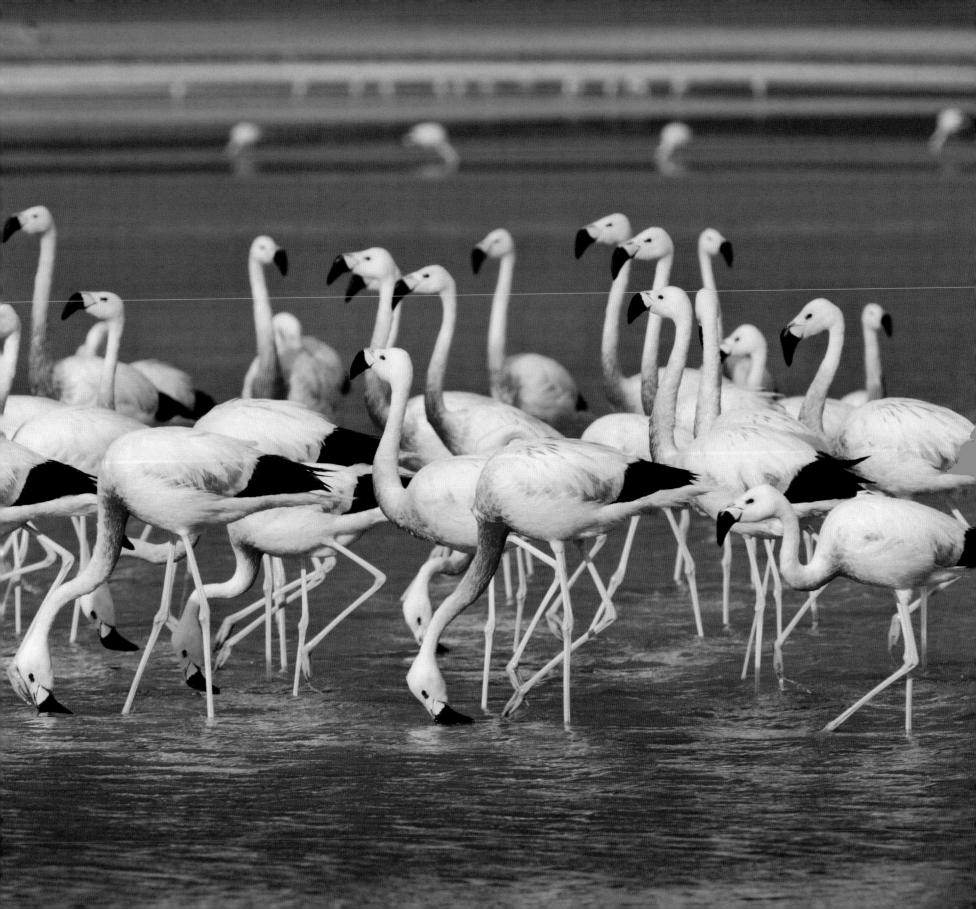

Piles of salt dry in the arid atmosphere of Bolivia's Salar de Uyuni. Salt reaches depths of over six feet in the vast, ten-thousand-square-kilometer salt flat, once a prehistoric lake. Villagers rake salt into piles that they will sell in cities throughout South America.

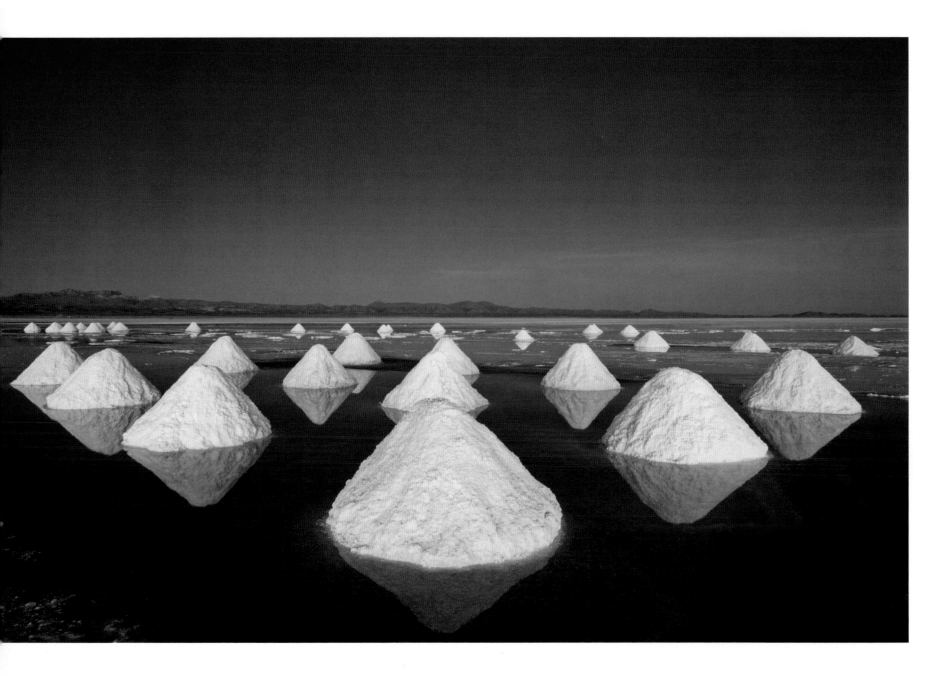

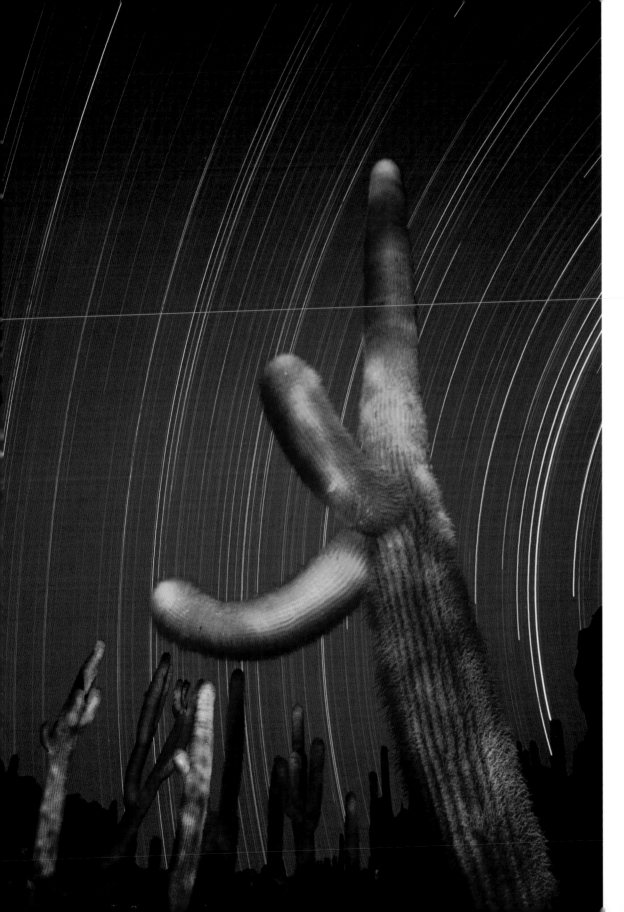

Nine-hundred-year-old candelabra cacti provide a striking foreground element to stars crossing a clear sky in Bolivia's Altiplano region in South America. To achieve this image, I walked up the hill and illuminated each cactus with a hand-held flashlight during an eight-hour exposure.

A salt lake on the Altiplano plateau reflects light from a half moon. The moon provided just enough light to illuminate the foreground with a shutter speed that allowed the sensor to record the stars. A full moon would have overexposed the foreground.

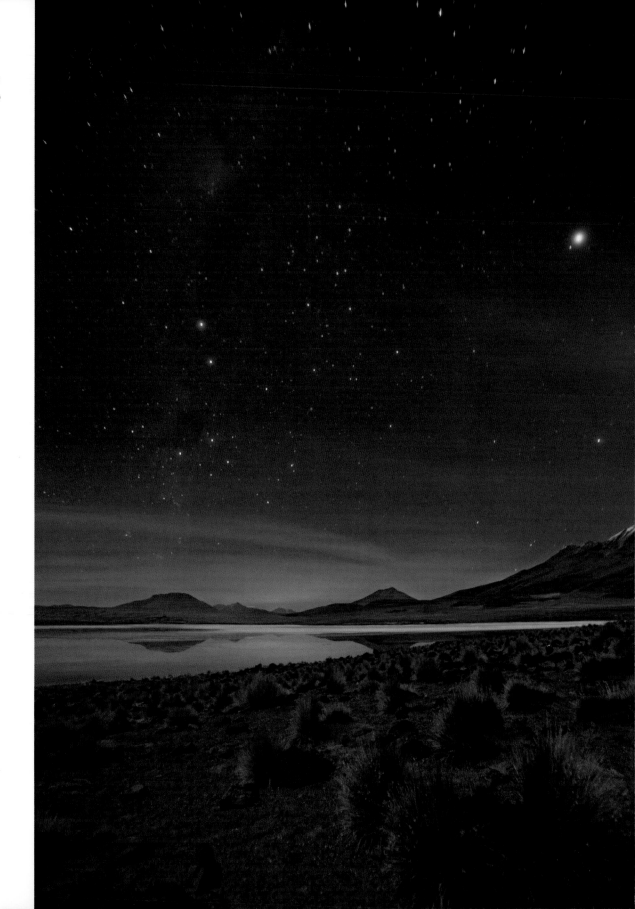

The super-heated steam of a geyser basin stands out dramatically against the frigid Andean sunrise at fourteen thousand feet in Bolivia's Altiplano.

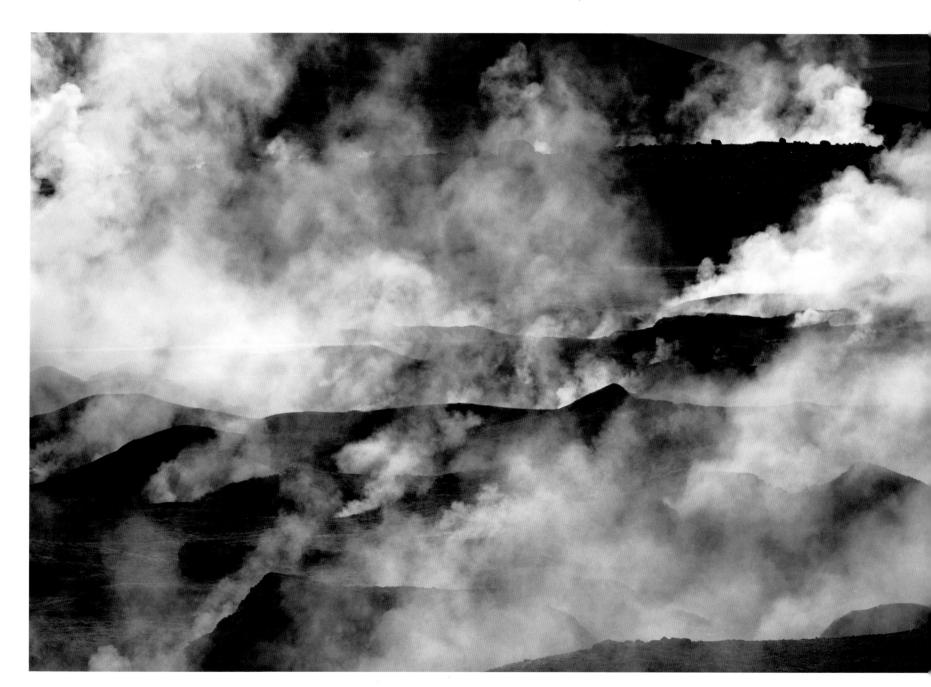

The brilliant red plumage of the Andean Cock-of-the-Rock, the Peruvian national bird, provides a startling contrast to the muted greens of a cloud forest high in the Peruvian Andes. Few birds on earth are as distinctive as this extraordinary creature. To get this shot, I hid in a blind near the lek, or mating grounds, of the Cock-of-the-Rock.

MANU, PERU

The Amazon Basin harbors the largest rain forest and most powerful river on the planet. From eleven thousand feet, we descended through the cloud forest into the Amazon Basin in southern Peru. On the way, we encountered a boldly colored Cock-of-the-Rock dancing its courtship ritual at nine thousand feet. After arriving at the largest area of protected rain forest in the Amazon, I photographed noisy macaws, parti-colored frogs, blue-headed parrots, and the three-toed sloth.

A group of blue-headed parrots cling to the vertical, clay cliffs that line the Manu River in Peru's Amazon Basin. The noisy, foot-tall parrots congregate each morning to nibble minerals embedded in the clay. The minerals counter toxins the birds ingest when eating certain nuts and fruits included in their diet.

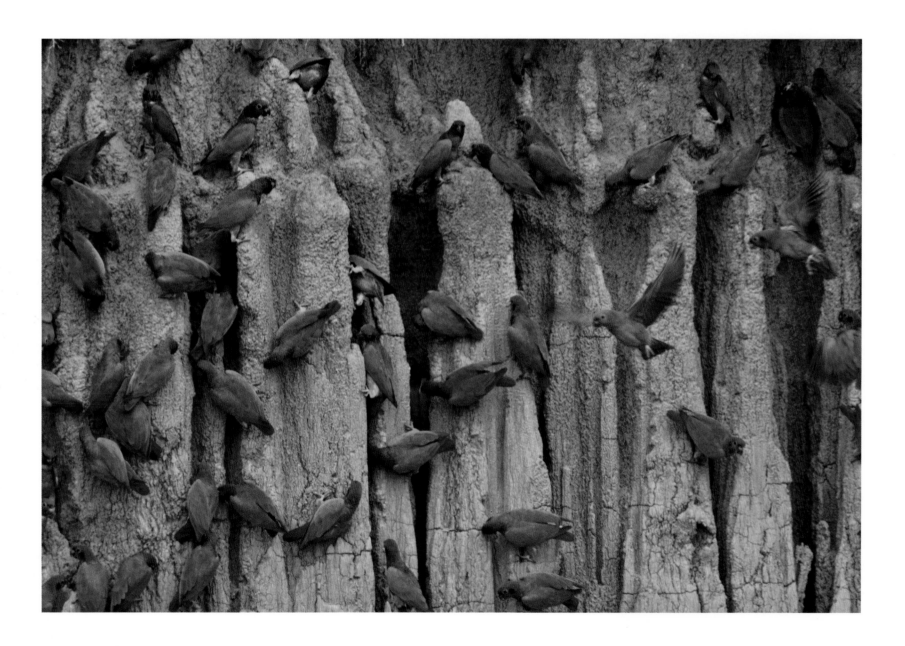

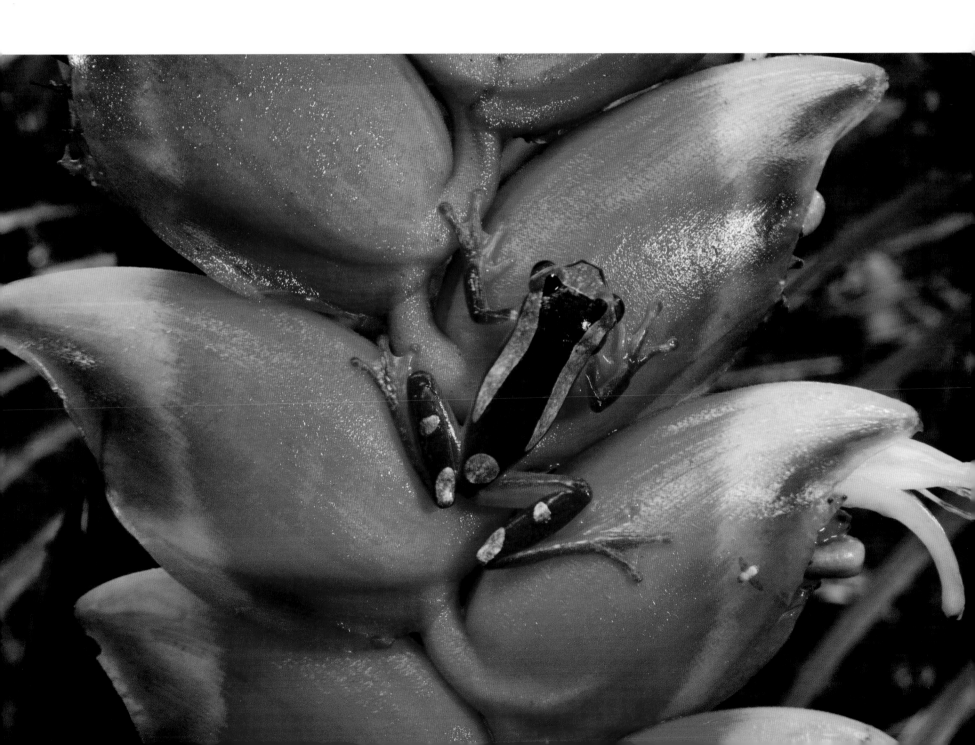

A clown tree frog ascends a brightly colored heliconia in Manu National Park. The frog's bright colors warn potential predators to stay away. Some nonpoisonous frogs mimic the colors of deadly poison arrow frogs—a sort of conceptual camouflage.

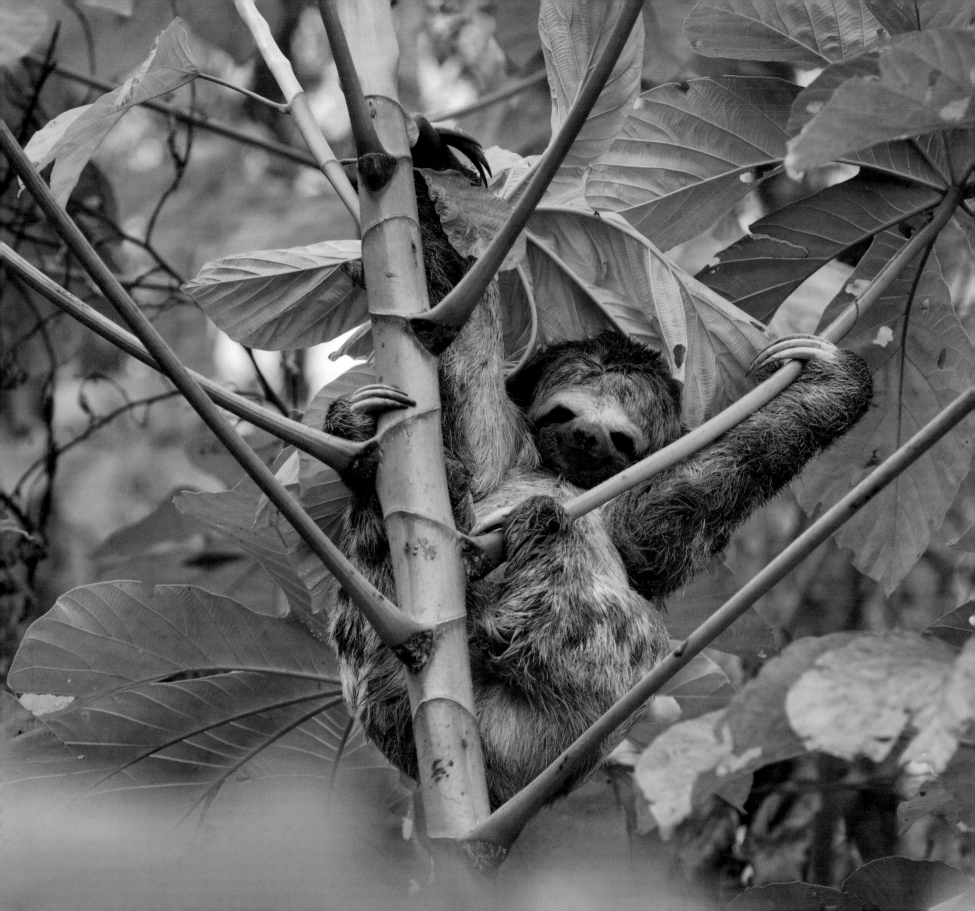

The three-toed sloth moves deliberately through the canopy of the South American Amazon. These unassuming leaf-eaters are known for hanging upside down and exhibiting an extraordinary lassitude—evolutionary traits that enable them to avoid the notice of sharp-eyed birds of prey. The harpy eagle often dines upon the three-toed sloth, which weighs only seven to ten pounds.

Scarlet and green-winged macaws convene above the Tambopota River in the Peruvian Amazon rain forest. The populations of these colorful birds have been diminished by the pet trade and deforestation.

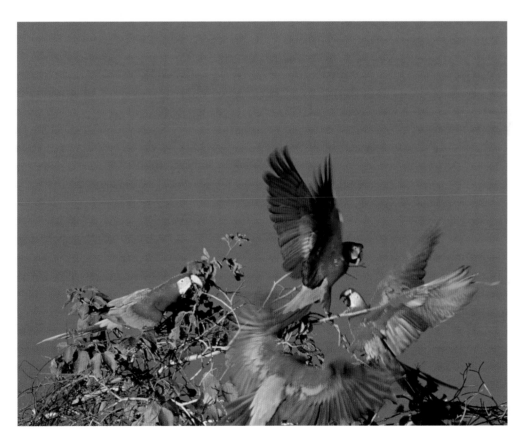

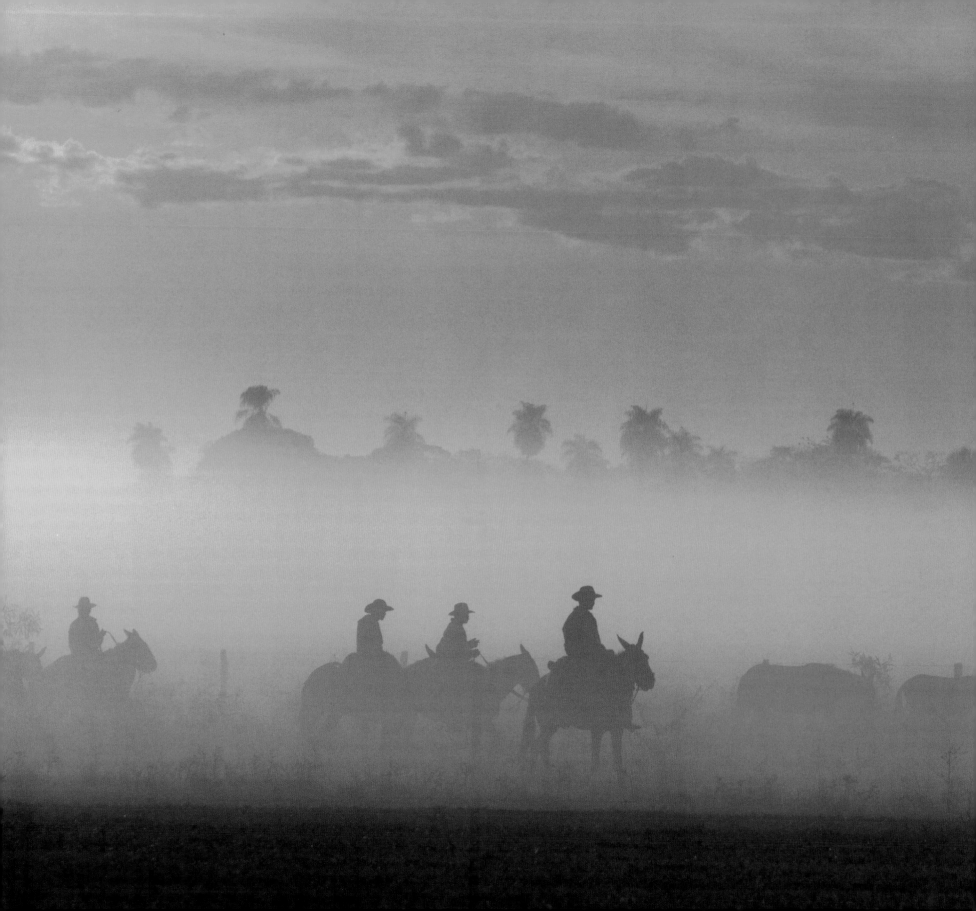

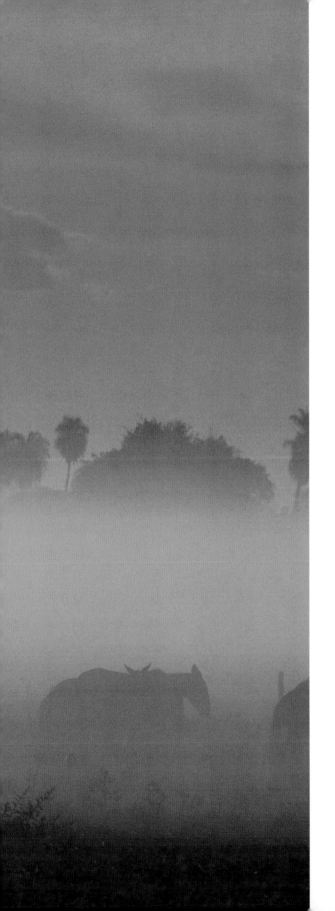

Except for the bolos and the wetlands, this could be a scene from the American West. Brazilian cowboys drive their mules and cattle to high ground in the rainy season, working to keep the herds safe from crocodilians, jaguars, and floodwaters.

The giant anteater is the largest of the anteaters, reaching nearly 140 pounds. Native to Central and South America, they eat tens of thousands of ants and termites each day. While they appear harmless, they can kill a person or fend off a jaguar with a swipe of their powerful claws.

THE PANTANAL, BRAZIL

Located in the heart of South America, the Pantanal is the world's largest wetland and home to one of the densest concentrations of wildlife on the planet. It's a unique place where human activity and wildlife coexist. Here, Brazilian cowboys ride herd alongside toothy caimans, giant otters, capybaras, macaws, and toucans. We arrived just as the seasonal floods receded to reveal both an ecological paradise and a vibrant cowboy culture.

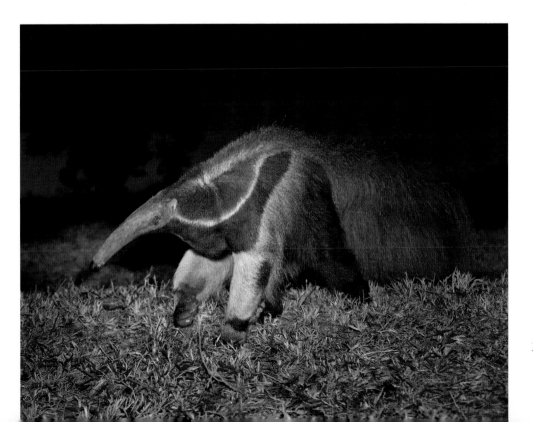

A hyacinth macaw loses its grip on an exposed limb in the
Pantanal. The macaws are highly endangered, but their numbers
are increasing in protected *fazendas*, or ranches, in this area.

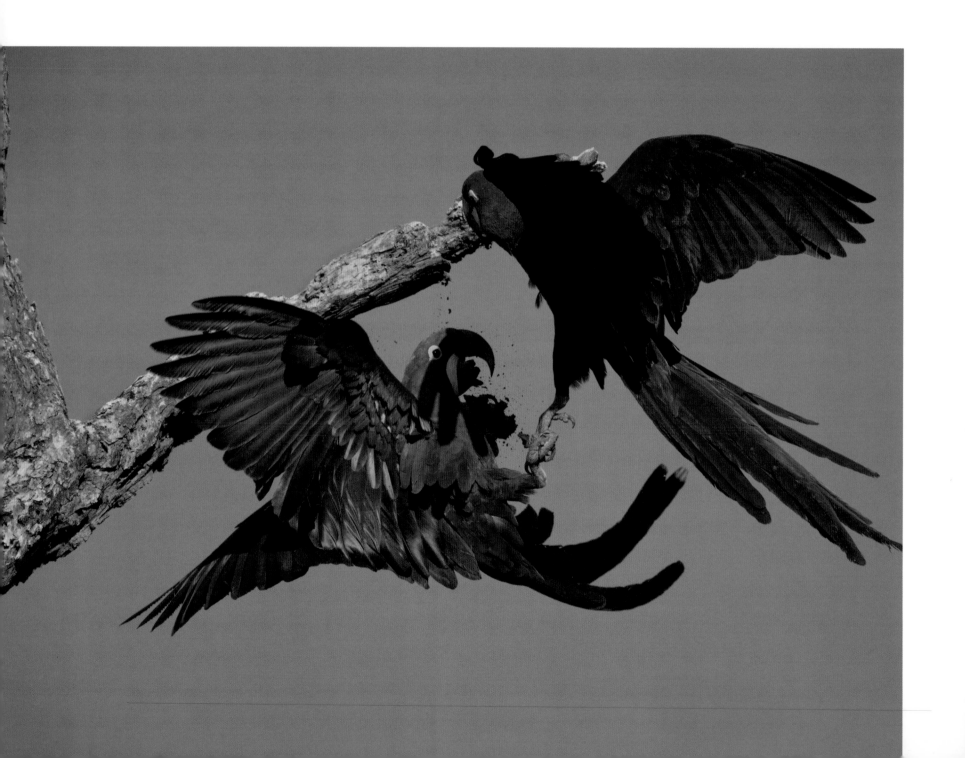

Five-foot long Yacare caimans emerge from a wetland in Brazil's Pantanal marsh. These midsized members of the crocodile family are not dangerous to humans because they are accustomed to being fed by local ranchers. When one of these bold reptiles came within six inches of me, I used my tripod leg as a largely symbolic barrier.

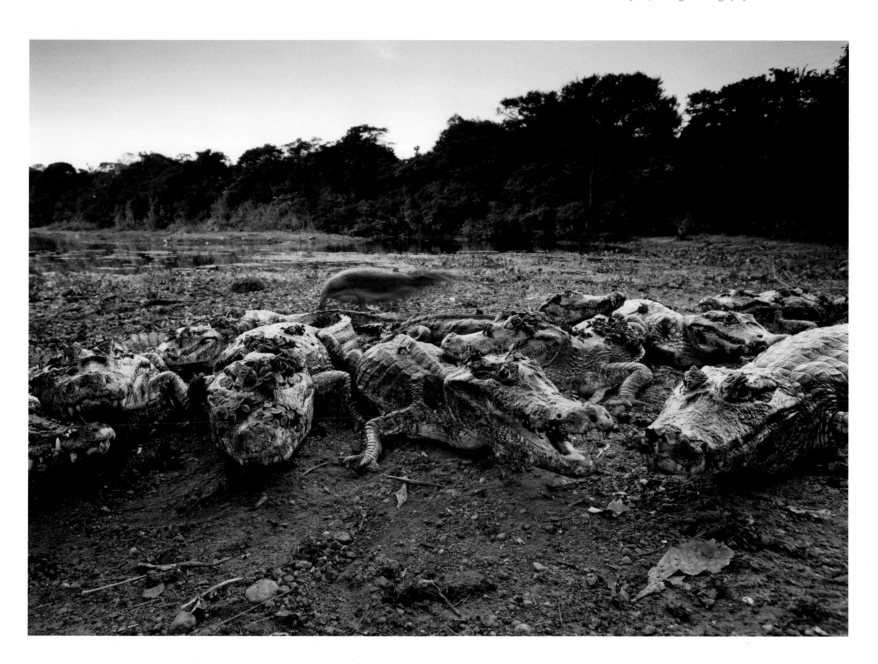

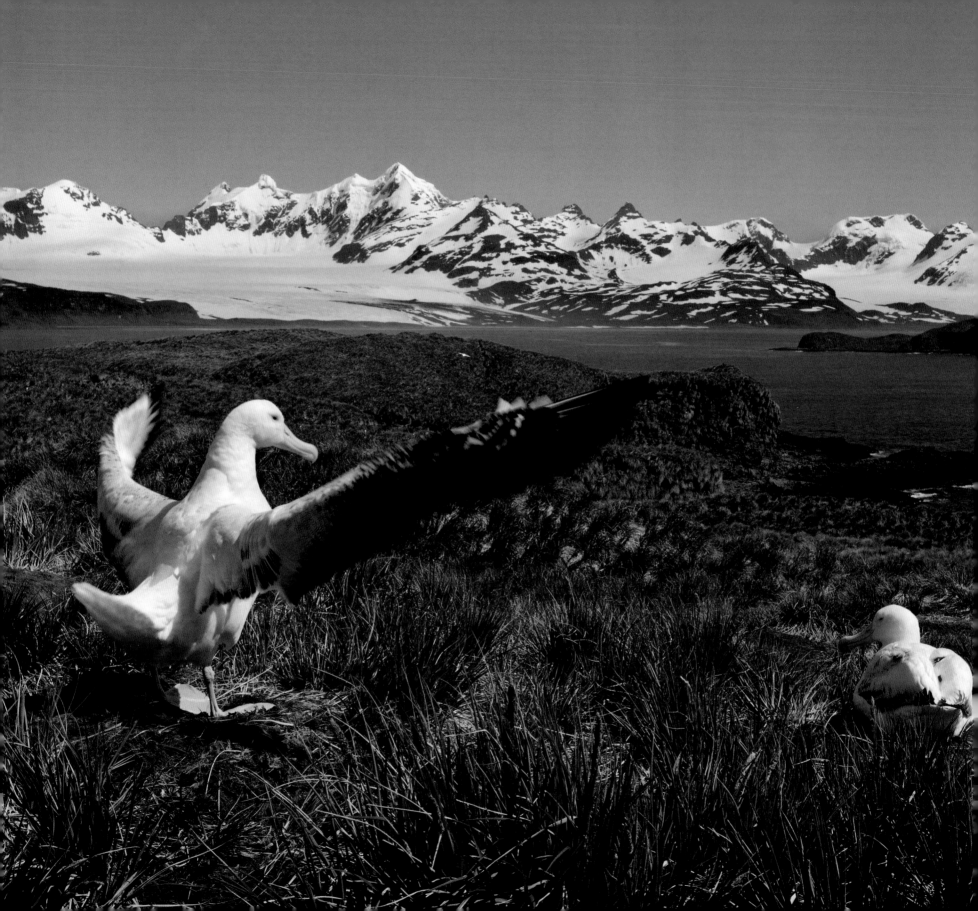

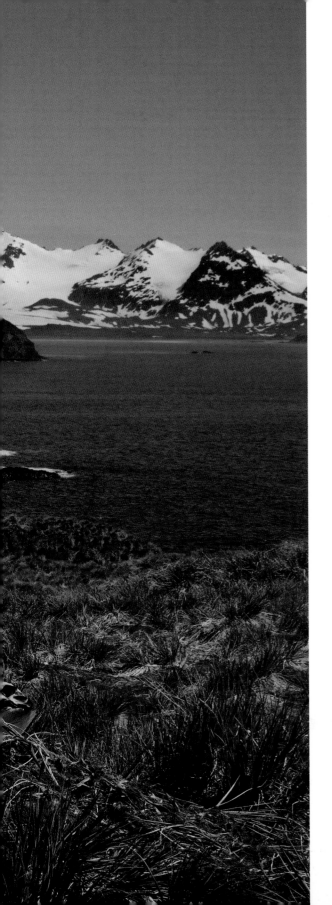

On a tiny island near the coast of South Georgia Island, a courting male albatross bonds with its potential lifelong mate. The wandering albatross, with an eleven-foot wingspan, is clearly the king of ocean birds, but overfishing and destructive longline nets threaten its survival in southern oceans. Some nets stretch up to sixty miles and snare fish and birds indiscriminately.

SOUTH GEORGIA ISLAND, THE SOUTHERN OCEAN

Despite its cold, unwelcoming climate, South Georgia Island in the South Atlantic is one of my favorite places on earth. A remote, hundred-mile whaleback of rock, South Georgia Island resides in the Southern Ocean, more than eight hundred miles southeast of the Falkland Islands. It features glacier-clad mountains rising two vertical miles above the sea. South Georgia is as wild as it gets, hosting one of the largest concentrations of wildlife anywhere. Over four hundred thousand pairs of king penguins walk the beaches and swim the frigid blue ocean. Seals, albatross, and even reindeer (imported for meat by long-gone Norwegian whalers) also inhabit this isolated island. I used a wide-angle lens to photograph austere landscapes, intimate plant studies, and endearing animal behavior in this wildlife oasis.

This iceberg, photographed off the coast of South Georgia Island, clearly displays the layers of an ancient glacier. The blue ice formed when pressure squeezed bubbles out of the white ice.

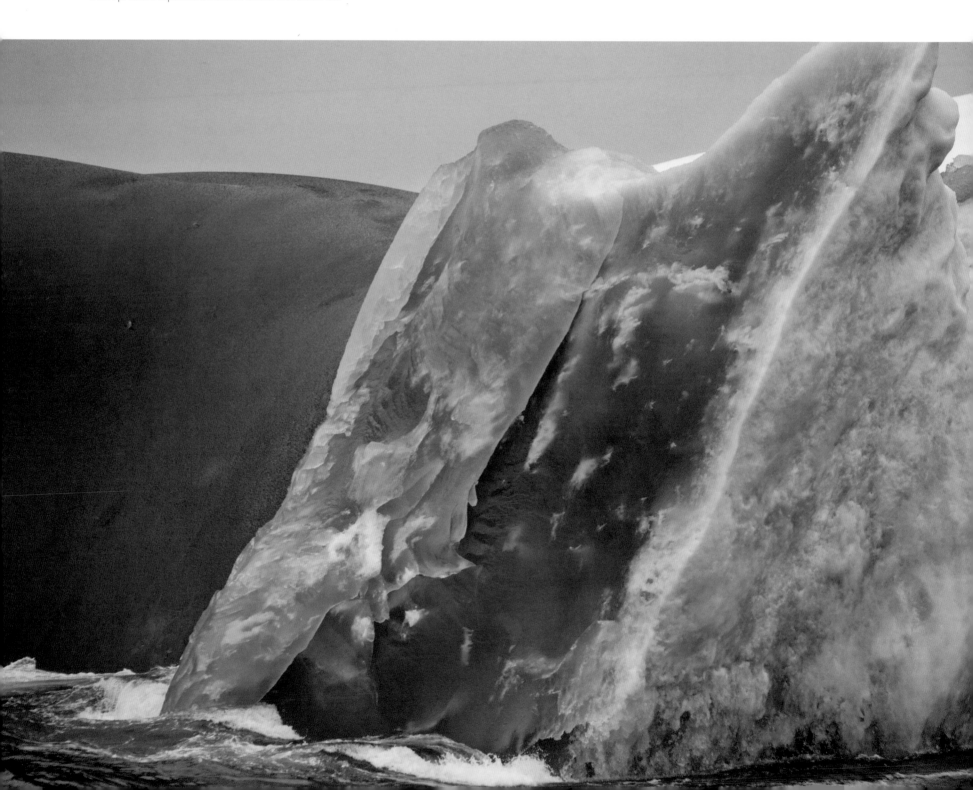

An adolescent king penguin challenges reindeer crossing through a penguin rookery on South Georgia Island. Long-gone European whalers brought reindeer to the island as a dietary alternative to whale meat. Reindeer herds continue to roam throughout the remote island.

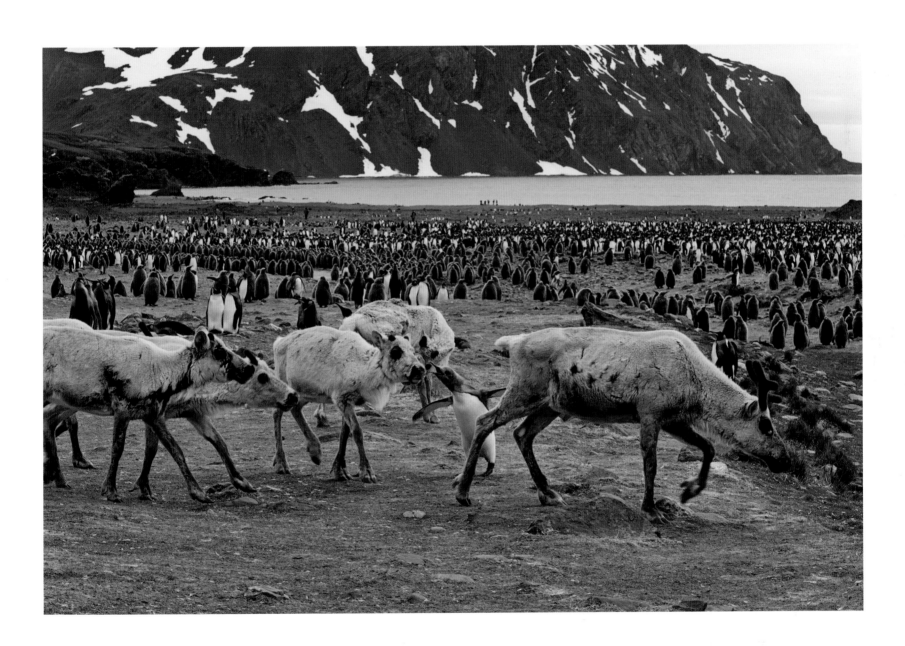

This king penguin chick catches the first light of the rising sun at the edge of a vast rookery on South Georgia Island. King penguins mature in a little over a year; eventually, this bird will weigh nearly forty pounds and stand three feet tall.

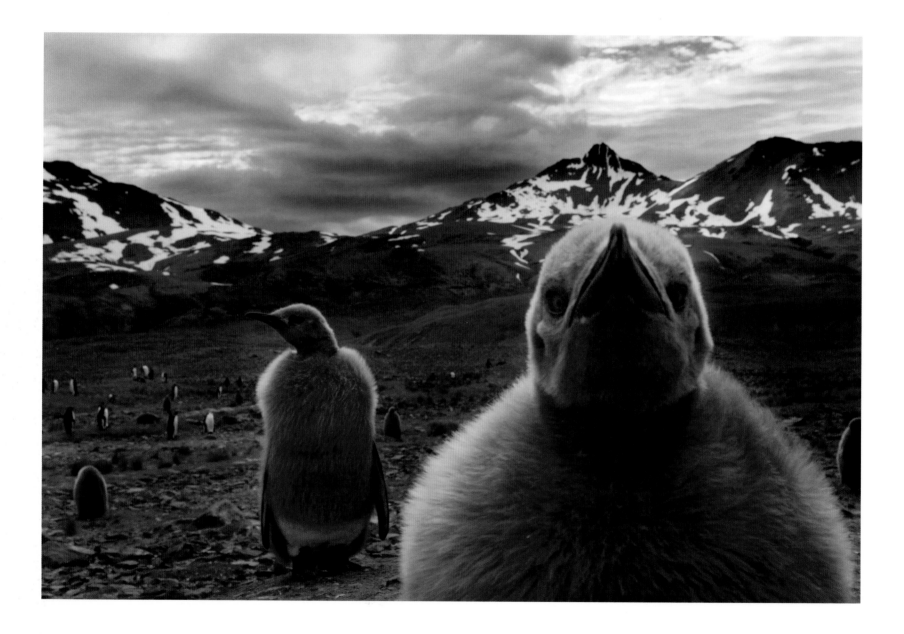

King penguins incubate their eggs in large, compact rookeries. A rookery's density—birds are just about pecking distance from one another—provides a warmer, safer environment for incubating eggs and raising chicks.

Following page Forty-pound king penguins line the shores of South Georgia Island. They are on their way to the rookery where territorial instincts prompt numerous quarrels among the birds. The beach is a respite from the dangers of the ocean and the crabby neighbors on the nests. Although the island experiences some of the worst weather in the world, we were fortunate to shoot in the pink light of a clear sky with the sun hidden behind the horizon.

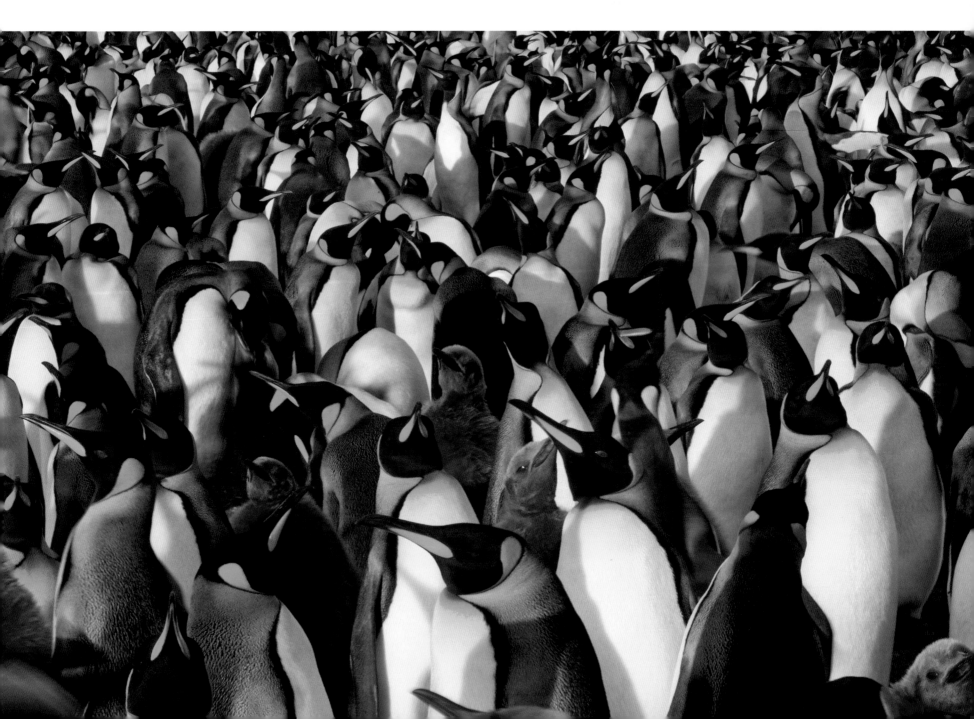

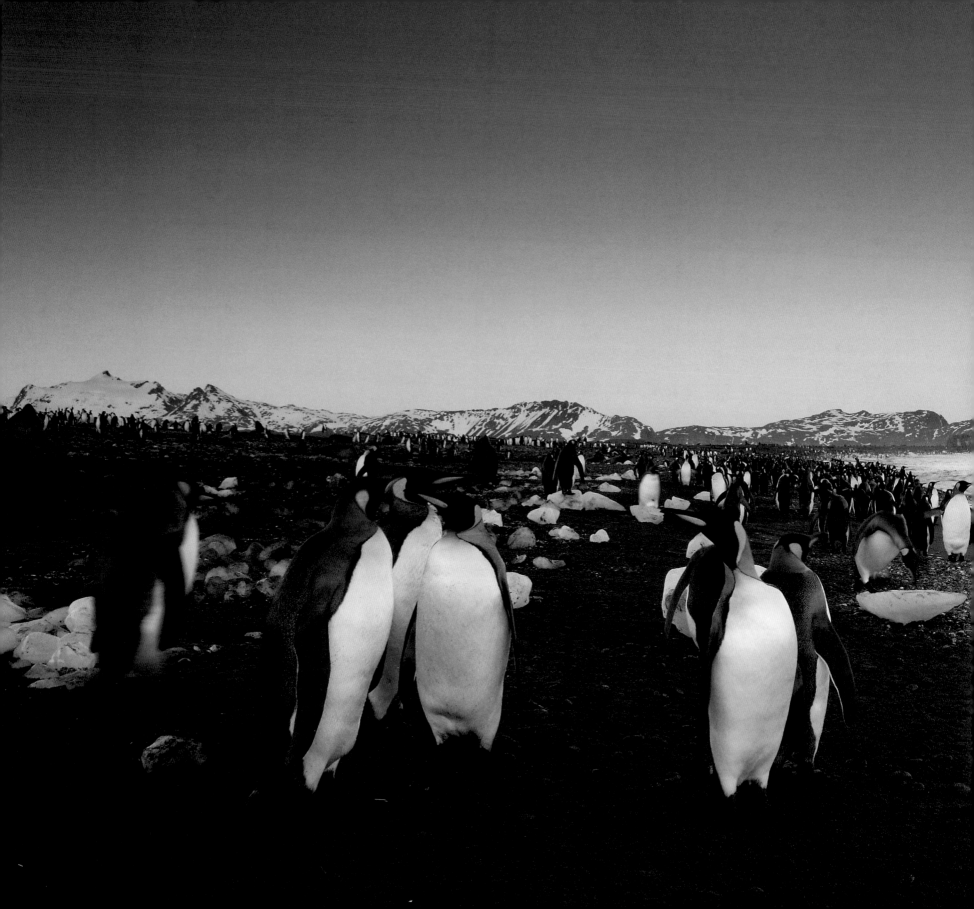

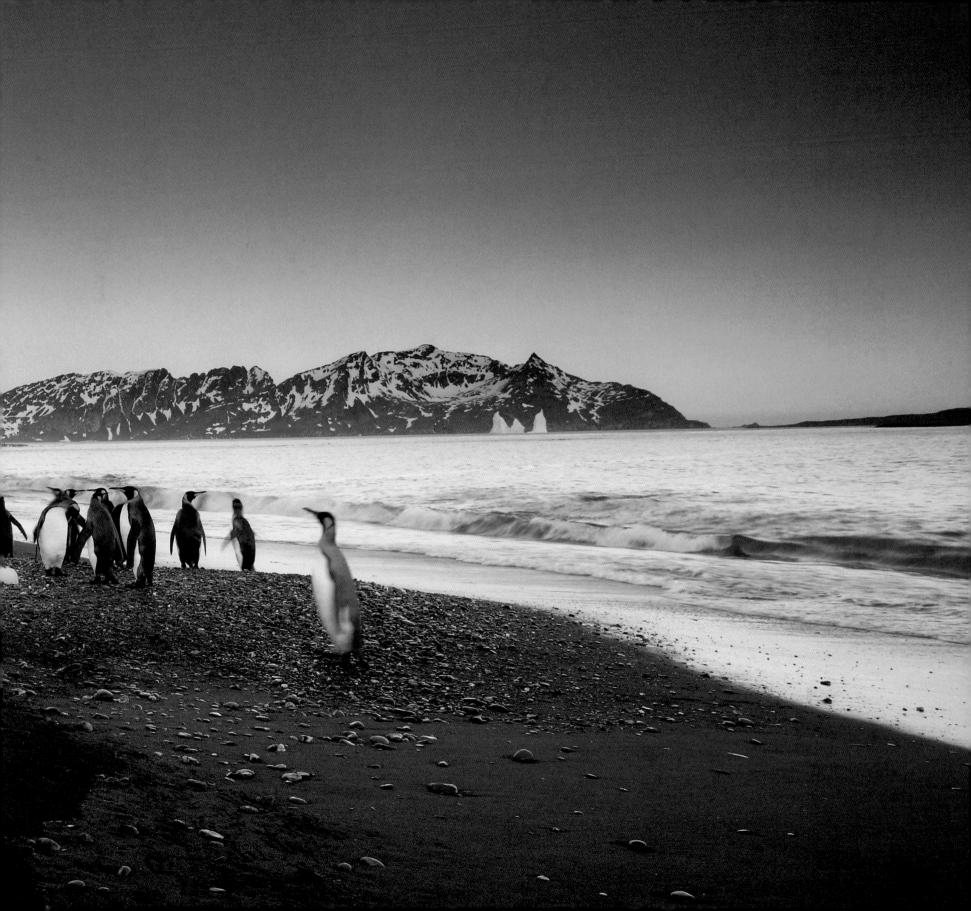

Elephant seal pups playfully joust in the calm waters of a shoreline lake on South Georgia Island. At this age, they are called "weaners" because they have recently been weaned from mother's milk. These weaners will grow to be the largest seals on earth—elephant seals weigh as much as several tons and reach up to twenty feet in length.

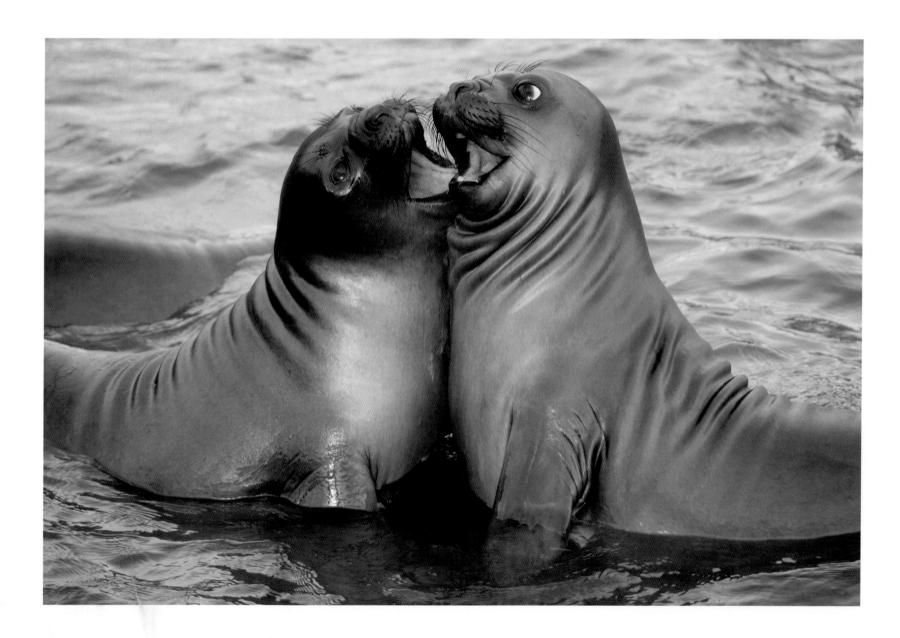

Two young southern fur seal males fight for dominance in the turbulent surf of South Georgia Island. Southern fur seals are extremely aggressive and dangerous, sometimes charging people on the shore. Fur hunters nearly brought them to extinction on the island, but the seals have rebounded to a population of approximately two million.

I crawled under a snow overhang on the Antarctic Peninsula to find an alternative to counter the harsh, bright light of a sunny day. From this vantage point, I highlighted vertical icicles in the compressed recesses of the overhang, creating a more complex, intriguing composition.

ANTARCTICA AND THE FALKLAND ISLANDS

It was spring on the Antarctic Peninsula and the frozen wilderness was a veritable nursery for penguins, shore birds, and seal pups. We crossed the infamous Drake Passage—the treacherous body of water south of Cape Horn—after exploring the Falkland Islands en route to the Antarctic coast. Our journey was rich with opportunities to photograph the wildlife and landscapes that represent this pristine, unforgiving land.

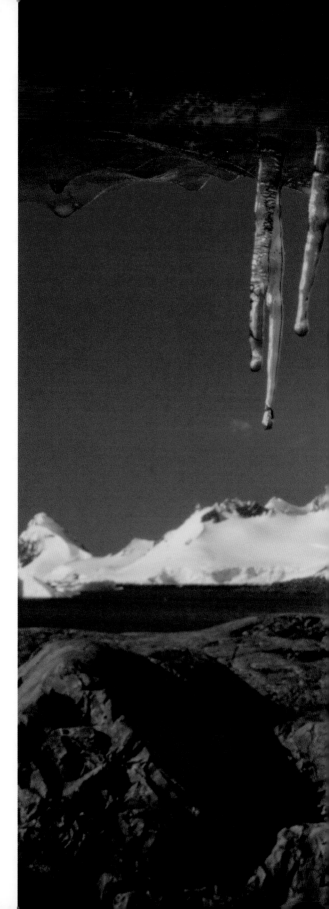

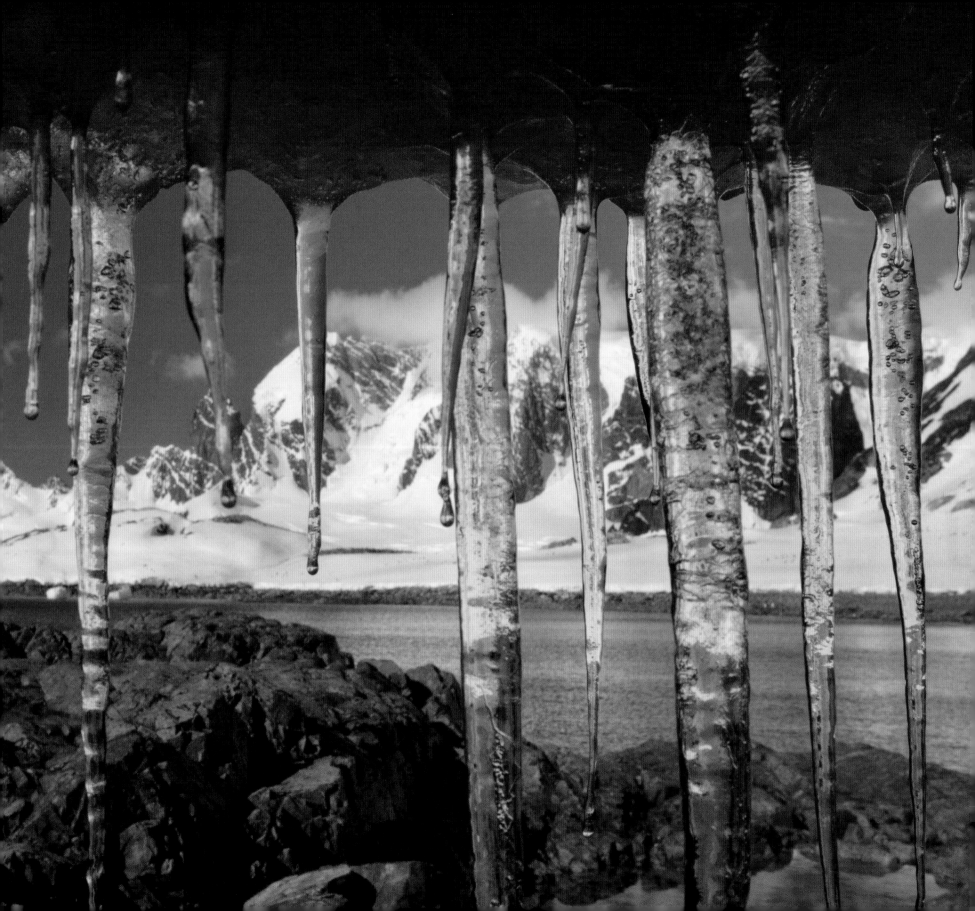

This is the largest black-browed albatross rookery in the world. Situated on Steeple Jason Island, northwest of the main Falkland Islands, the nesting area sees few visitors. A wide-angle lens allowed me to focus on two individuals while still encompassing the expanse of the rookery.

Late evening summer light illuminates the mountains of the Antarctic Peninsula, which is an extension of the Andean mountain range one thousand miles to the north. The collision of continental and oceanic plates crumpled the crust to heave the mountains skyward.

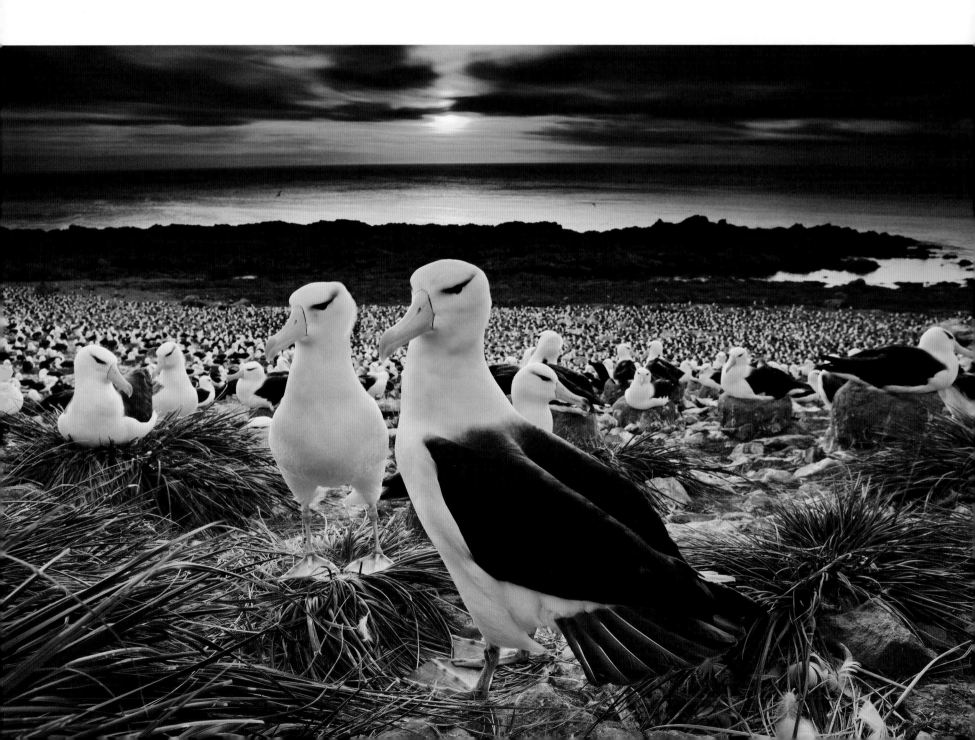

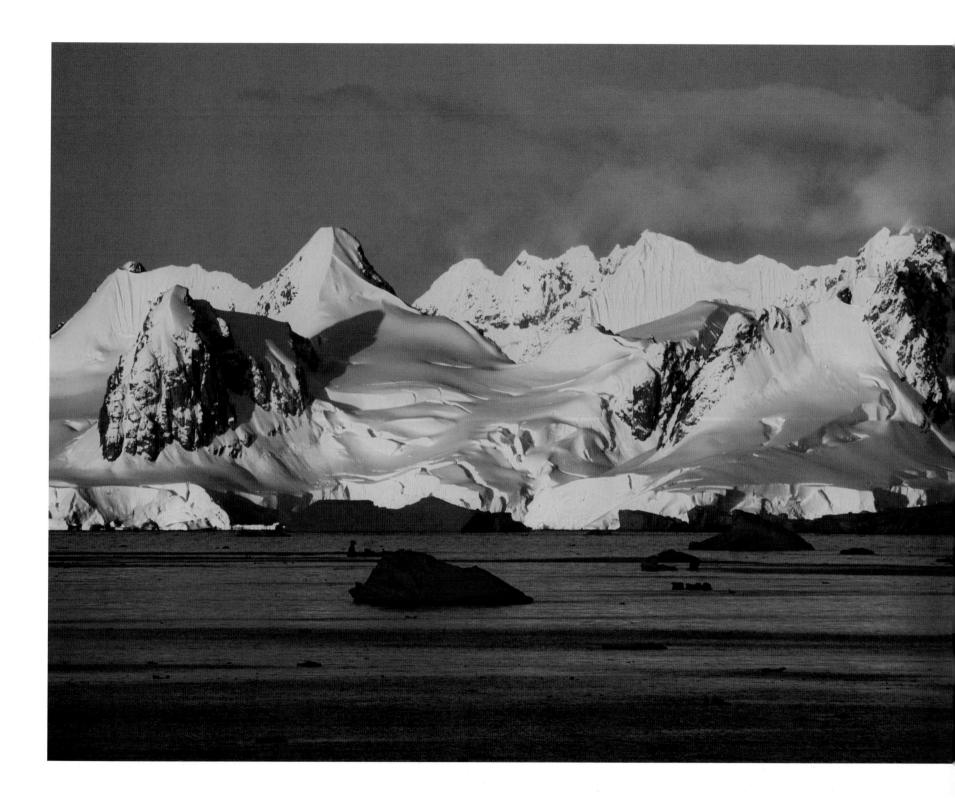

On Paulet Island off the Antarctic Peninsula, Adélie penguins gather in groups numbering into the hundreds. The groups display a reluc-tance to dive into the frigid water, wary of the leopard seals that patrol the perimeter of the rookeries looking to feed.

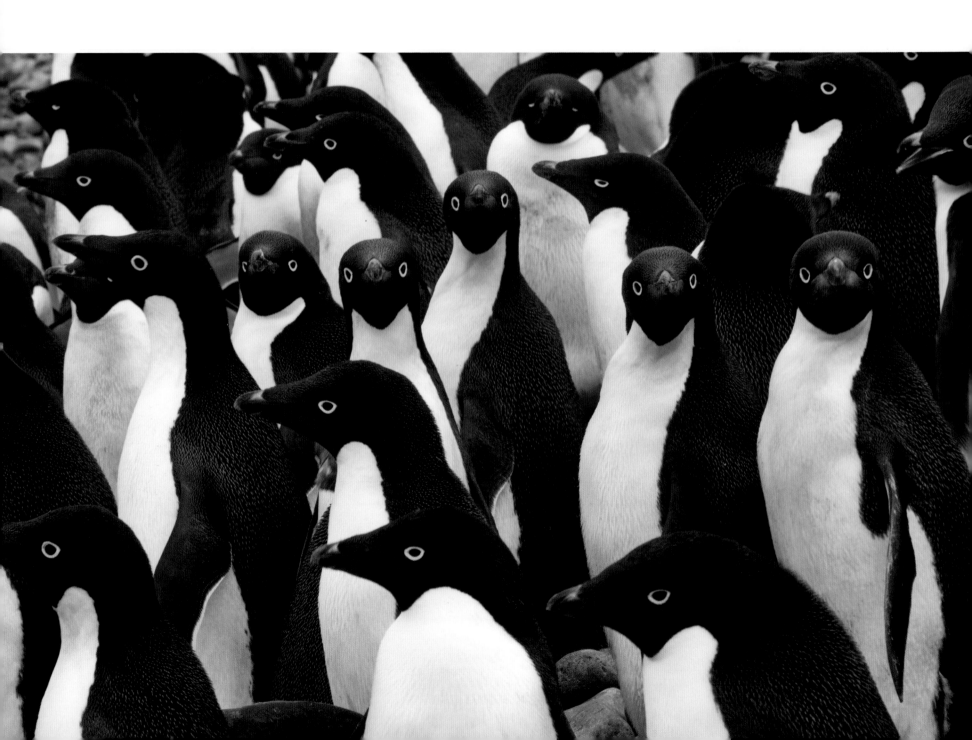

This Weddell seal and Adélie penguins exhibit almost no fear of humans since no human population has ever lived or hunted on Paulet Island. With a 16-mm wide-angle lens, I was able to capture this curious seal just inches away, as well as penguins resting on ice floes in the distance.

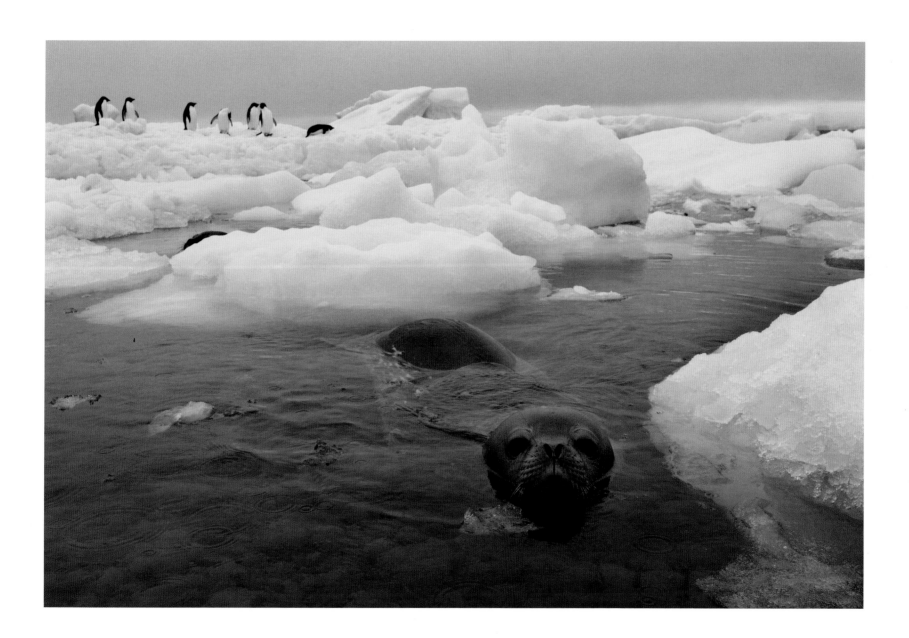

The Dogon gathered in this remote, mountainous region after fleeing slave traders in the seventeenth and eighteenth centuries. Sun rays slash through cook-fire smoke as these villagers begin their day. I'm drawn to images that combine atmospheric conditions with daily routines.

SAHEL TO THE SAHARA, MALI

The southern Sahara is a fabled land of sand, salt, and nomads. But Mali is more than the Sahara; it is a place where the Niger River flows past some of Africa's tribal and architectural wonders. We followed the river road to the camouflaged villages of the cliff-dwelling Dogon people; floated downriver to Djenné's fantastic mud mosque; headed into the desert accompanied by an armed contingent to visit nomadic Tuaregs; and finally continued on to Timbuktu to meet up with a camel caravan.

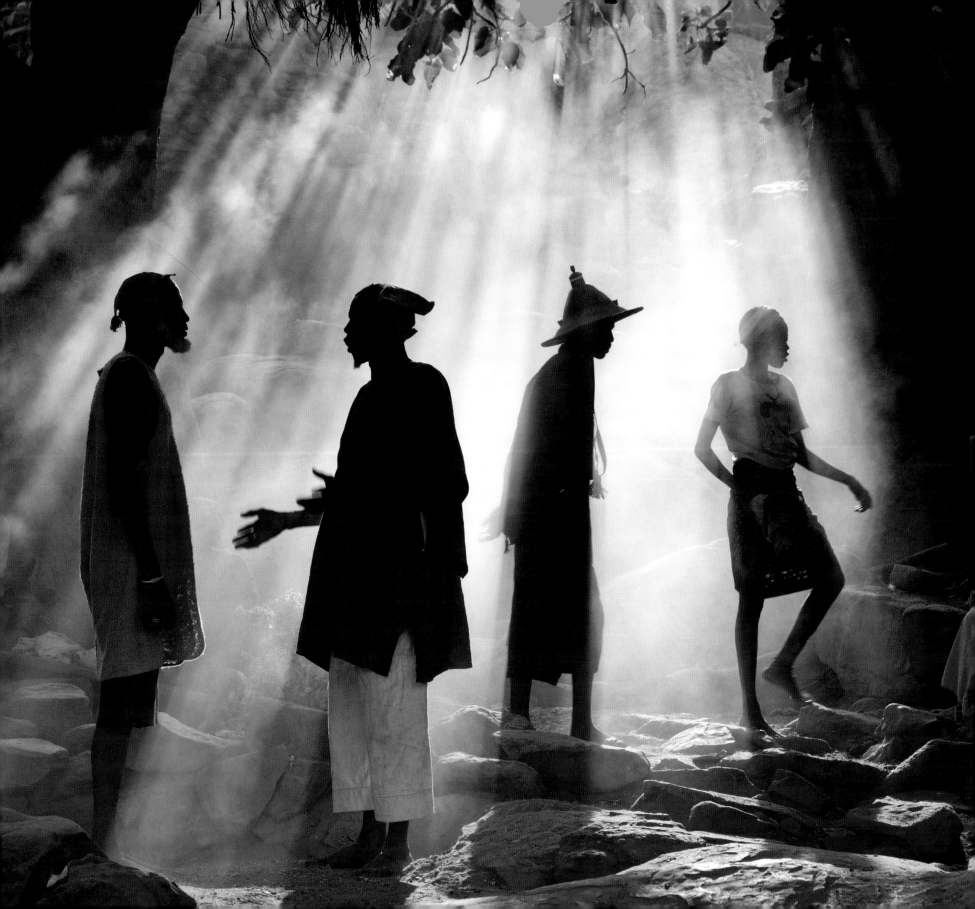

A Dogon hunter sits below a wall proudly adorned with furs garnered from recent hunts. The Dogon believe that such a display pays homage to the hunted animals and releases their spirits. Early morning light catches the adobe home carefully built within a protective mountain overhang. Finding the hunter's village was not easy; it is well-concealed in a deep canyon in remote southern Mali.

Grains and other crops dry on rooftops beside adjacent homes with beautifully thatched roofs. The Dogon build granaries with airtight roofs to protect their food from rodents. From this perspective, the repetitive pyramidal roofs and earth-tone palette combine to create an abstract composition, while a single villager provides scale.

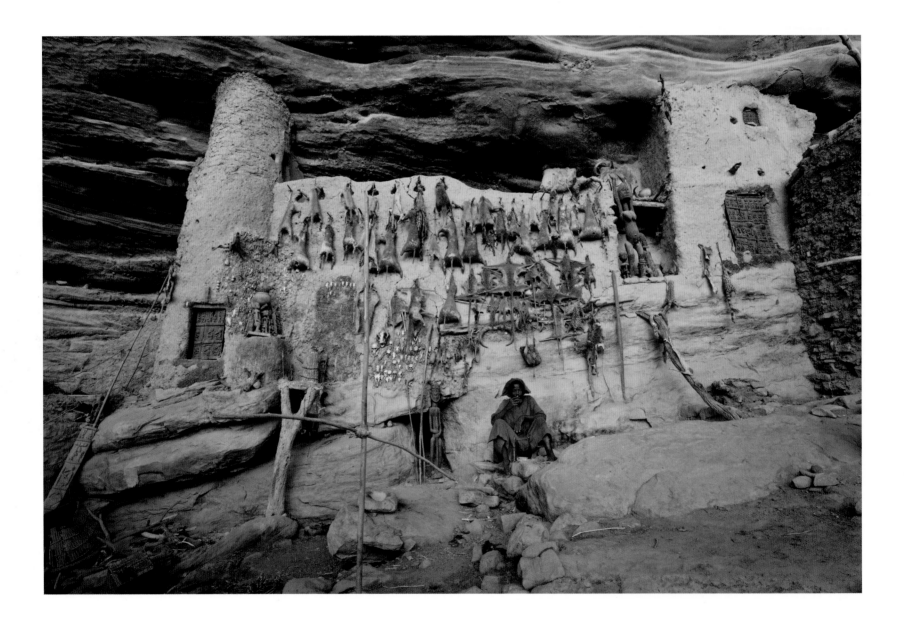

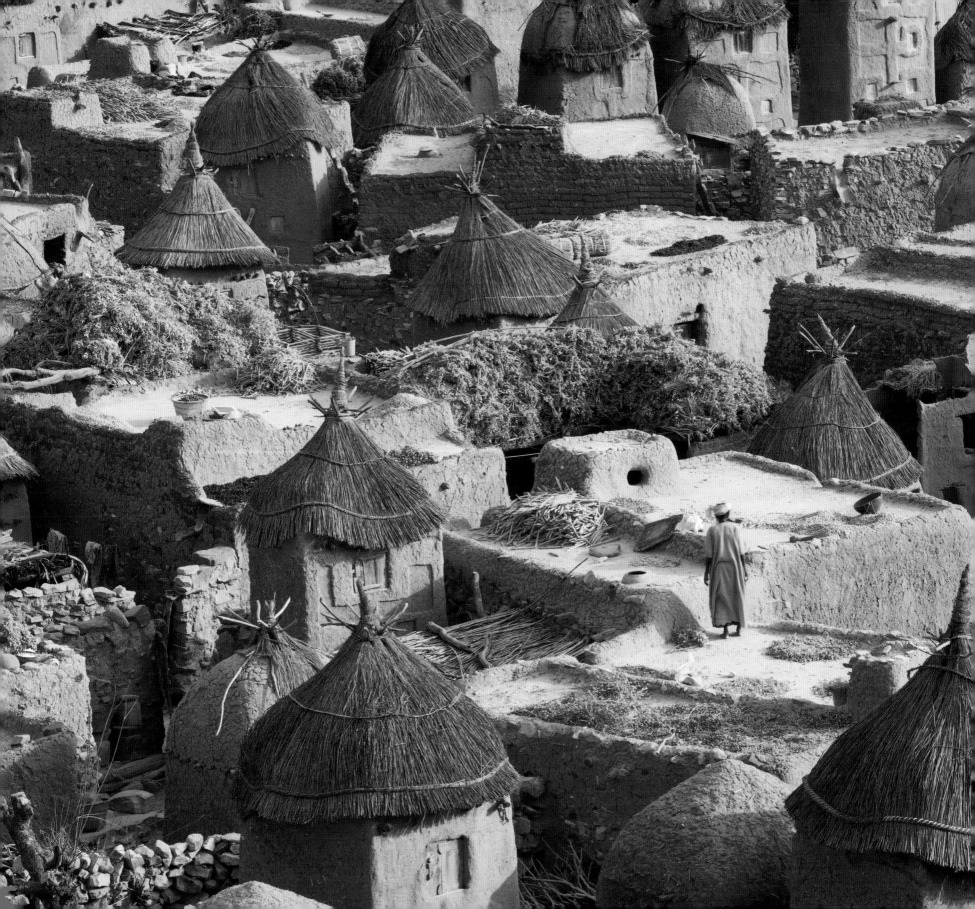

Djenné, the oldest known city in sub-Saharan Africa and a center of Islam since the thirteeth century, is the site of the world's largest mud structure, the Great Mosque of Djenné. Built on the site of earlier mosques, the current structure was begun in 1907. The citizens climb on the horizontal posts annually to apply new mud, which preserves the mosque.

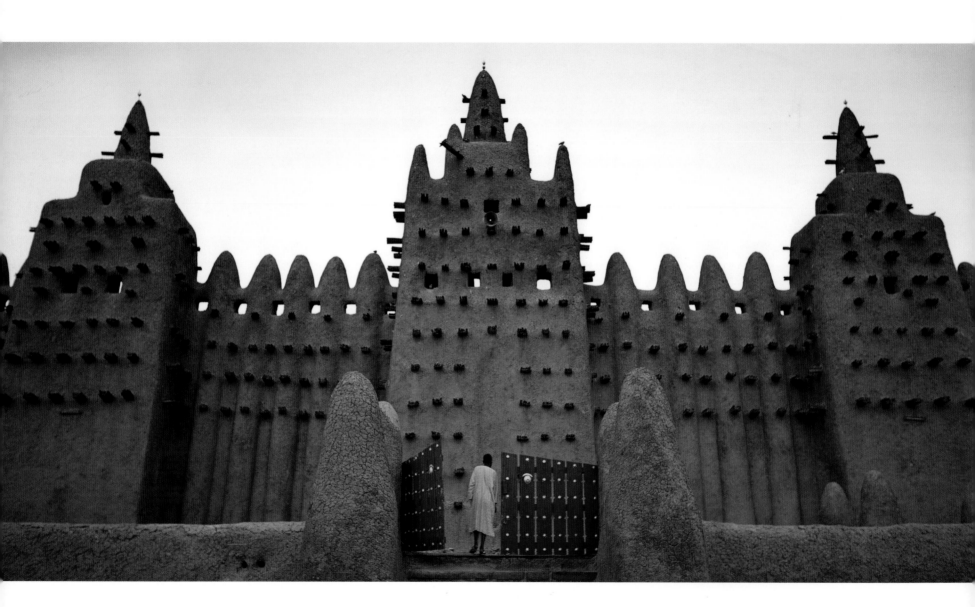

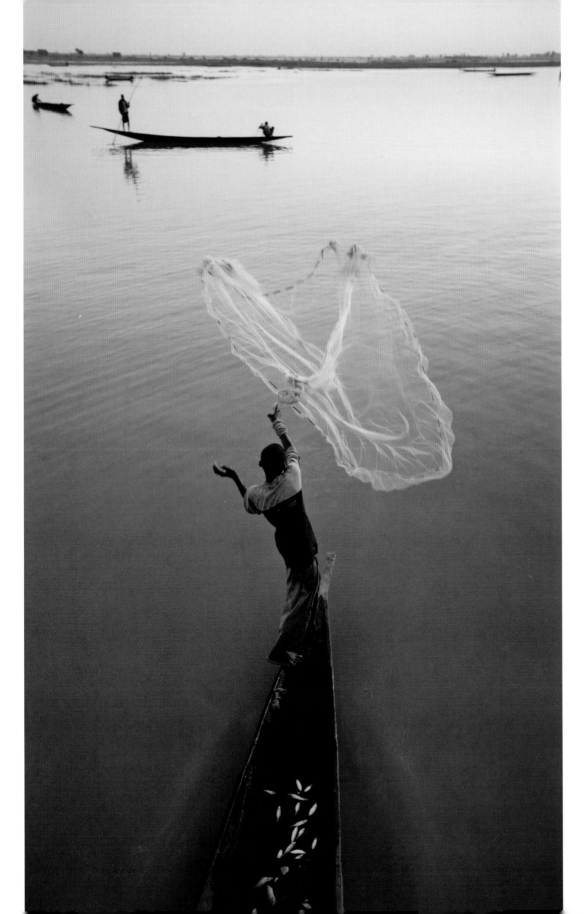

As his ancestors have done for centuries, a young boy tosses his fishing net into the Niger River at sunrise. The Niger is the grand river of West Africa, serving as its primary access to the rest of the world.

Following page In the Sahara Desert, which is larger than the continental United States, time seems to stand still. This image of silhouetted camels and salt traders in Mali documents a way of life unchanged for centuries.

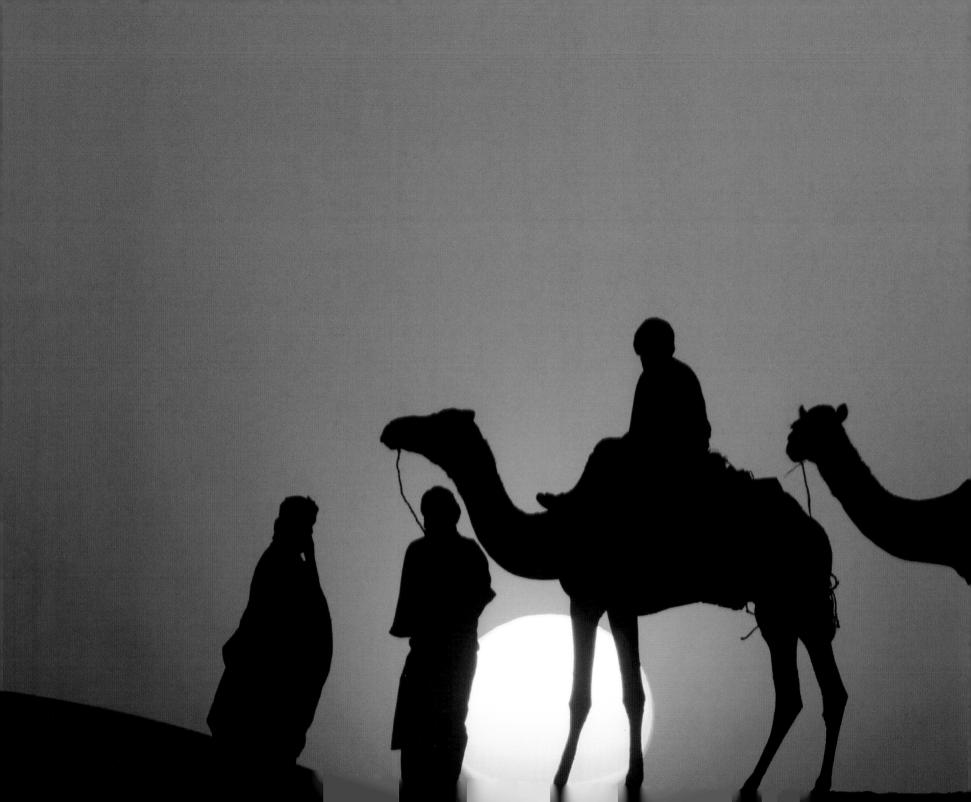

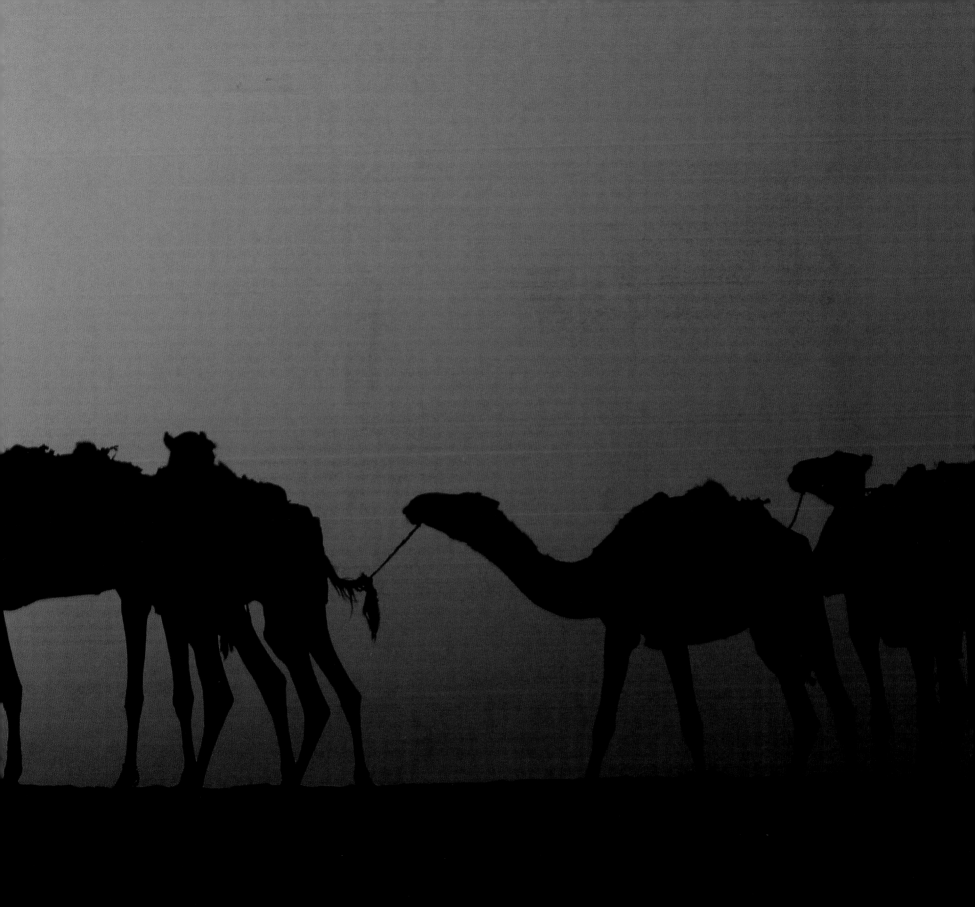

Tuareg tribesmen, the iconic people of the Sahara Desert, gather at a groundwater well. These wells were built sporadically across the Sahara and provide life-sustaining water for the Tuareg and their herds of donkeys, goats, and camels.

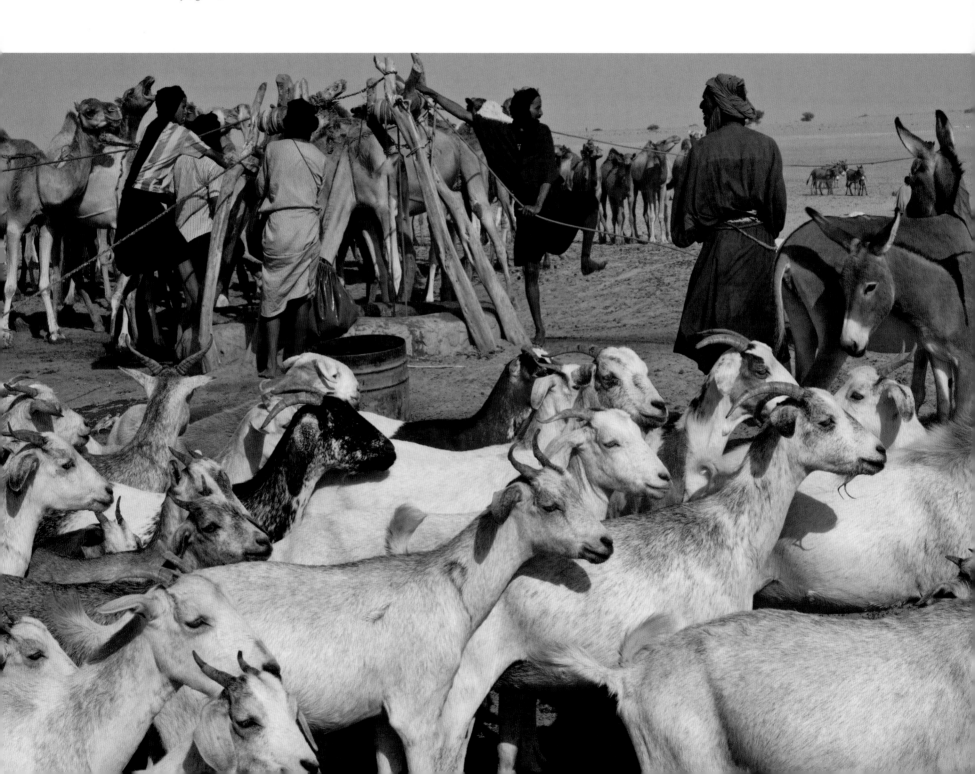

A caravan of salt traders and camels heads to the ancient city of Timbuktu on the southern margin of the great desert. Once one of the most famous cities in the world, Timbuktu has served as a trading hub for hundreds of years. The traders harvest salt from a lake bed in the heart of the Sahara and transport it to the Timbuktu market. This image captures a timeless moment, virtually identical to what the greatest traveler of the fourteenth century, Ibn Battuta, might have seen when he ventured to Timbuktu.

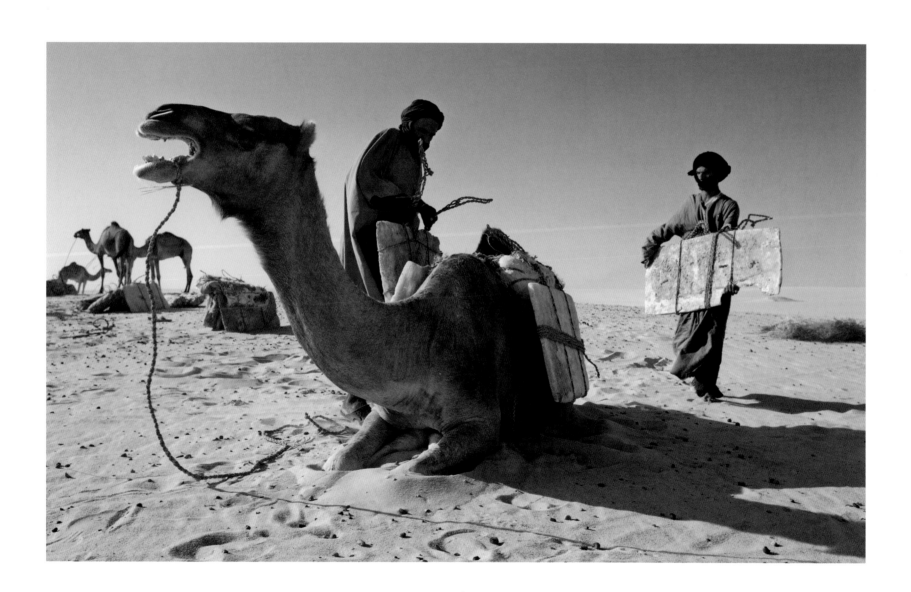

We were traveling through Benin when an adobe building caught our eye. We stopped to photograph it, and suddenly some children trailed by puppies appeared. This image captures one of many serendipitous moments we encountered in our travels.

A woman wears the horns of an antelope, a sign of prestige in this Togolese village. I was attracted to the curves of both the doorway and the horns as well as to the sense of mystery found in a silhouette, a figure without an identity.

TOGO AND BENIN, WEST AFRICA

West Africa is the birthplace of voodoo; in Togo and Benin ancestors commingle with the living. Whether it is vulture heads for sale at a fetish market or sacred bloodstained altars, voodoo is always front and center. Our team visited villages known for their vibrantly dressed residents and intense rituals. We witnessed frenzied trances, powerful masked dances, and an extraordinary fire-eating ceremony—all part of everyday life.

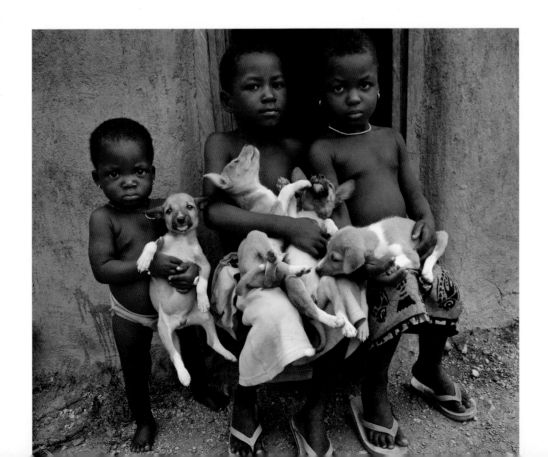

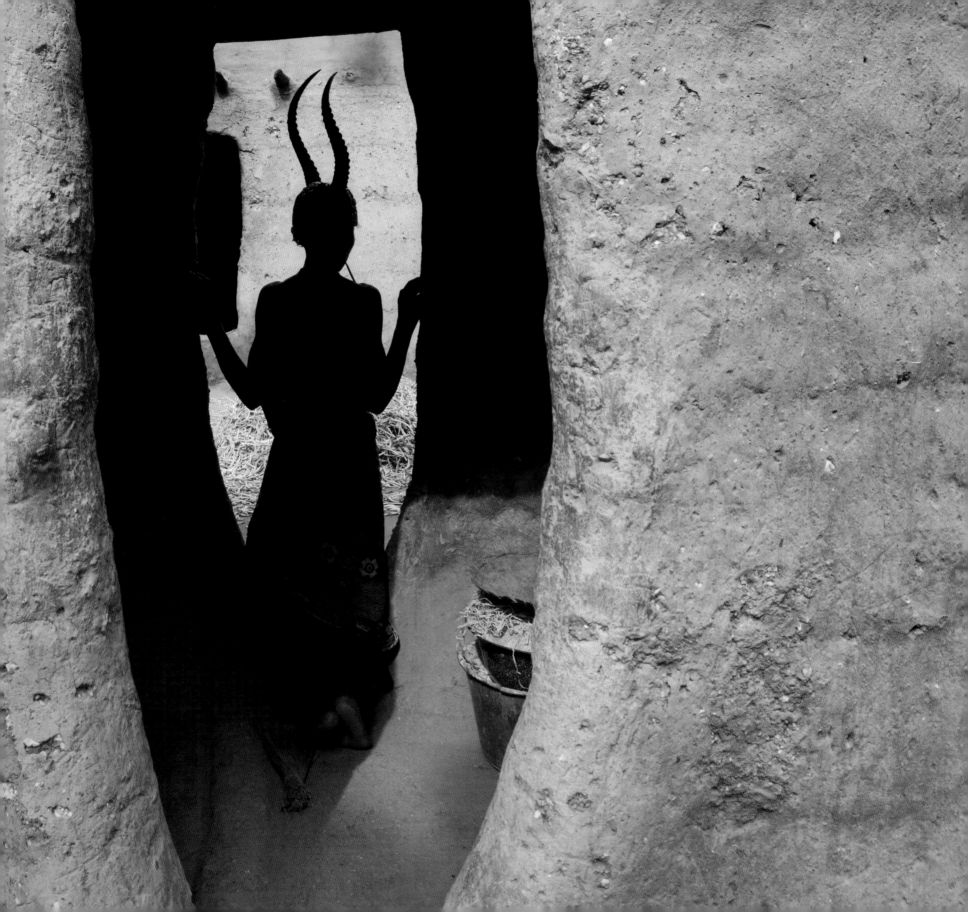

In the tiny country of Benin, West Africa, large freshwater lakes provide a bountiful harvest for local fishermen and open-air markets. This marketplace presents a colorful foreground as a storm builds on the distant horizon. Moments later, the skies opened in a tremendous downpour, producing a frenzied search for shelter.

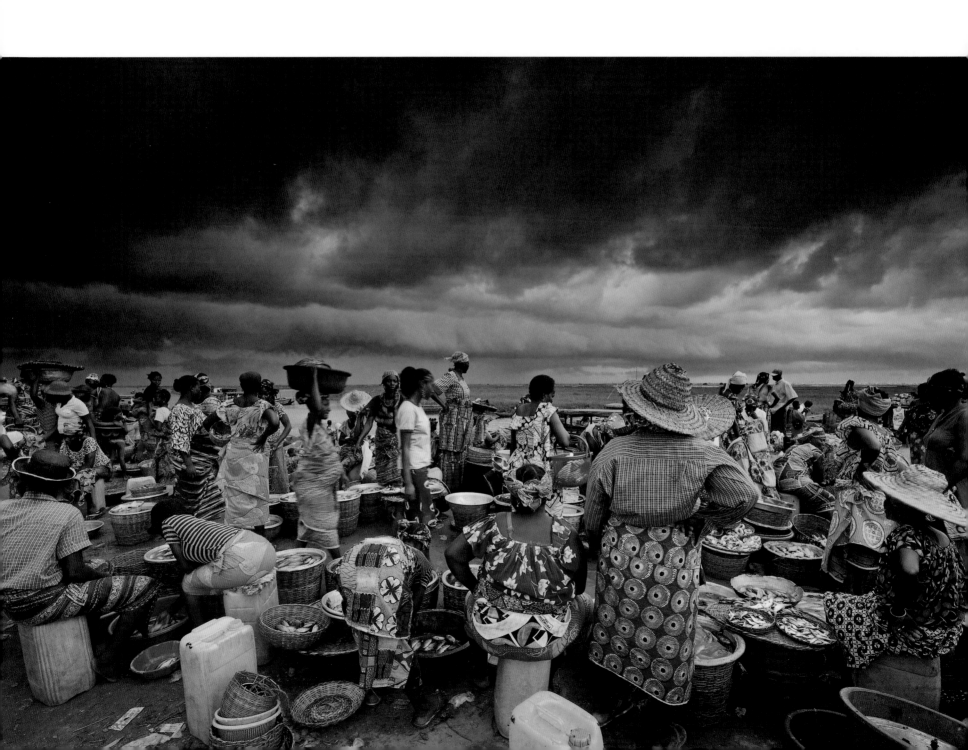

I've seen incredible things before but nothing like this. A group of men went into a trance and performed what appeared to be miracles. This man lay down on a roaring fire for more than a minute and emerged from the flames unscathed; not even his pants were burned. I have no explanation.

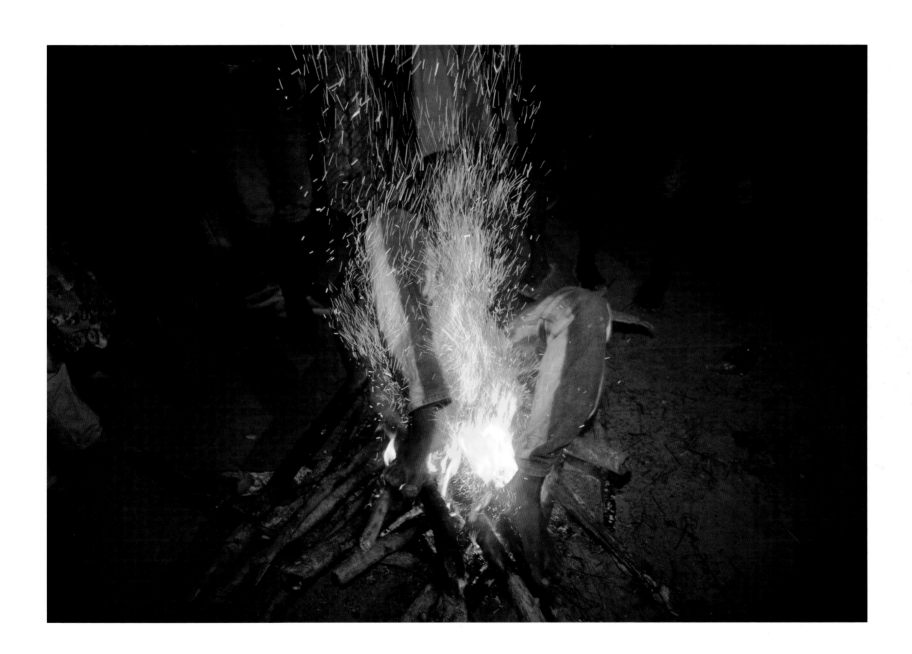

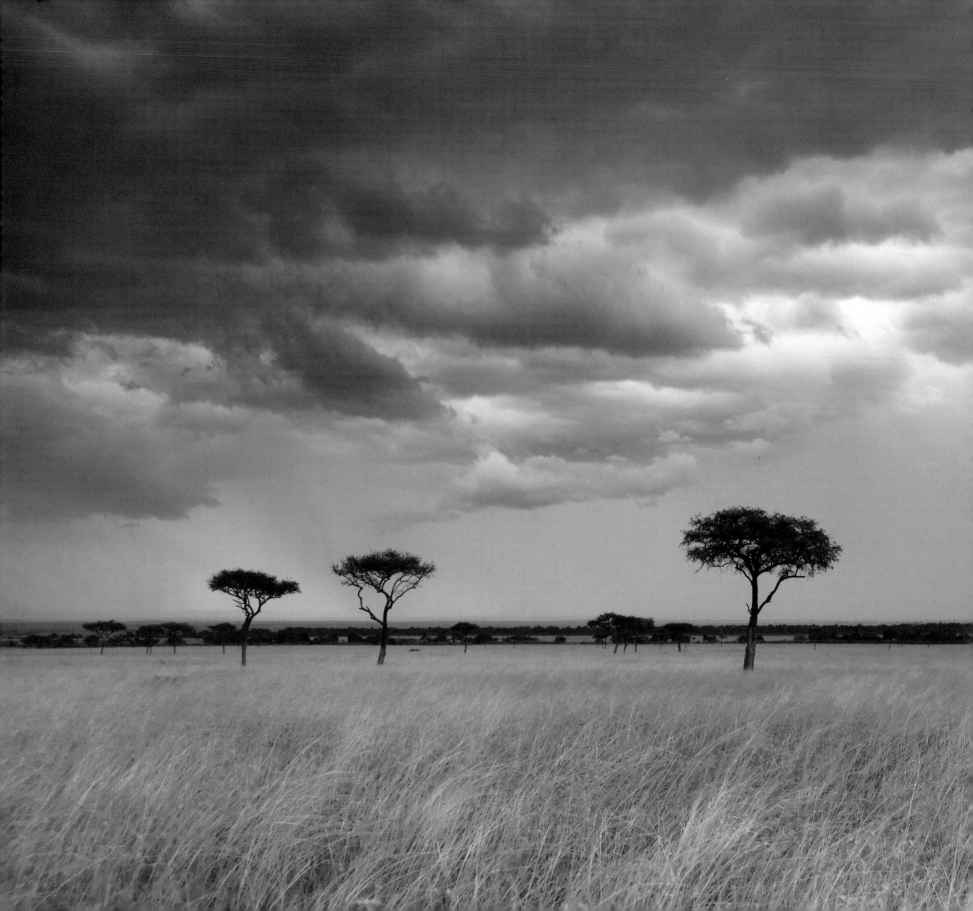

A fast-moving storm gathers over the Mara River Plain in southcentral Kenya, signaling the annual storms that convey life-sustaining moisture to the region.

While some animals, such as chameleons and octopus, have developed amazing camouflage, sometimes simple adaptations work best. The coloration of this male lion renders him nearly invisible in the tall grass.

KENYA AND TANZANIA

East Africa's open savannah hosts the largest terrestrial migration remaining on the planet. When seasonal grass flourishes, great nomadic herds of wildebeest and zebra commute to Kenya from the Serengeti. On the Masai Mara Reserve, we witnessed this living river of animals and its dependent predators. A pilot friend took me up in his plane so I could shoot aerial views of pink flamingo flocks and Lake Natron's colorful, mineral-rich water, and we rode on horseback to approach giraffes feeding in the bush.

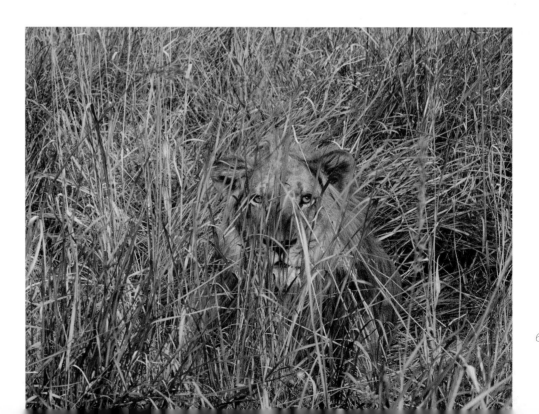

A vast herd of rain-drenched wildebeest crosses the open plains of southern Kenya's Mara River region. Annual rains return to the parched land in late August, prompting this yearly migration. Between one and two million mammals travel at the height of the migration.

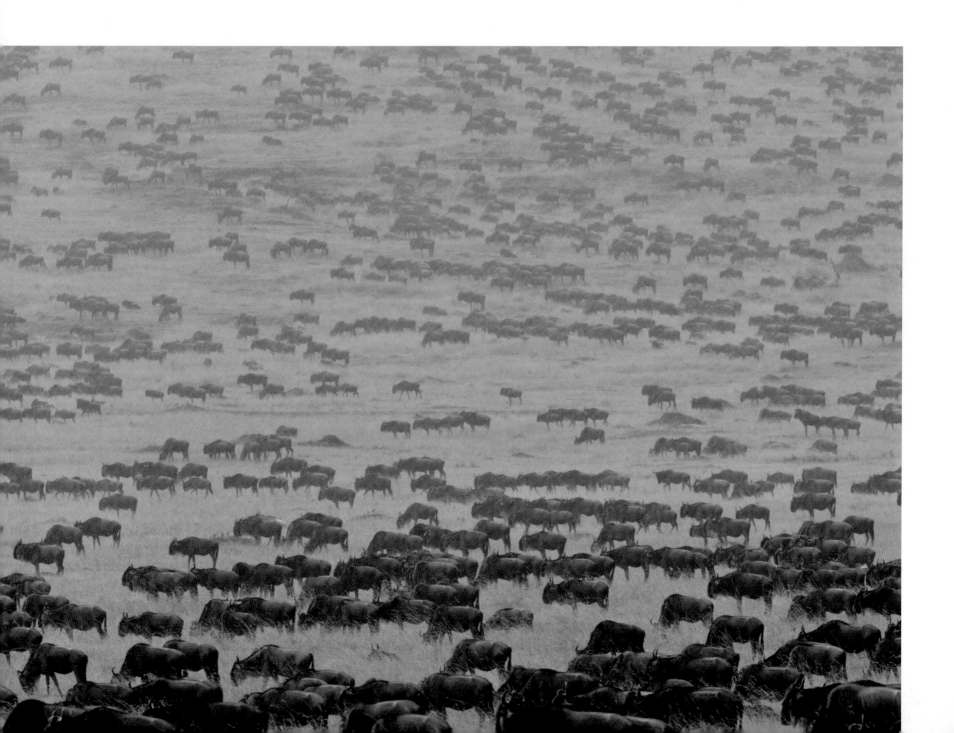

Six giraffes browse the thorn acacia in northern Kenya's scrublands. Late afternoon light combined with an aerial perspective add to the graphic appeal of this image.

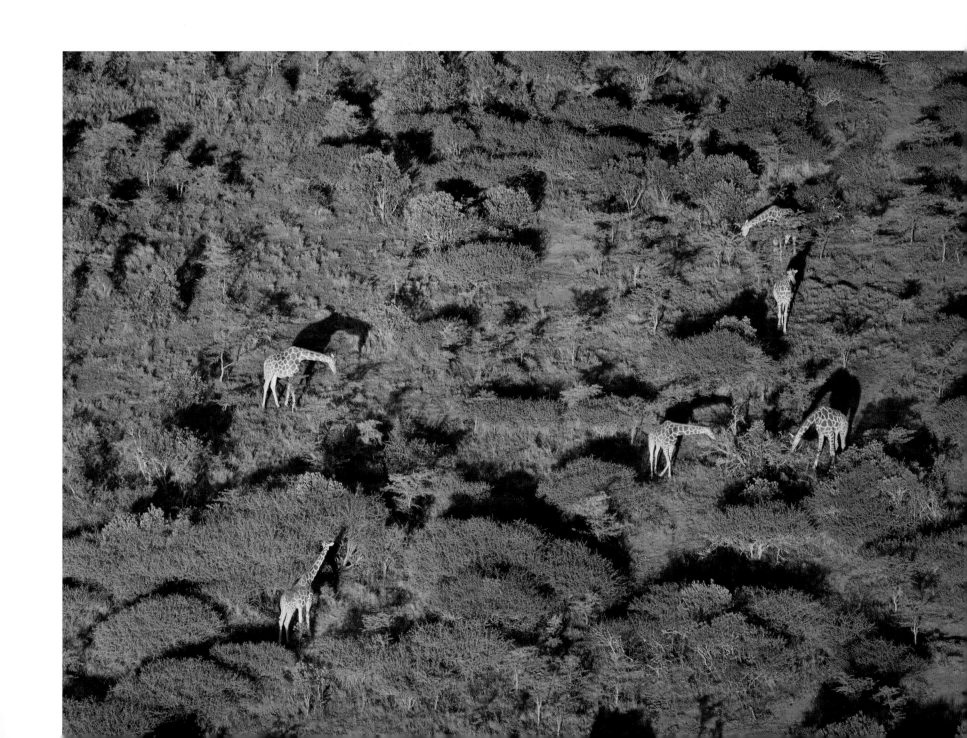

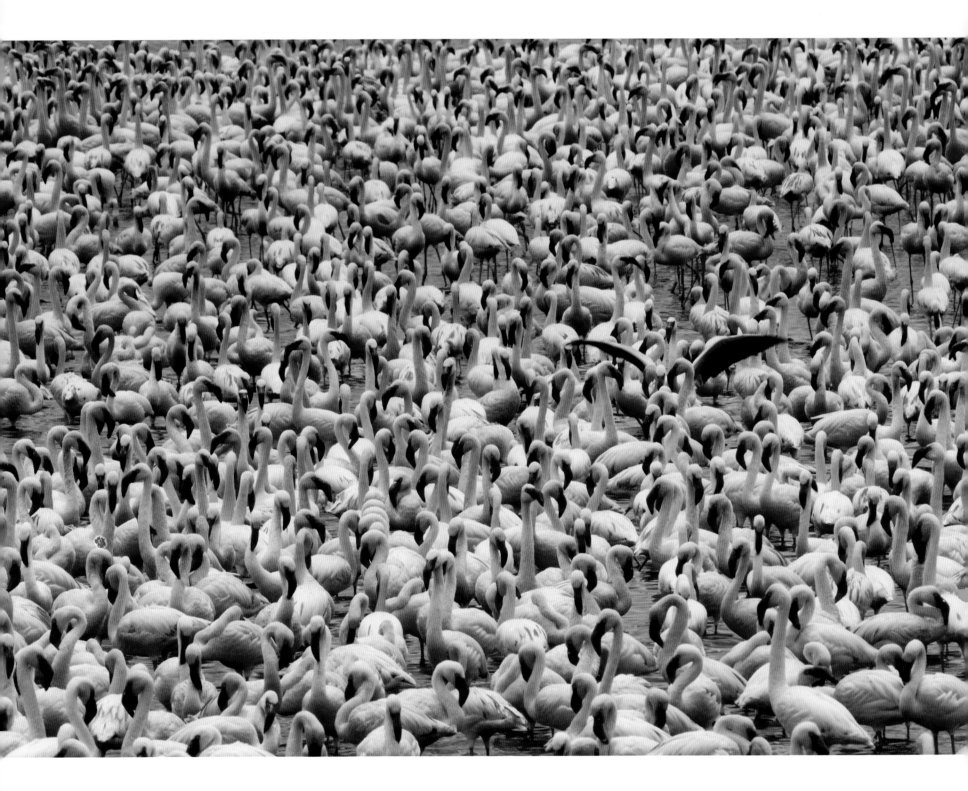

Numbering in the millions, lesser flamingos feast on krill in the alkaline mineral-rich lakes of Kenya's Great Rift Valley. The birds' color often parallels its food; consuming pinker krill produces pinker flamingo plumage. I climbed on top of a Land Rover to photograph this flurry of pastel birds. I'm drawn to images where one subject stands out from a larger group, like the flamingo that is stretching its graceful wings.

This aerial shot shows about two thousand feet of Lake Natron in the Great Rift Valley, which straddles Kenya and Tanzania. The red color comes from algae that live in the alkaline waters and provide food for shrimp, which in turn feed flamingos. The lake's alkalinity is so strong that no predators venture into it to threaten the millions of lesser flamingos that raise their young there. In the late summer's low water, however, the alkaline waters become as caustic as pure ammonia, which even the flamingos can't tolerate.

The Donga, a traditional stick fight between rival villages in the remote mountains of southwestern Ethiopia, takes place on an open plain. The stick fight establishes the strongest warriors in each village. The mountains have long served as a barrier to conquering tribes, as well as to the relentless creep of western civilization.

THE OMO RIVER VALLEY, ETHIOPIA

From the Ethiopian Plateau, the Omo River extends into Lake Turkana, the Jade Sea of southern Ethiopia. The river carved the Omo River Valley, a region so remote that it didn't appear on a map until the early 1900s. The isolation has preserved distinct cultures that are thousands of years old. The team visited the Hamer, Karo, and Surma tribes, shooting both candid and staged portraits to reveal each culture's tradition. From regal adornments to harvest celebrations to the exhilarating Donga stick fight, the expedition through the Omo Valley offered a view of unique peoples and cultures virtually untouched by the modern world.

When we travel to seldom-visited cultures, we find that the people are not jaded or looking to gain anything from the encounter except to satisfy their curiosity. I try to engage them in an authentic way so they may enjoy the experience as much as I do. Often, I hand someone a camera so they may take my picture and see the image on the LCD screen moments later, an experience that is always a crowd pleaser.

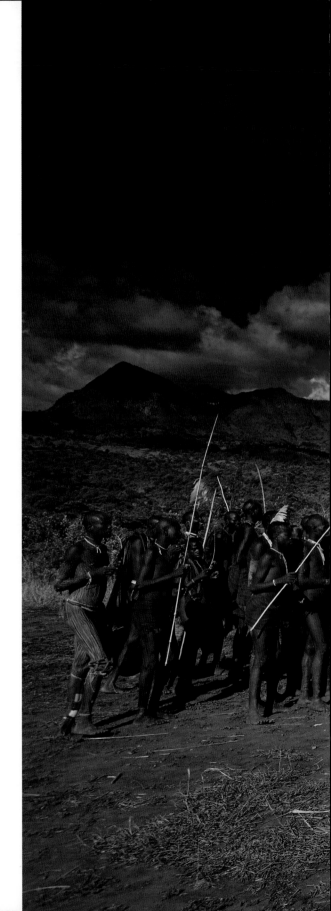

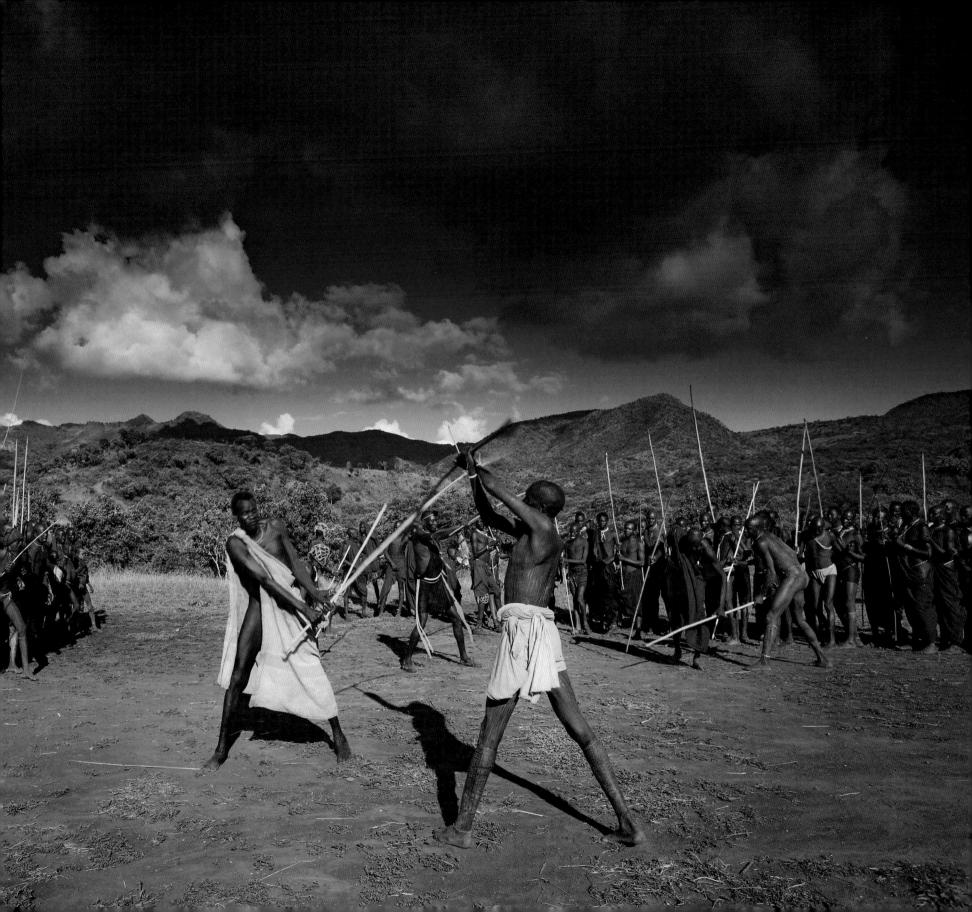

Six Surma warriors embrace prior to the Donga stick fight.
Preparation includes bathing in the mountain river and then
adorning each other's skin with clay from the river's bank.

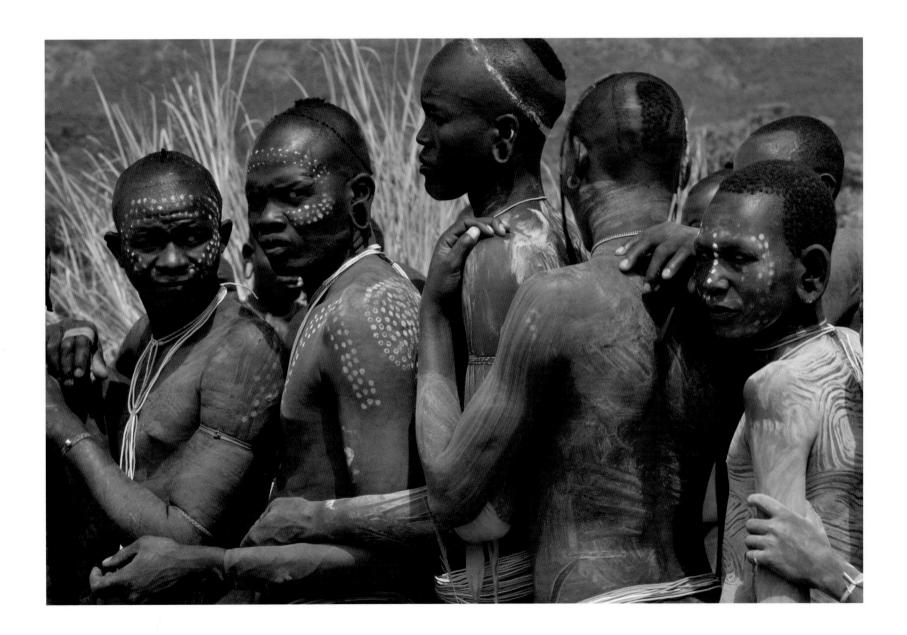

The Karo are one of numerous ethnic tribes inhabiting the barren lands of southwestern Ethiopia. These Karo youngsters humored me by sitting in a circle so I could photograph the pattern of their bare feet.

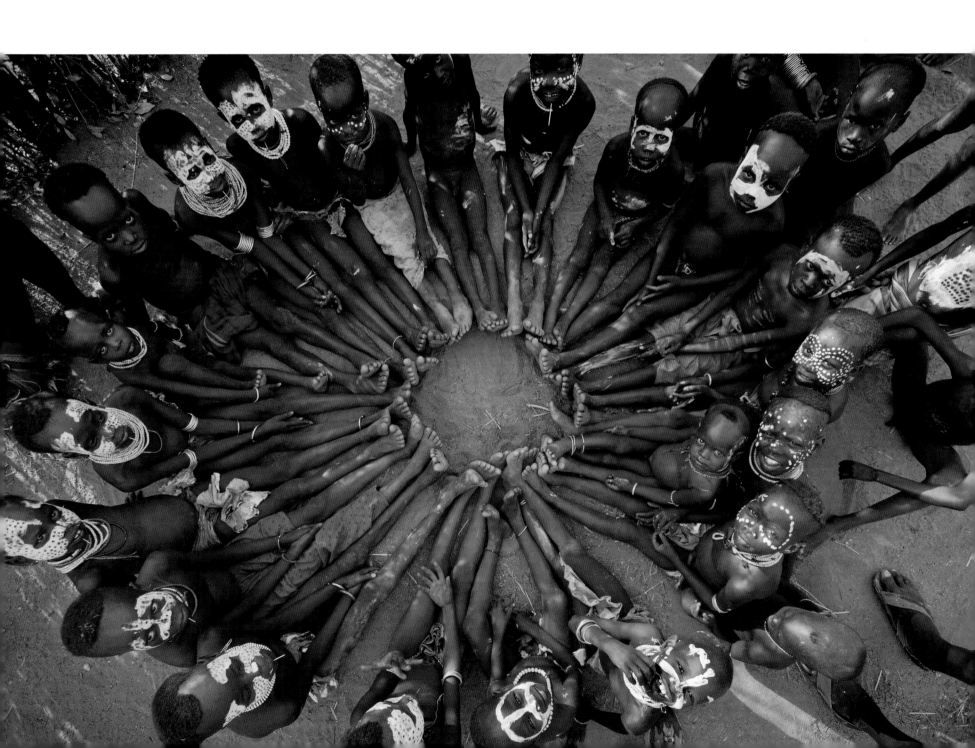

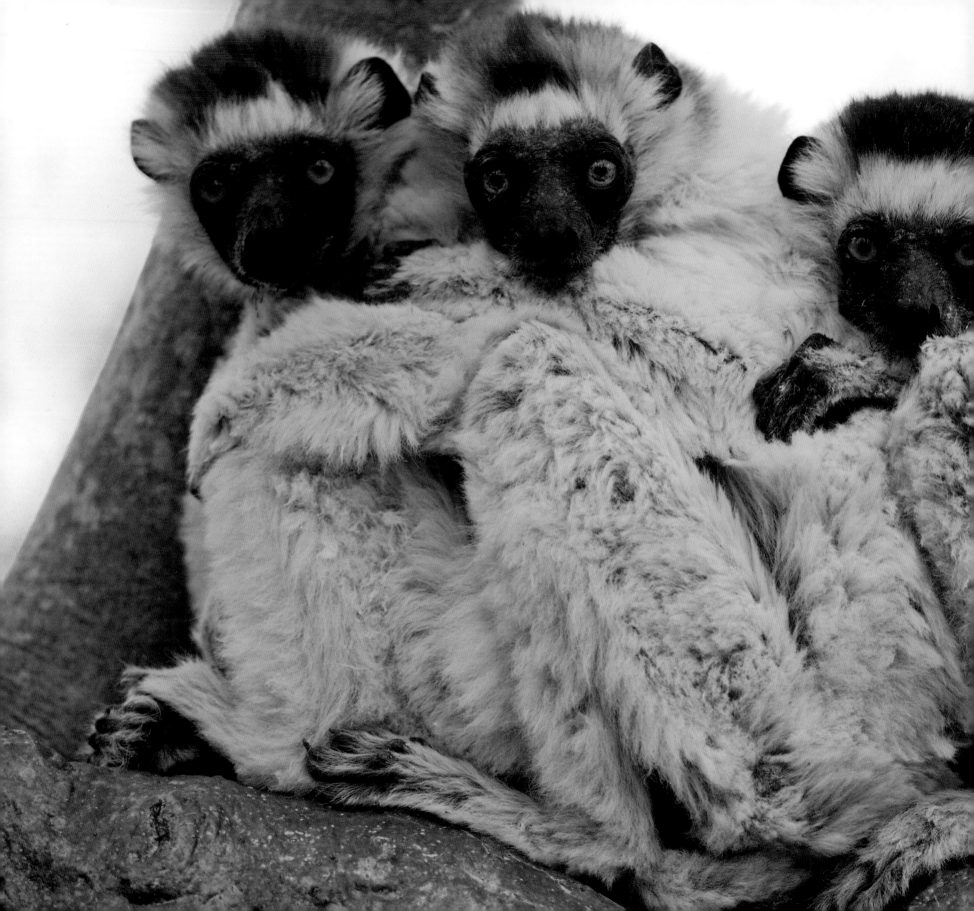

Few of Madagascar's inhabitants are as cute as sifaka lemurs, including these three huddled together for warmth. The island's nighttime temperatures drop precipitously in the desert regions. Sifakas are great leapers, bouncing from tree to tree like pinballs. Their legs are ill-suited to walking so they skip sideways when moving on the ground.

MADAGASCAR

Tens of millions of years ago, Madagascar, the earth's fourth-largest oceanic island, separated from Africa and India, resulting in a hotspot of biodiversity. Madagascar lies in the Indian Ocean off the coast of Mozambique and hosts all of the world's lemurs and many other remarkable animals, strange vegetation, and varied landscapes. Its incredible evolutionary journey is at a crossroads as a burgeoning human population pressures the remaining pockets of untouched wild lands.

Tropical cattle, known as *zebus,* pull a cart past iconic baobab trees in rural Madagascar, where they are the most common form of transportation. Madagascar's climate also suits the baobab tree, which stores water in order to survive the long, dry season that dominates the year.

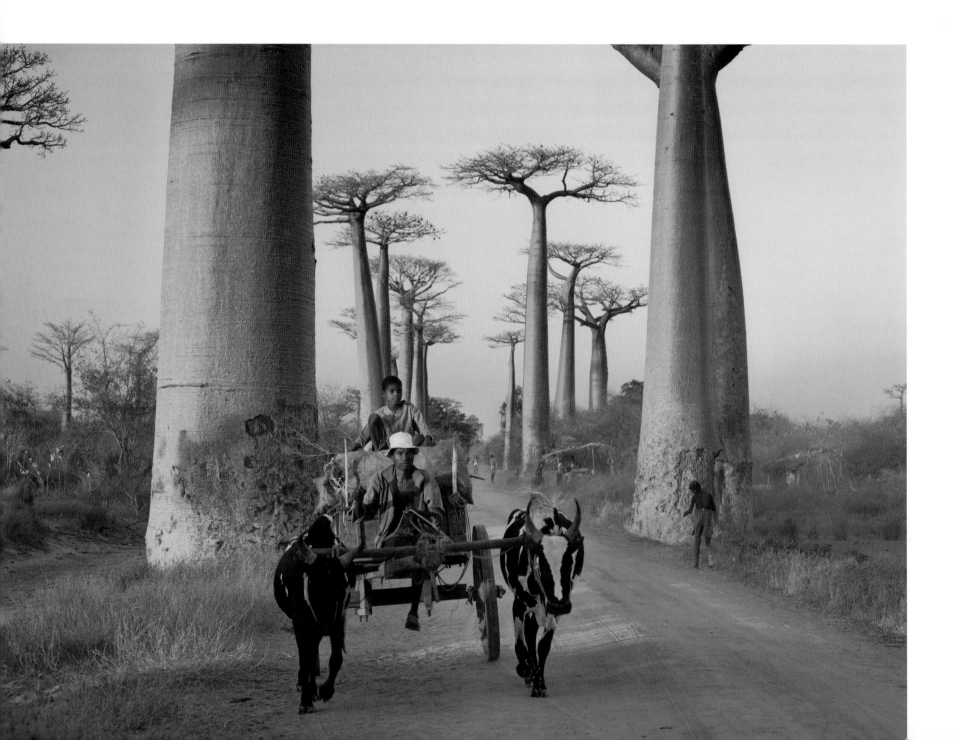

Clear nighttime skies in Madagascar allow the glow of the Milky Way to shine behind baobab trees. The sky's clarity is largely a result of fresh ocean breezes that sweep across the island. No large cities exist within a thousand miles of this site. This thirty-second exposure captures the galaxy—it is a long enough exposure to record the light but short enough to limit blurring.

Following page Tsingy are needle-like limestone formations, or karst, in western Madagascar. The fantastic shapes of this karst are created by slightly acidic water eroding the stone.

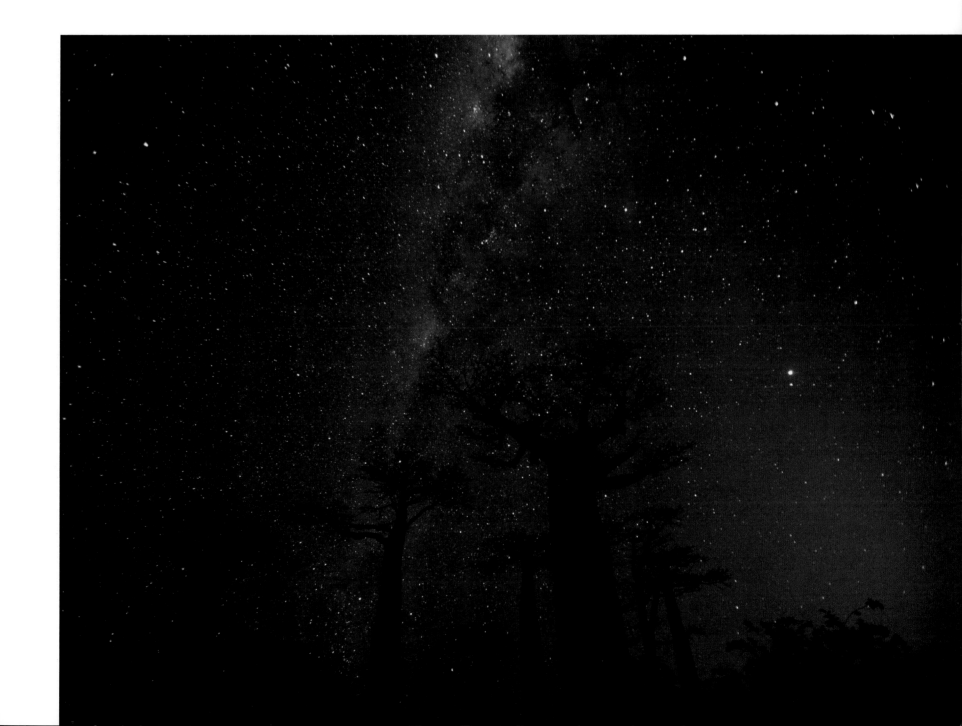

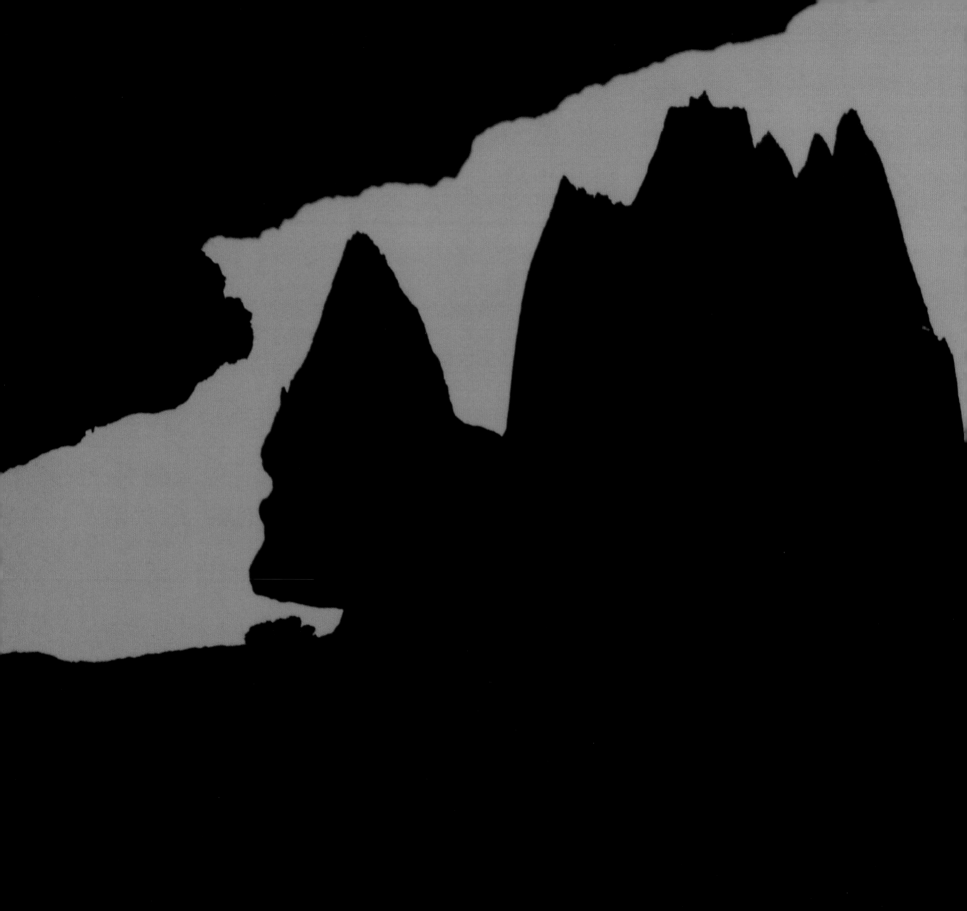

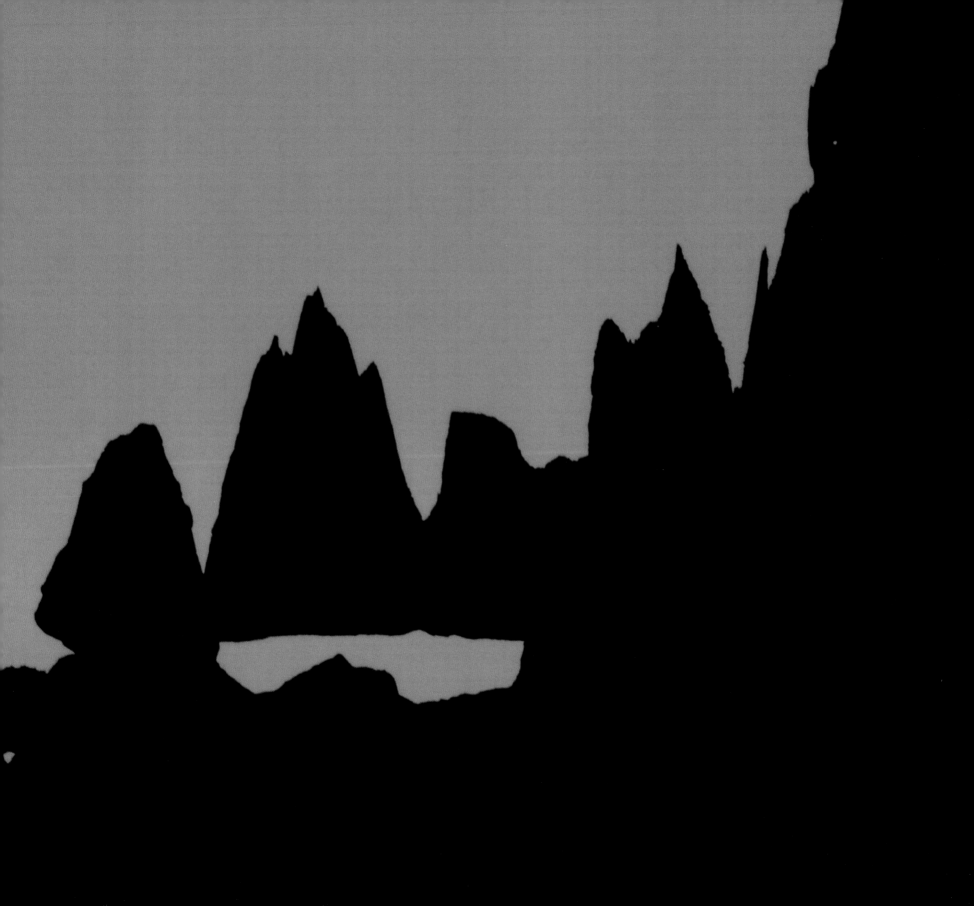

Among sweeping bands of brightly colored minerals, thermal geyser basins dot the Landmannalaugar Mountains. Just before sunset, low-angle soft light enriches the beautiful bands of Iceland's interior mountainscape. The exposed rock reveals layers of volcanic deposits and the deep furrows indicate how quickly the soft rock erodes.

ICELAND

Iceland is a land of geysers (the word itself is Icelandic), glaciers, volcanoes, and rough-hewn coastlines. Nowhere else on Earth do the four elements collide in such powerful fashion as in Iceland. We worked to capture dramatic expressions of the planet's geomorphology using composition, pattern, and light to create striking portraits of a volatile and dynamic landscape.

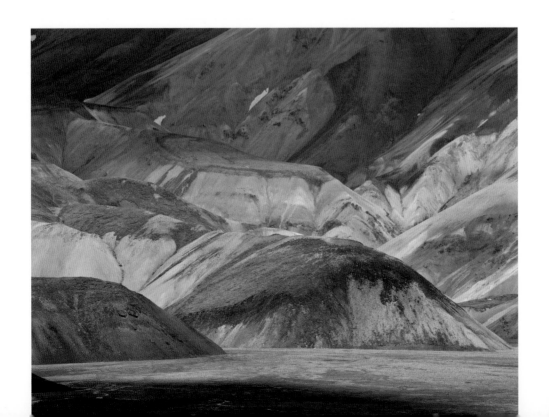

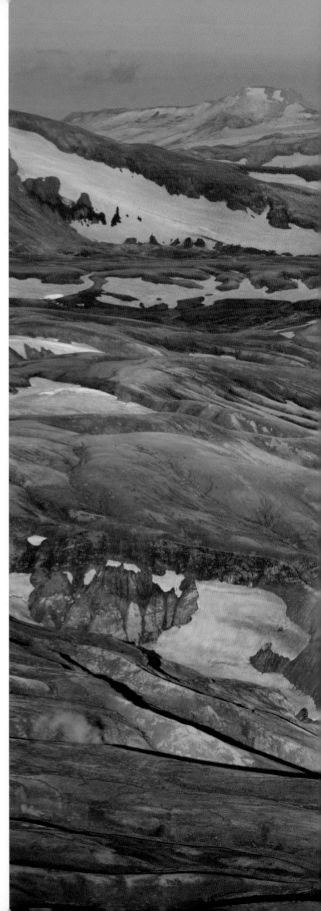

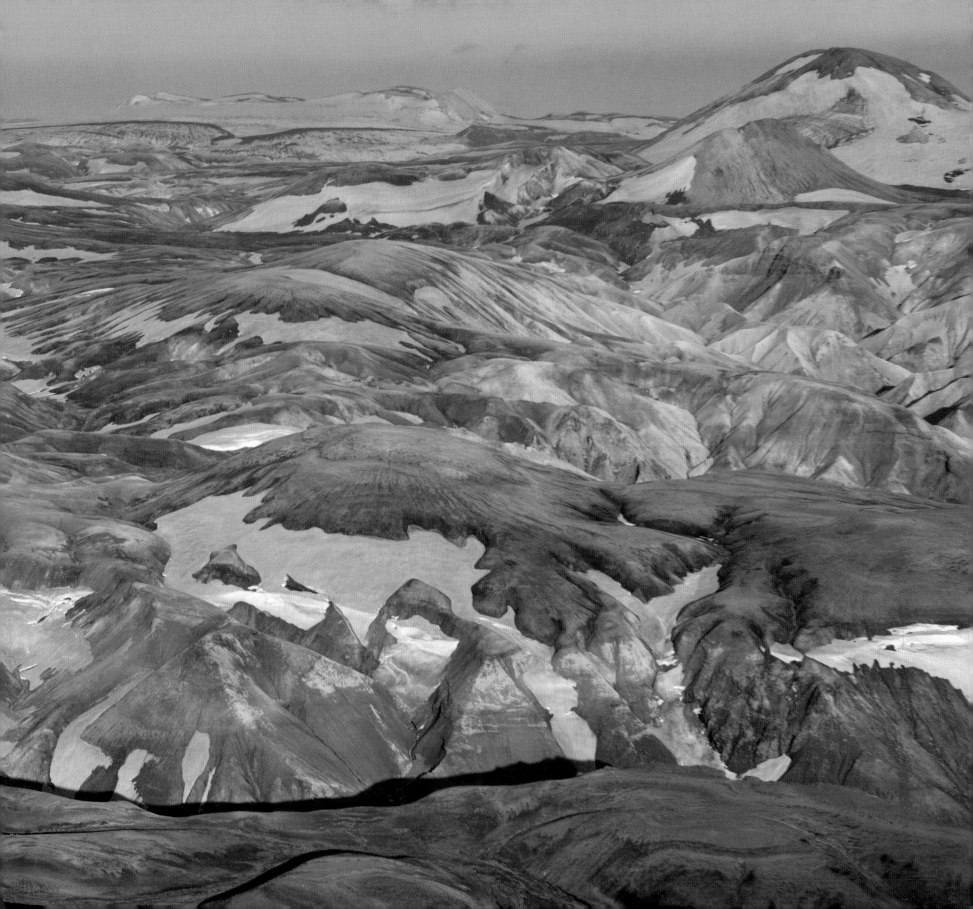

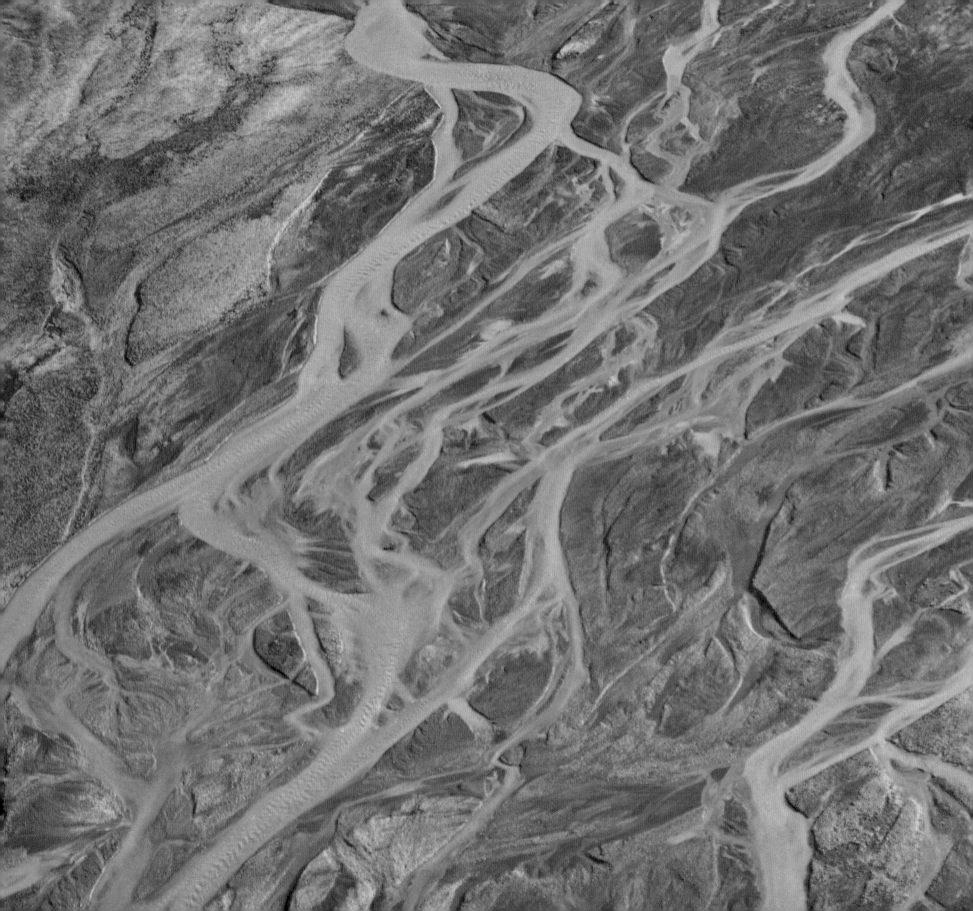

Iceland formed only ten million years ago when oceanic volcanoes erupted along the earth's tectonic plates, resulting in this rapidly changing landscape. These aerial views display the exquisite beauty of erosion patterns on flood plains left by *jökulhlaups*—glacier bursts —that occur when geothermal heat melts subglacial ice, and water bursts through in a catastrophic flood.

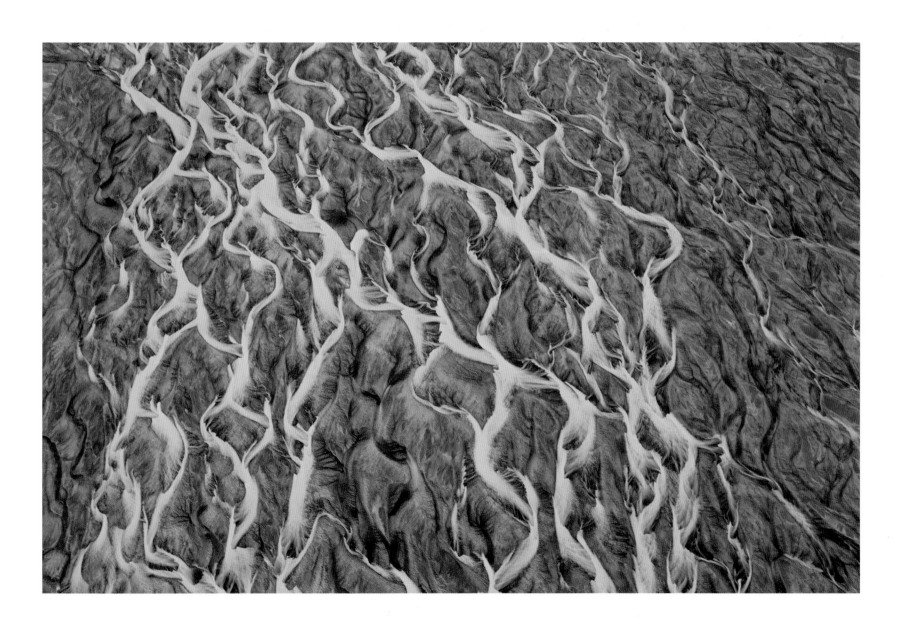

Powerful ocean currents sweep Iceland's southern coast, tossing these enormous icebergs like dice. The ice, which formed in Europe's largest ice cap over a thousand years ago, calves into striking bergs at the shore of Jökulsárlón ice lagoon. After floating through an outlet to the sea, the icebergs slowly melt in the pounding surf, returning their moisture to the water cycle. In this photograph, the low, flat light of the overcast sky reveals gradations of blues contrasted with the ocean's grayer tones.

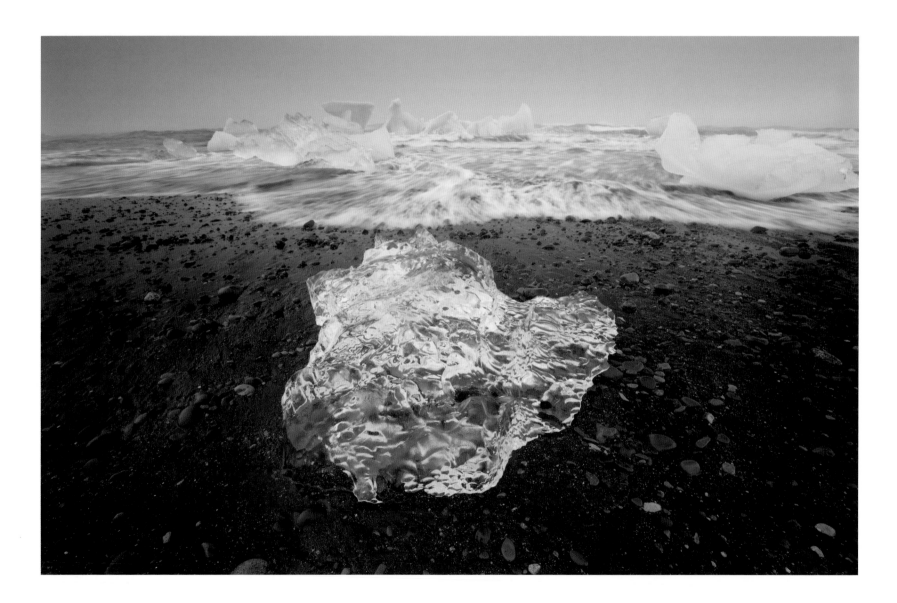

Two enormous glaciers calve in Jökulsárlón on the southeastern side of Iceland. The freshwater lake lies less than a quarter mile from the turbulent waters of the North Atlantic Ocean and is heavily influenced by the rise and fall of the tide. At slack tide, the lake's surface remains placid, occasionally permitting perfect reflections, an ideal situation for photographing fragments of pattern and line.

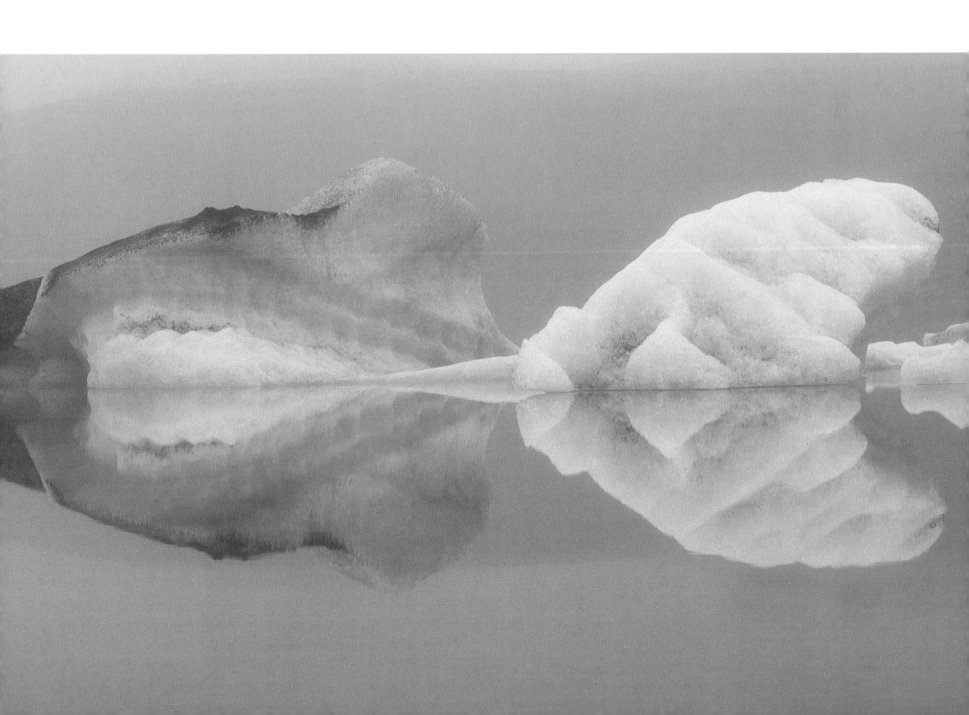

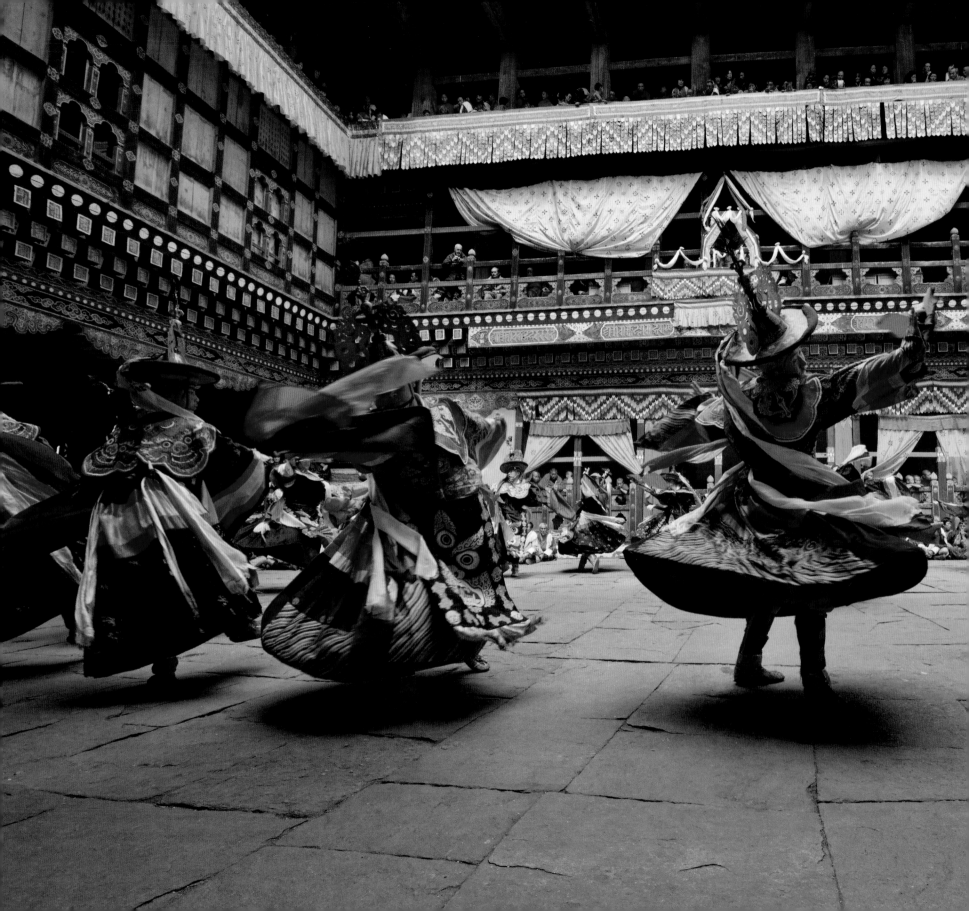

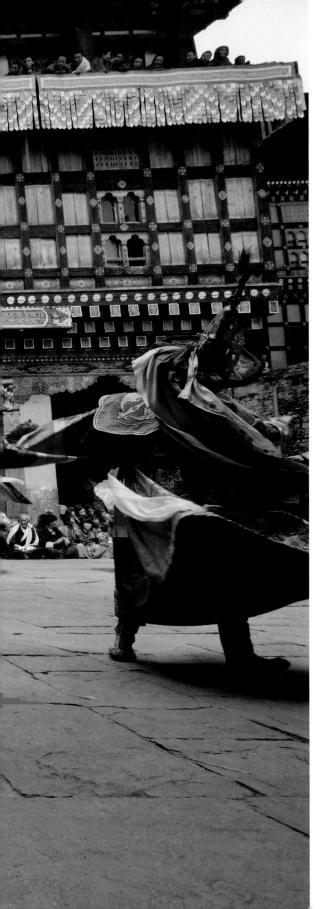

Skilled Buddhist monks perform ancient dances that communicate their history and traditions. The series of elaborate dances takes place in an historic *dzong*, or Buddhist fortress, to celebrate the New Year in the Himalayan country of Bhutan.

A brilliant giant red rhododendron stands out against the soft tones of moss and lichen. Unlike neighboring Nepal, Bhutan has placed a high value on protecting its forests.

THE KINGDOM OF BHUTAN

Known as the Land of the Thunder Dragon, Bhutan has survived in isolation for more than a thousand years. As this enlightened Buddhist kingdom greets the twenty-first century, its greatest challenge is to preserve its soul in the face of development and tourism. We visited mountainside monasteries, experienced sacred festivals, and observed chanting monks in an environmentally and spiritually progressive nation where the king measures Gross National Happiness instead of Product.

Buddhist monks blow ceremonial horns to announce the beginning of the Paro Festival in Bhutan. The festival takes place in early spring and the deep tones that resonate from these magnificent horns reverberate through the mountain valleys, calling the monks to the festival.

In a beautiful Buddhist tradition, white prayer flags are strategically placed on an exposed mountain ridge to maximize visibility and wind. The prayers inscribed on the flags are scattered to the heavens as frequent gusts fray the delicate fabric.

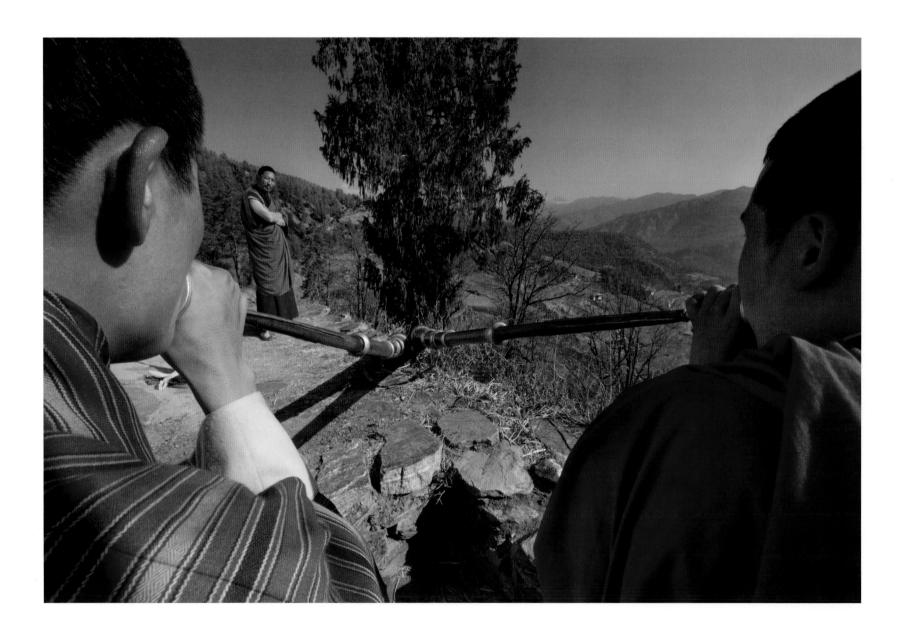

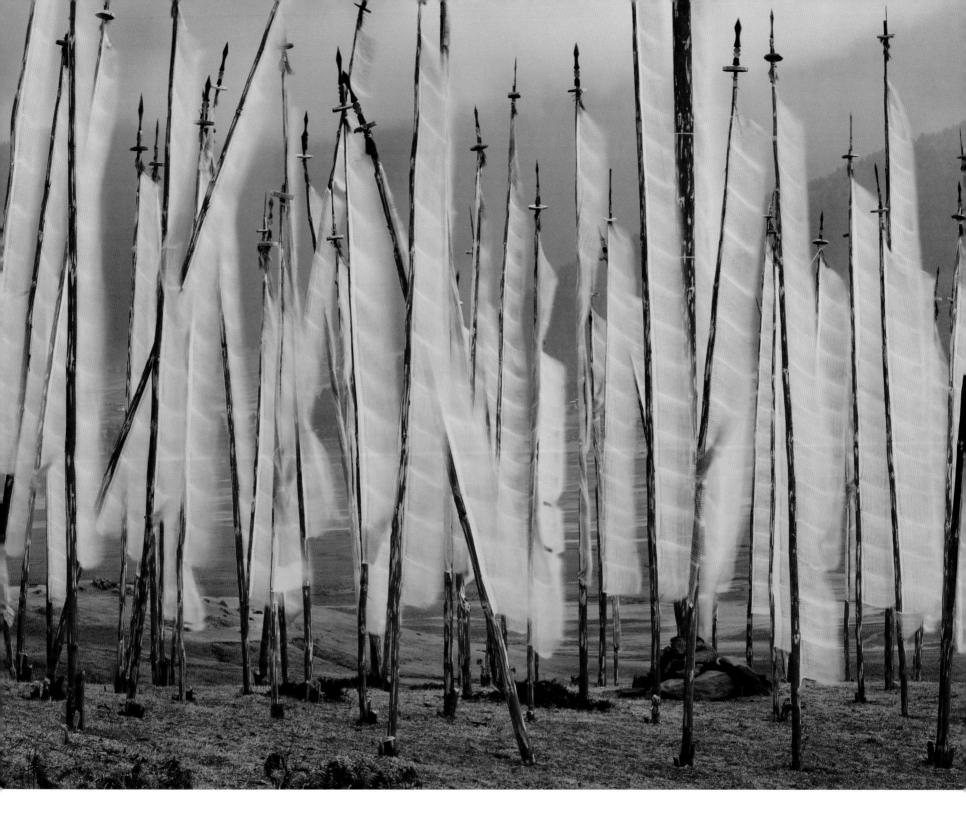

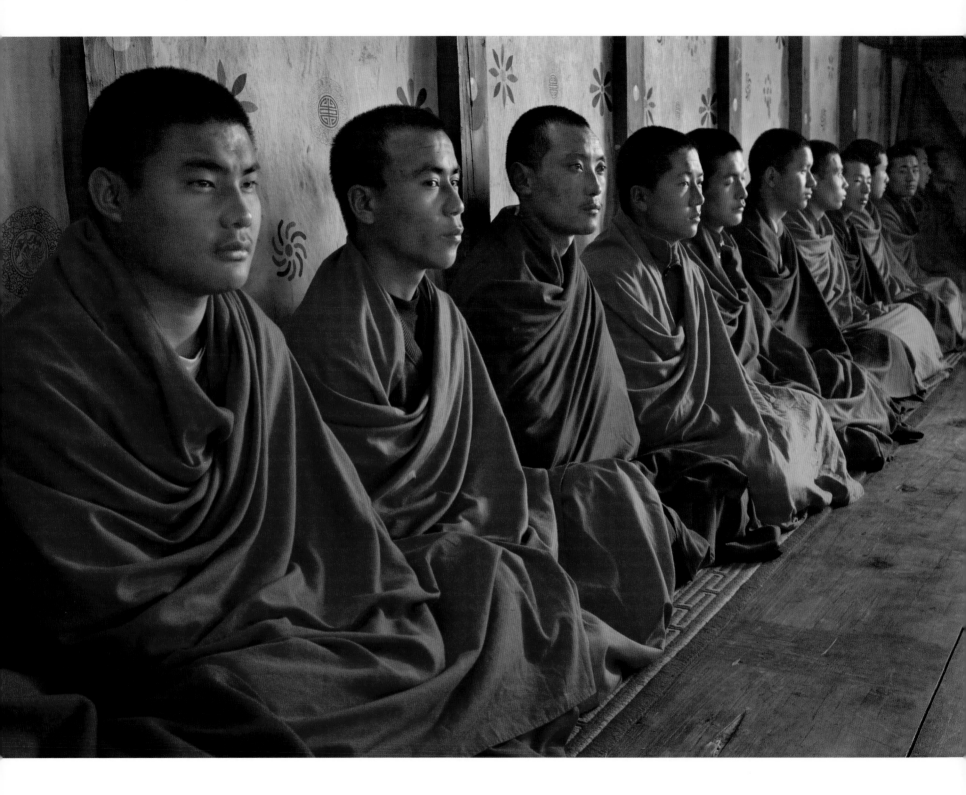

Young Buddhist monks practice chanting traditional prayers in a monastery situated high in a remote Bhutanese mountain valley. One of my most memorable experiences was witnessing the amazing focus and dedication of the two hundred or so young monks as I quietly moved among them. Drums and long deep-toned horns accompanied the chanting, adding to the sense of mystery.

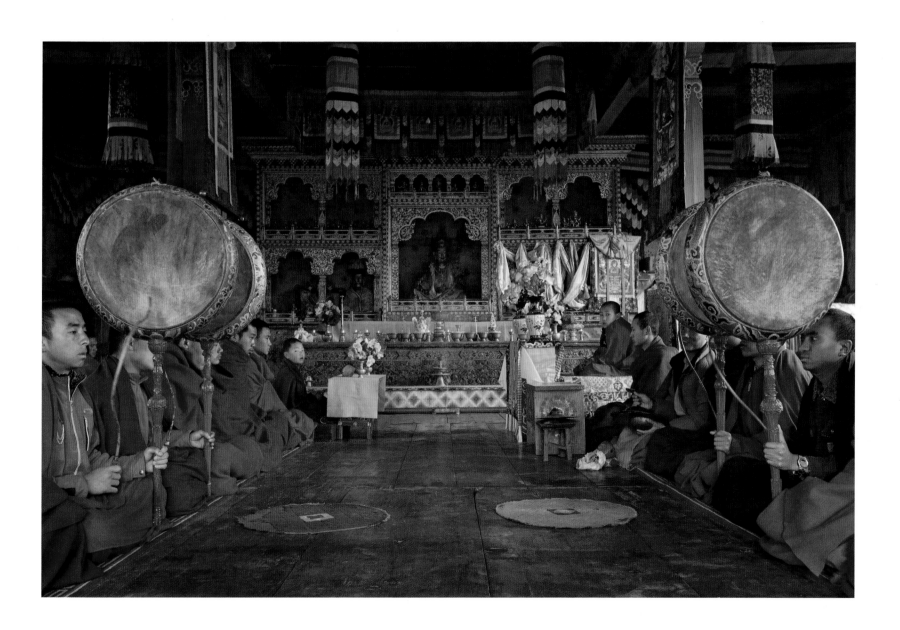

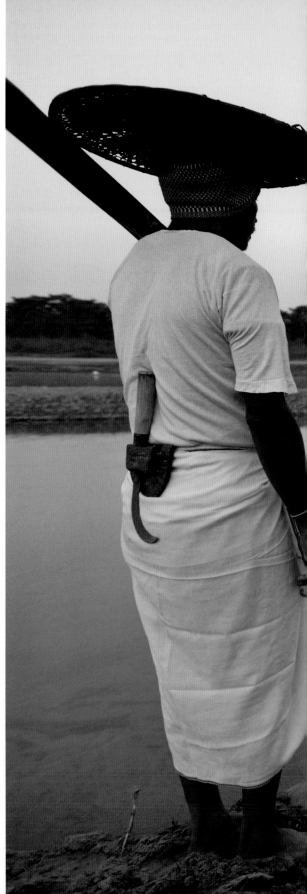

A mahout, who raises and works with elephants, leaps from one elephant to another near Chitwan National Park in Nepal.

Three Tharu tribesmen prepare to board their dugout canoes in the Narayani River, which borders Chitwan National Park in southern Nepal. The Tharu gather wood and grasses from the park's surrounding forest for building materials.

NEPAL AND INDIA

Beyond India and Nepal's crowded cities lie precious remnants of wild Asia where tigers, rhinos, and bears still roam. The crew traveled by elephant deep into Kipling country searching for some of the planet's last Bengal tigers. We sought images of mahouts—handlers bound to the elephants they've cared for from childhood—as they bathe and tend to their animals. In Nepal, we glimpsed exotic wildlife including rare Asian one-horned rhinos, elusive sloth bears, and primeval gharials.

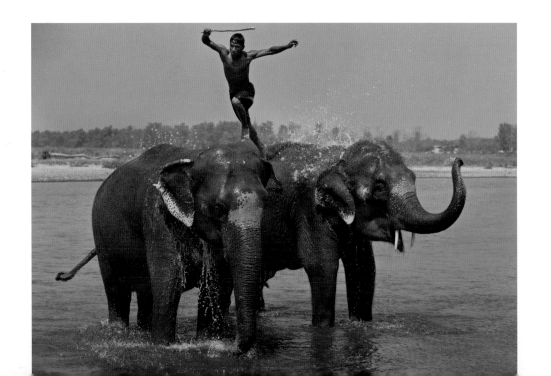

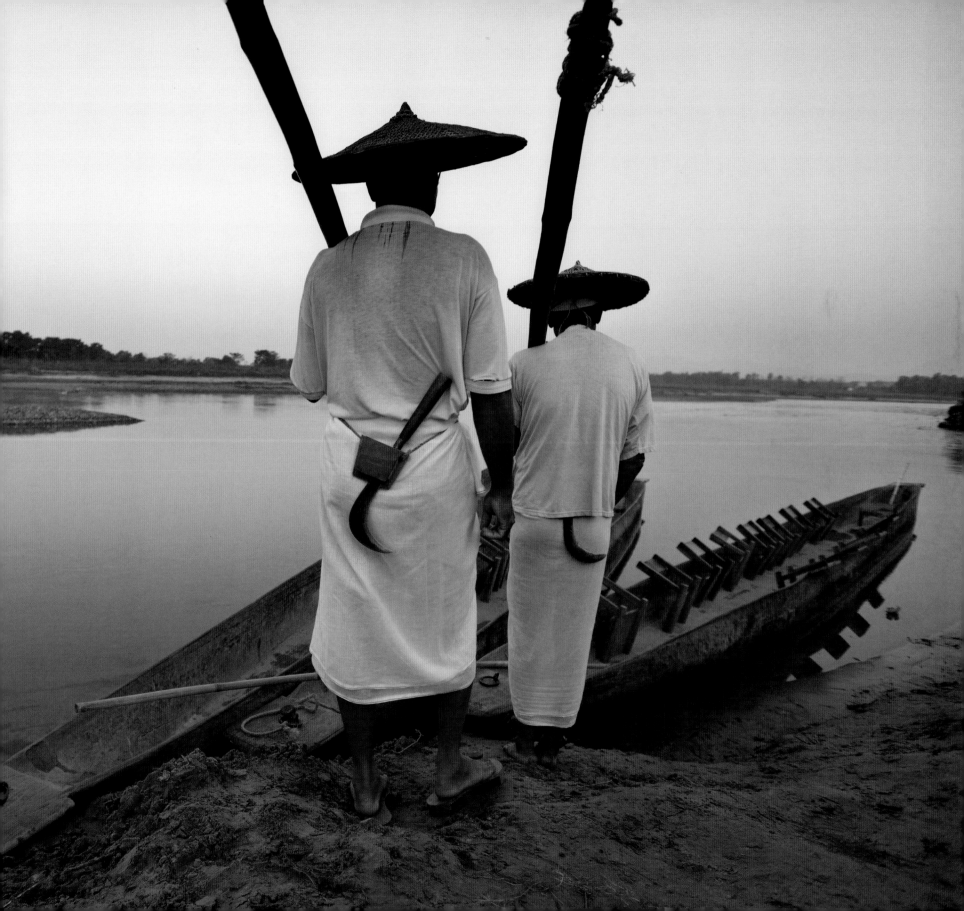

The Indian, or one-horned, rhinoceros lives in pockets of grasslands at the base of the Himalaya in India and Nepal, a small fraction of its original range. A rhinoceros mother is fiercely protective, willing to charge anything she deems threatening. The Indian rhinoceros is one of the largest subspecies, with males growing to 6,000 pounds.

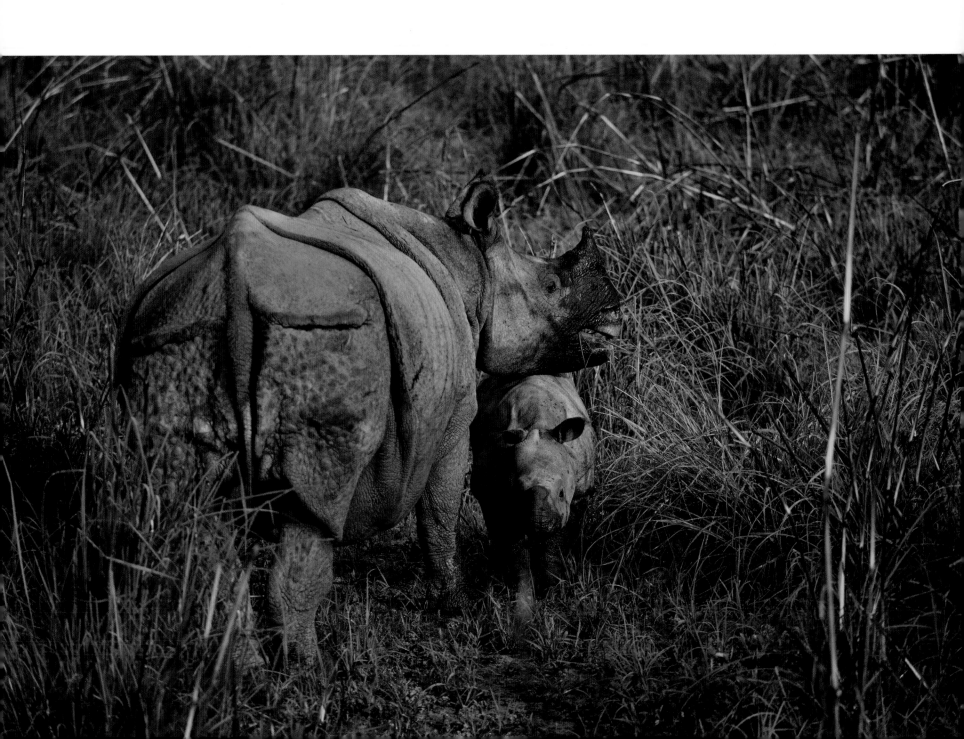

A Bengal tiger crosses a clearing in the dense forests of Bhandhavgarh National Park in central India. China's burgeoning economy has escalated the illegal trade of tiger parts, so tigers have become increasingly endangered throughout Asia. India's efforts to combat poaching and manage wildlife habitat represent the last remaining hope for these beautiful animals.

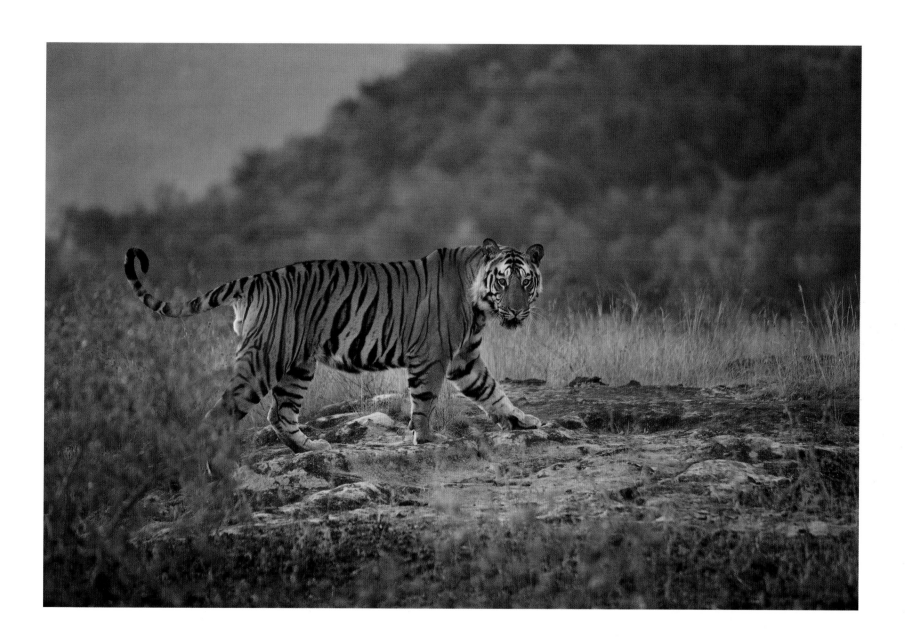

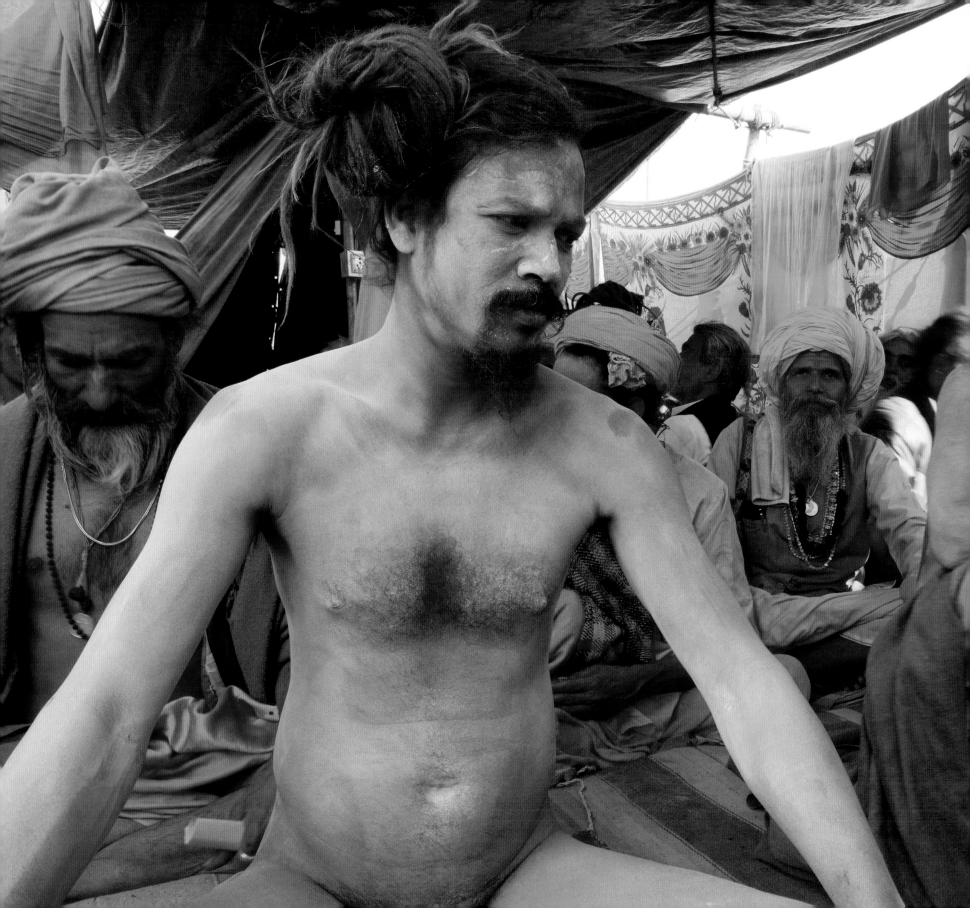

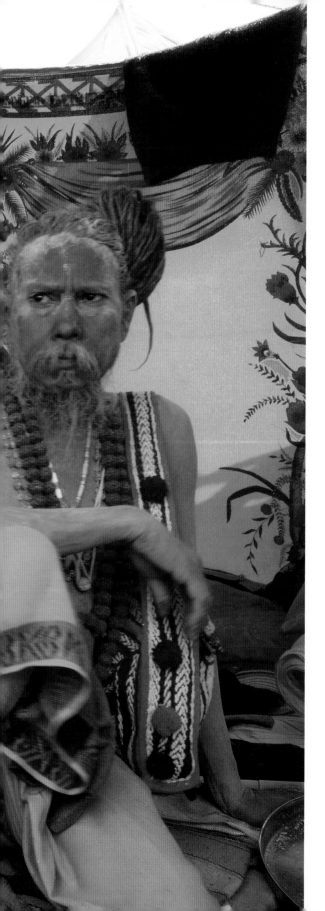

Naga sadhus, the holy men of India, assemble in the ancient city of Allahabad along the Ganges River in north-central India every six years to celebrate the Ardh Kumbh Mela. During this time, all naga sadhus travel down the Ganges tributaries, growing in number, until approximately three thousand mass at the Kumbh Mela. Shunning clothing to embrace suffering and discomfort in the frigid temperatures of the mountains of northern India, the sadhus believe they will reach Nirvana, the Hindu version of heaven, by renouncing the trappings of daily life and sacrificing creature comforts.

ALLAHABAD AND VARANASI, INDIA

We chose two locations on the Ganges River, the spiritual center for Hindus, for our shoot in northern India. We witnessed an amazing press of humanity as a planetary alignment signaled the Ardh Kumbh Mela, which occurs every six years. Tens of millions of Indians come to pray at the sacred river, the largest assemblage of humanity in the history of the world. In the margins of the days, I adapted traditional painting theory to photography, capturing reflective images of busy streets, sadhu holy men, and life on the banks of the Ganges. The elegance and simple pageantry of this timeless place creates a blended tapestry, vibrant with life, color, and spirituality.

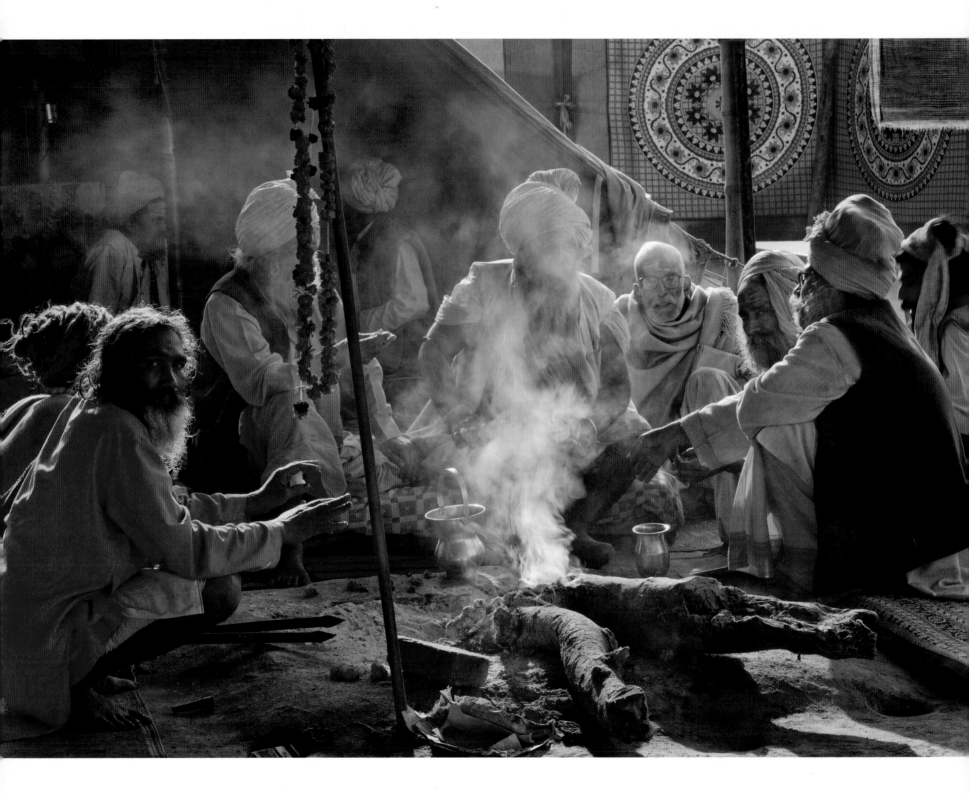

A sect of sadhus socializes around a morning fire at the Kumbh Mela celebration.

A sadhu holds a trident adorned with marigold blossoms. Sadhus highly revere the marigold's color: orange is the color of fire, and flame is the great purifier that dispels darkness and radiates light.

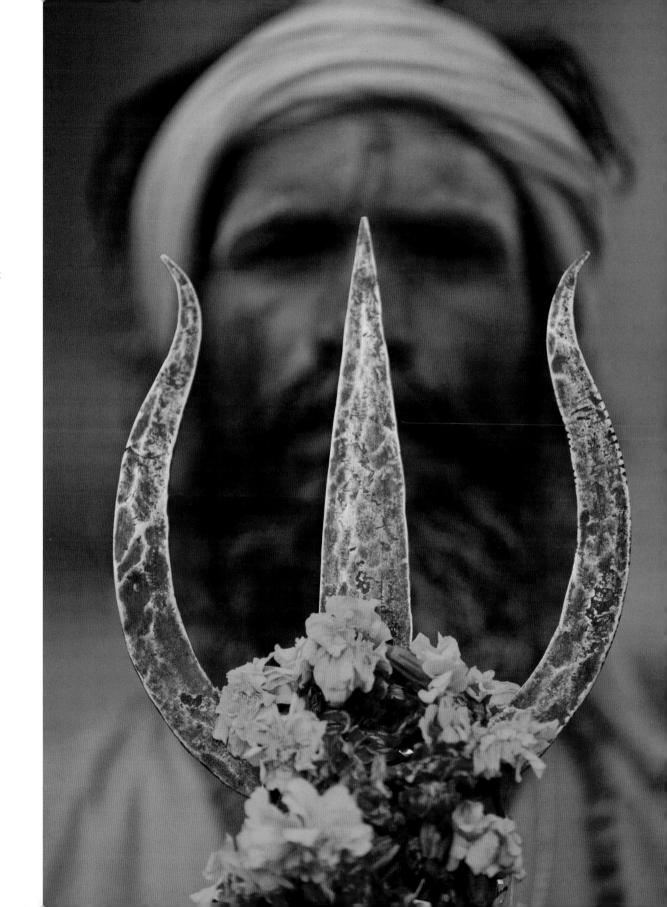

Dawn comes to the ghats of Varanasi on the banks of the sacred Ganges. The Hindu population burns their dead on the ghats—large stone platforms—and the ashes mingle with the rivers and are carried away on the breeze. Here, wreaths of marigolds encircle *diya,* lamps fueled by ghee (clarified butter) or vegetable oil, which serve to celebrate the new day.

Few urban settings intrigue me more than the city of Varanasi, India, on the banks of the sacred Ganges River. This ancient city, known as Benares during the British Raj, teems with thousands of people who are drawn to the river for daily activities such as bathing, commerce, and transportation.

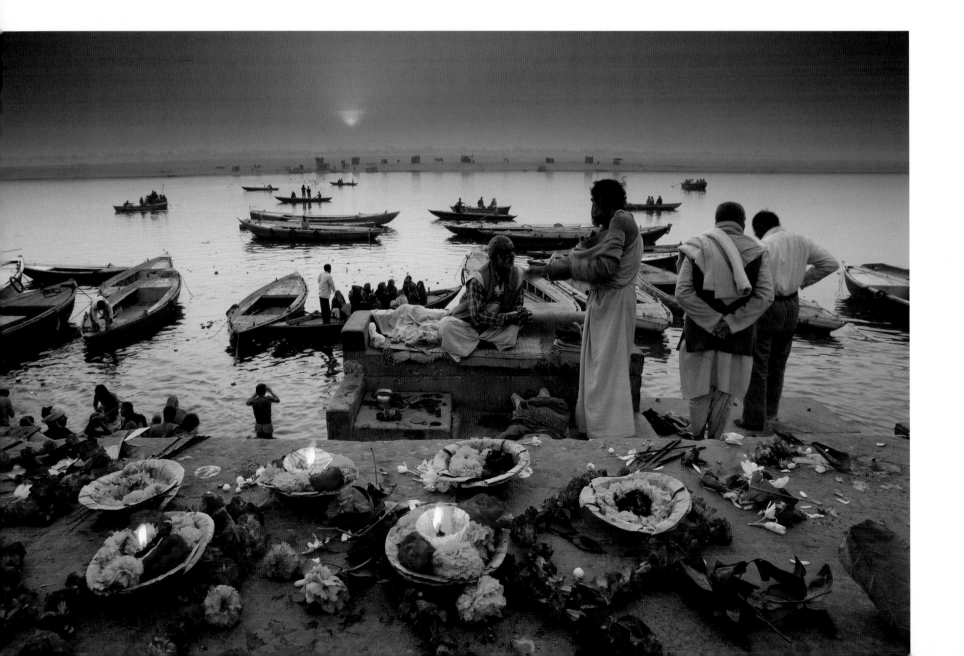

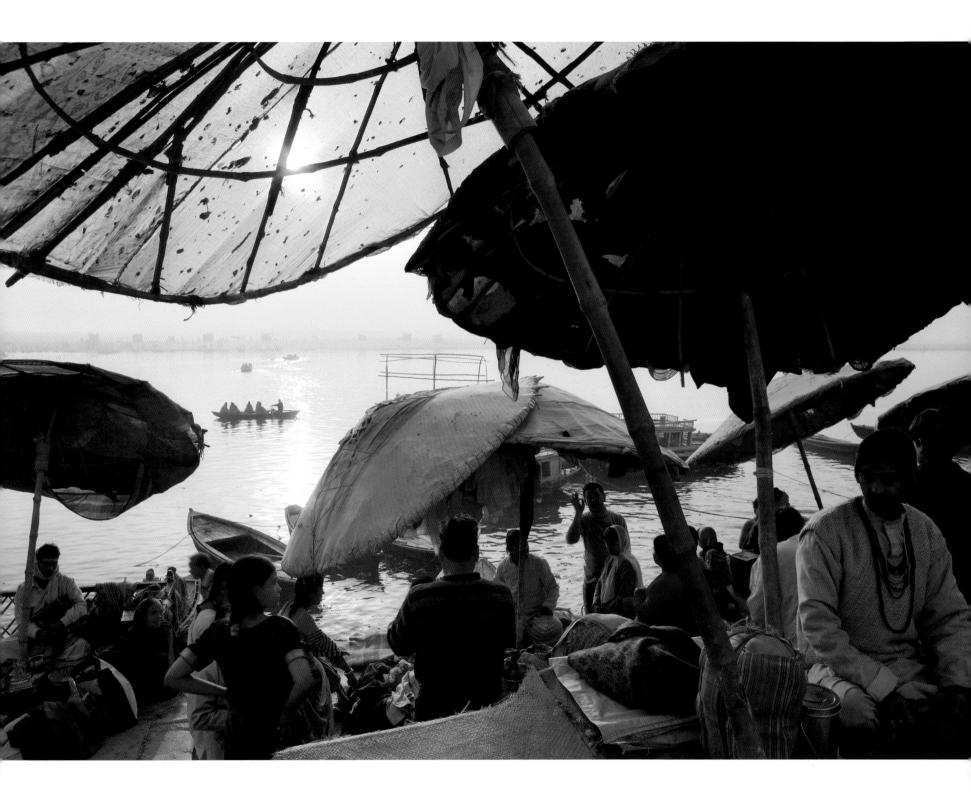

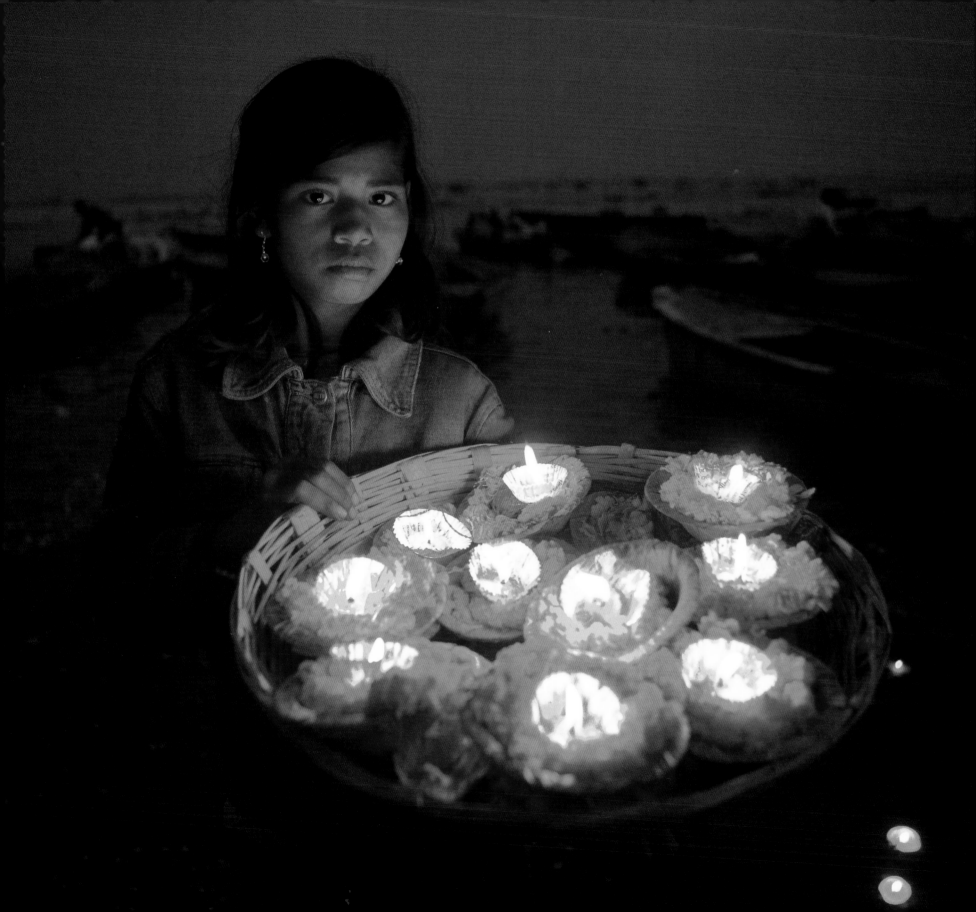

A sacred offering of *diyas* set within marigold blossoms illuminates this young girl's face at dusk. While strolling along the Varanasi riverfront, I encountered her transporting the candles to the Ganges River. This offering to Ganga, the river god, is a long-held tradition in this ancient culture. The illumination of the girl's face provided a warm contrast to the cool, blue twilight. Once afloat, the cluster of candles disappeared into the gathering darkness.

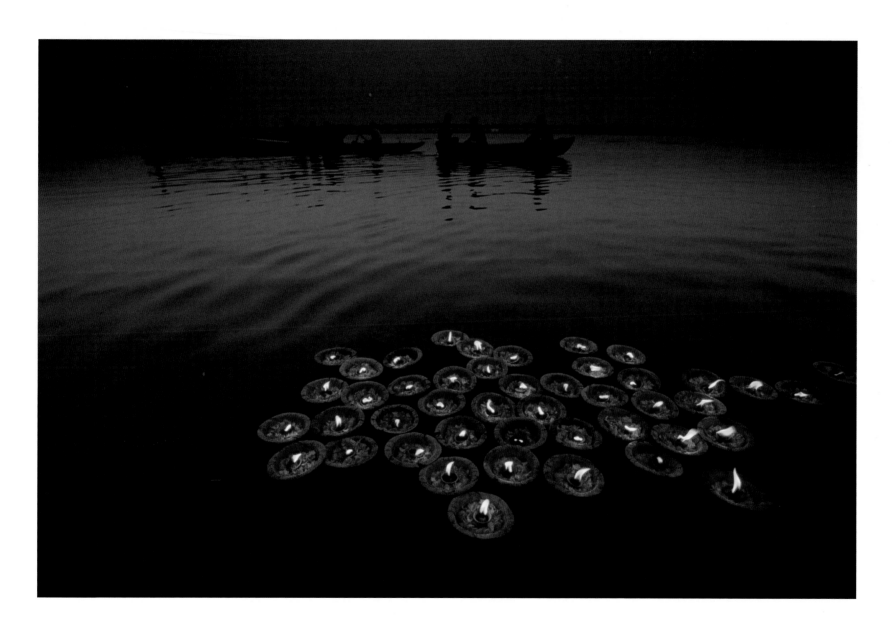

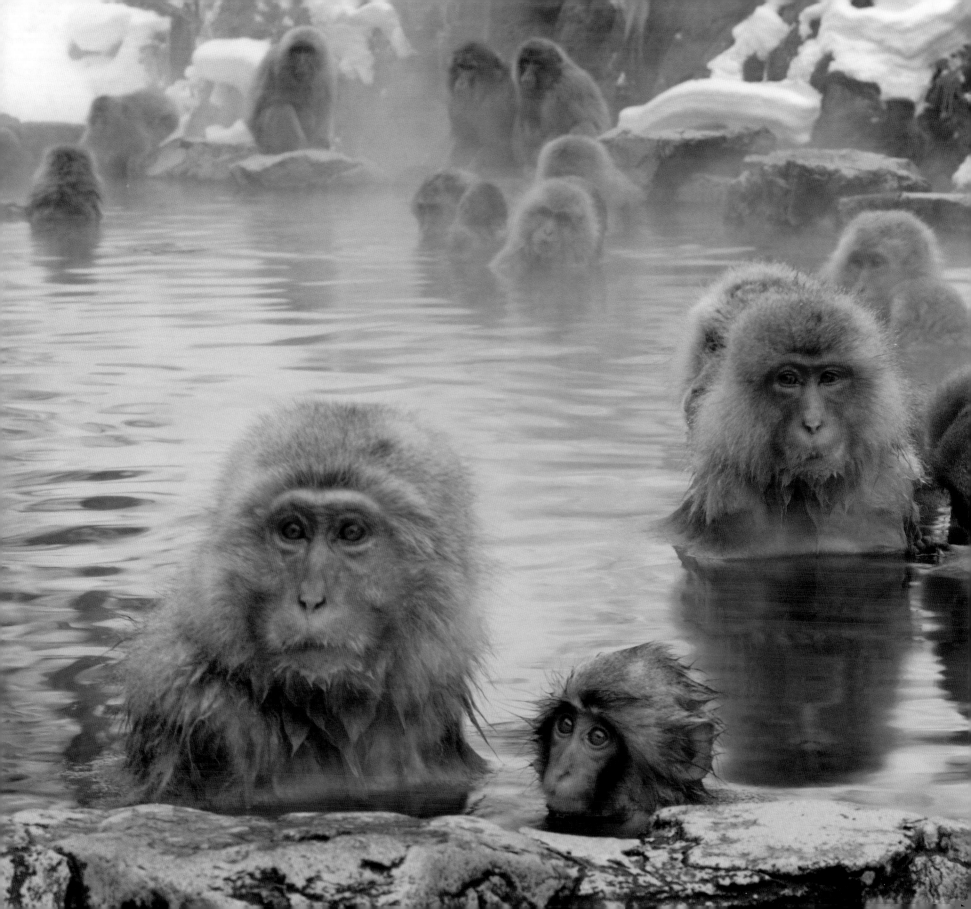

In the Japanese Alps of Honshu, these Japanese macaques, better known as snow monkeys, display almost human social interaction. When the animals began frequenting a local hot spring, human residents decided to build a monkey-specific spring where the macaques can enjoy a daily afternoon bath and grooming.

The red-crowned crane is one of Japan's most charismatic and emblematic animals. At approximately four feet tall, the cranes dance, jump, and chase one another in a poetic courtship display that is of great importance because they mate for life; their exuberant calls ring throughout the mountain valleys.

HOKKAIDO AND HONSHU, JAPAN

The image many of us have of Japan is congested and kinetic. But Japan has a natural side; beyond its crowded cities, the country offers quiet, unexpected, natural beauty. We ventured north to the remote region of Hokkaido to view iconic red-crowned cranes; we traveled south to the Japanese Alps to film the mischievous macaque snow monkeys that lounge in hot springs; and journeyed on to the sacred temples of Mounts Fuji and Kōya on a photographic pilgrimage.

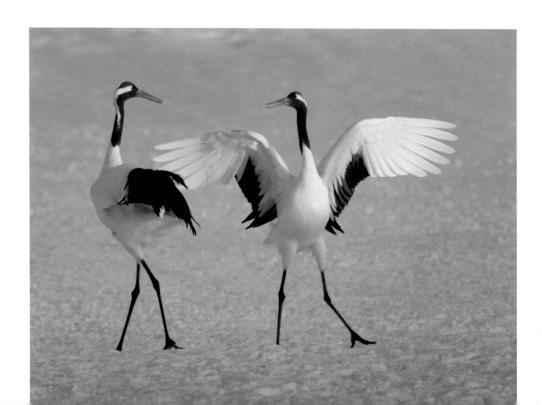

In perfect formation, three adult whooper swans glide to Lake Hokkaido's edge. Light reflecting from the ice illuminates their beautiful plumage, the glowing birds contrasting with the deep blue hillside.

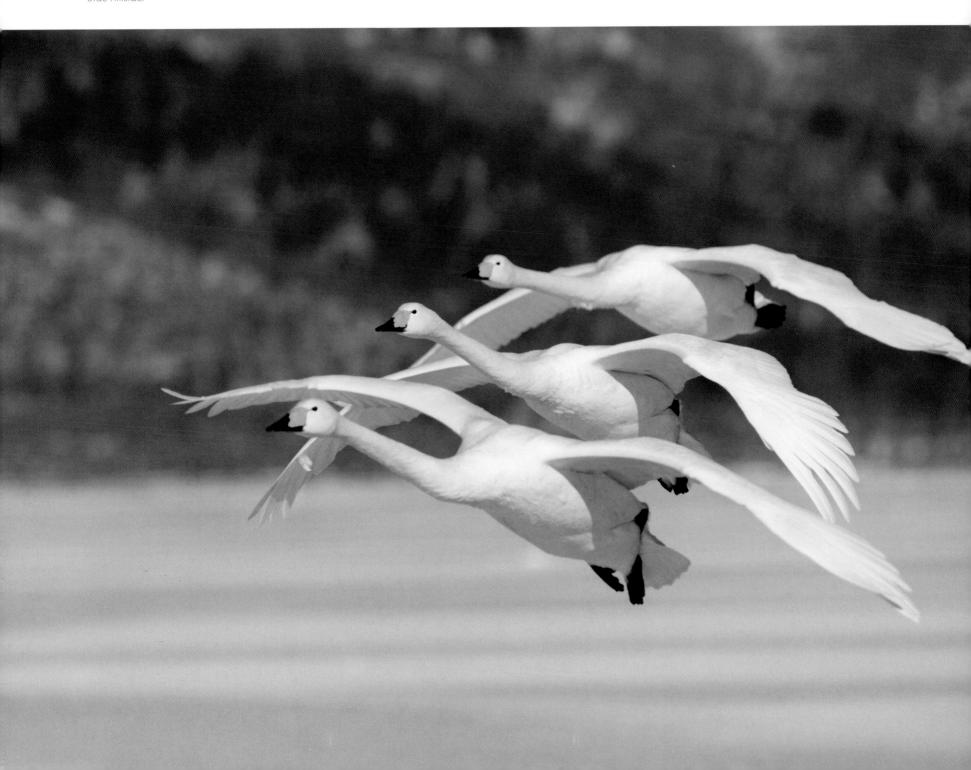

A large group of whooper swans crowd around me on Lake Kussharo's shore. Traditionally, the people of Hokkaido disperse grain during winter to augment the whooper swans' diet. As a result, these reclusive birds, which nest in the tundra of Eastern Europe, have lost all fear of humans. The loud, aggressive swans pecked at me, apparently expecting a reward for posing. With a 16-35 mm wide-angle perspective, I was able to emphasize the swans while including the surrounding mountains.

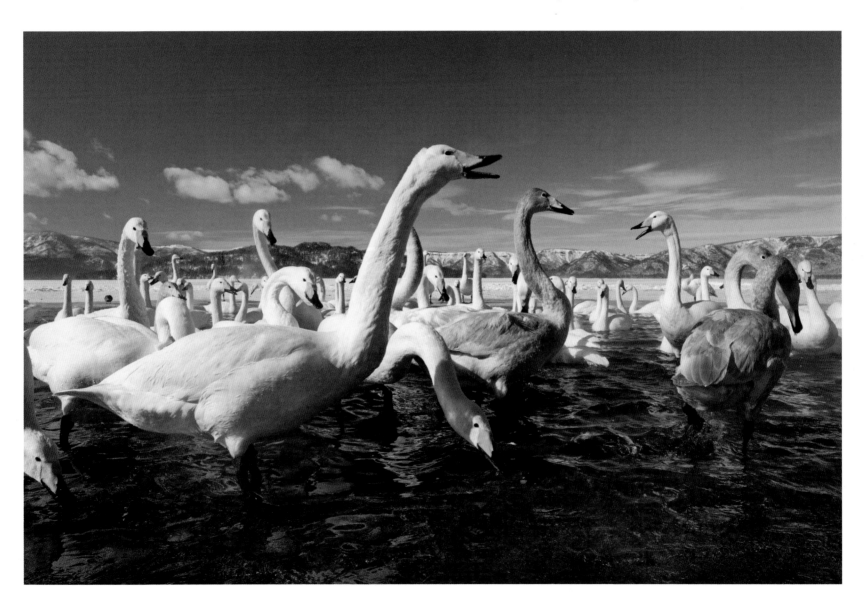

"When you sweep, sweep," says the Zen master. A Buddhist monk sweeps an entrance to a monastery high in Koyasan in southern Japan. "Koyasan" refers to a mountainous region dotted with Shingon Buddhist temples, multiple shrines, and monasteries amongst coniferous trees and is a center of the Buddhist faith. In the long winter months, Koyasan is blanketed in deep snow. I looked to juxtapose old and new, permanent and ephemeral. I framed the modern event with the ancient elements of the door while the gently falling snow softened the whole composition, evoking serenity.

Although bare wood temples predominate in Koyasan, melding with the forest, some are painted in bright colors. I sought to employ the temple to set off the branches and the snow, creating an abstract that suggests the life and motion of a sumi painting while still including color.

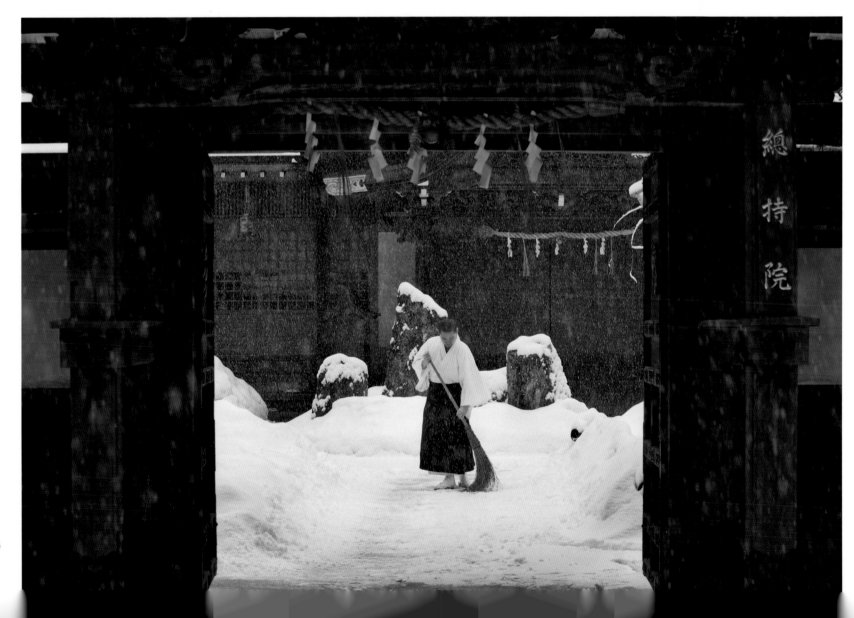

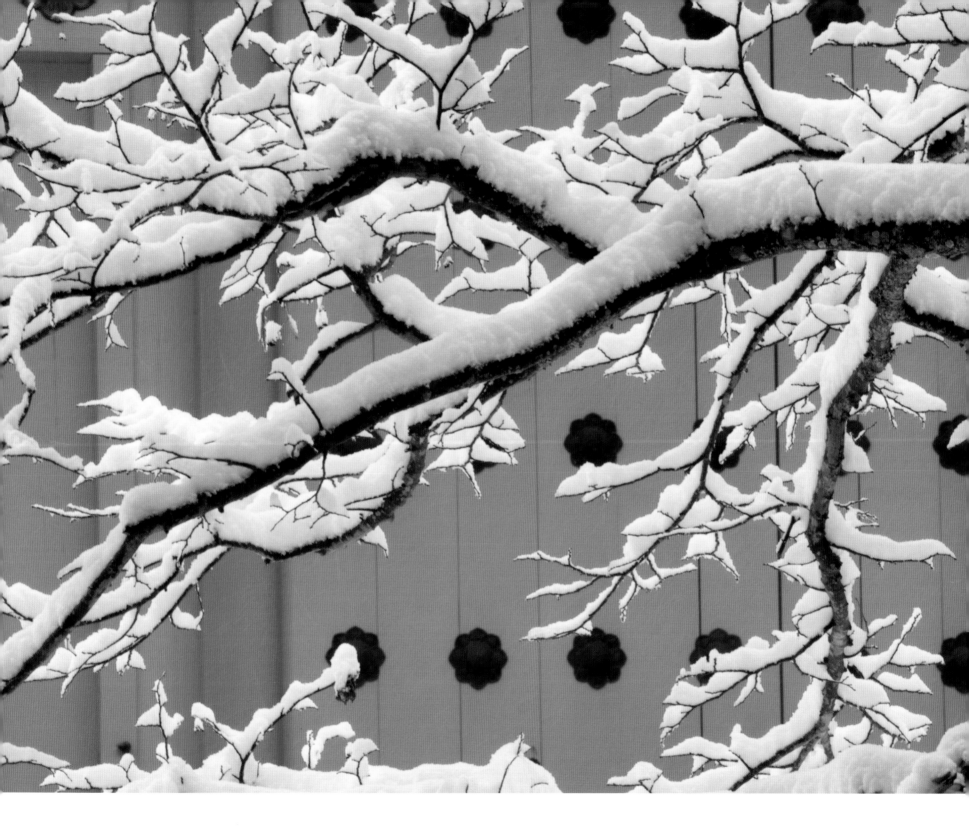

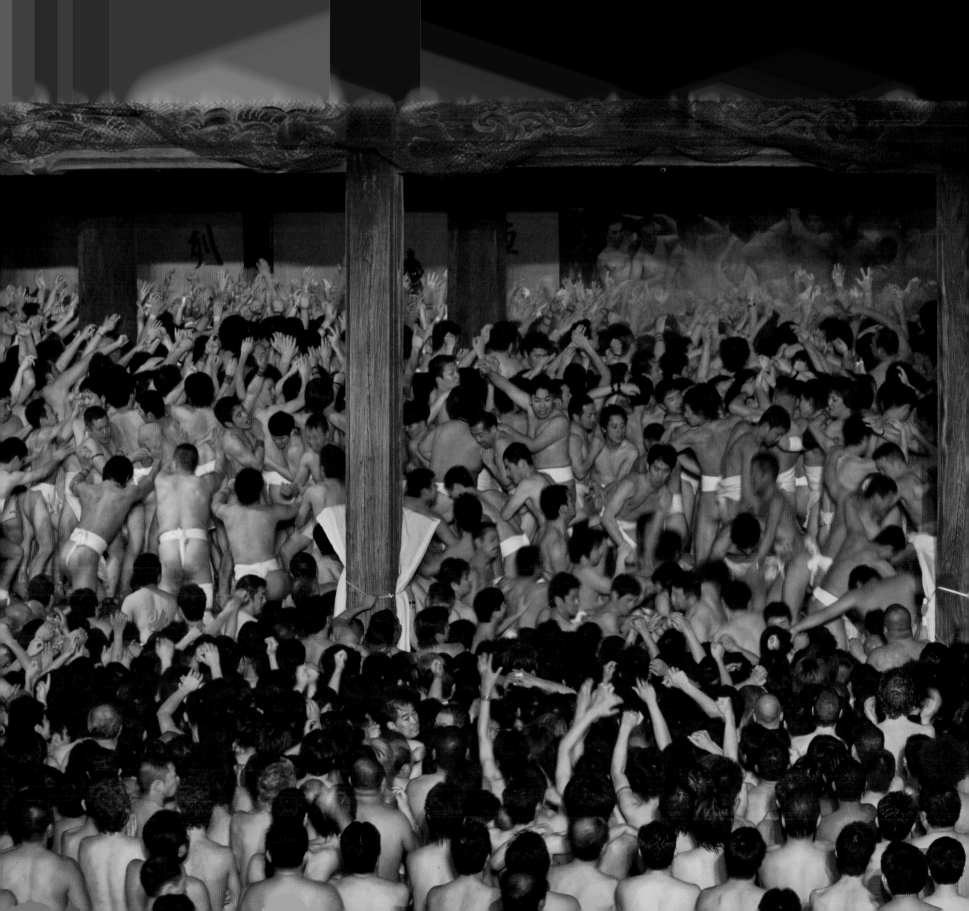

The Naked Man Festival, held on a winter evening in Okoyama, Japan, features five thousand men in loincloths vying for a symbolic baton, which is tossed into the inebriated throng. Whoever ultimately possesses the baton receives good luck for the year. The scrum becomes tumultuous when one man catches the baton because anyone who touches him acquires the good luck as well.

A Buddhist monk prays at a shrine in Koyasan, Japan. I zoomed in to show the beautiful contrast of mustard and white, while presenting the texture of the shrine's cracked wood. The monk's wooden slippers complete this vignette.

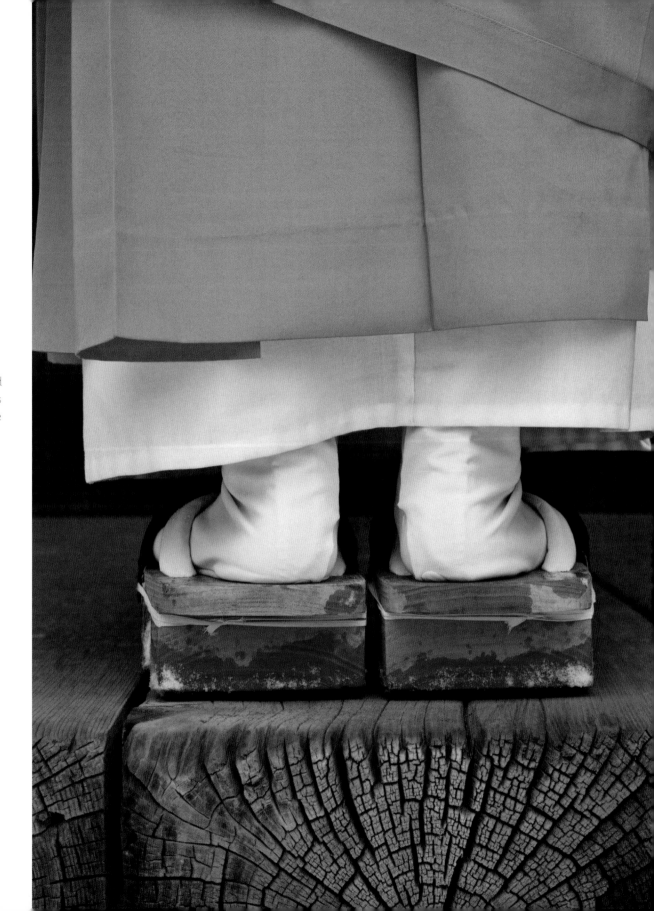

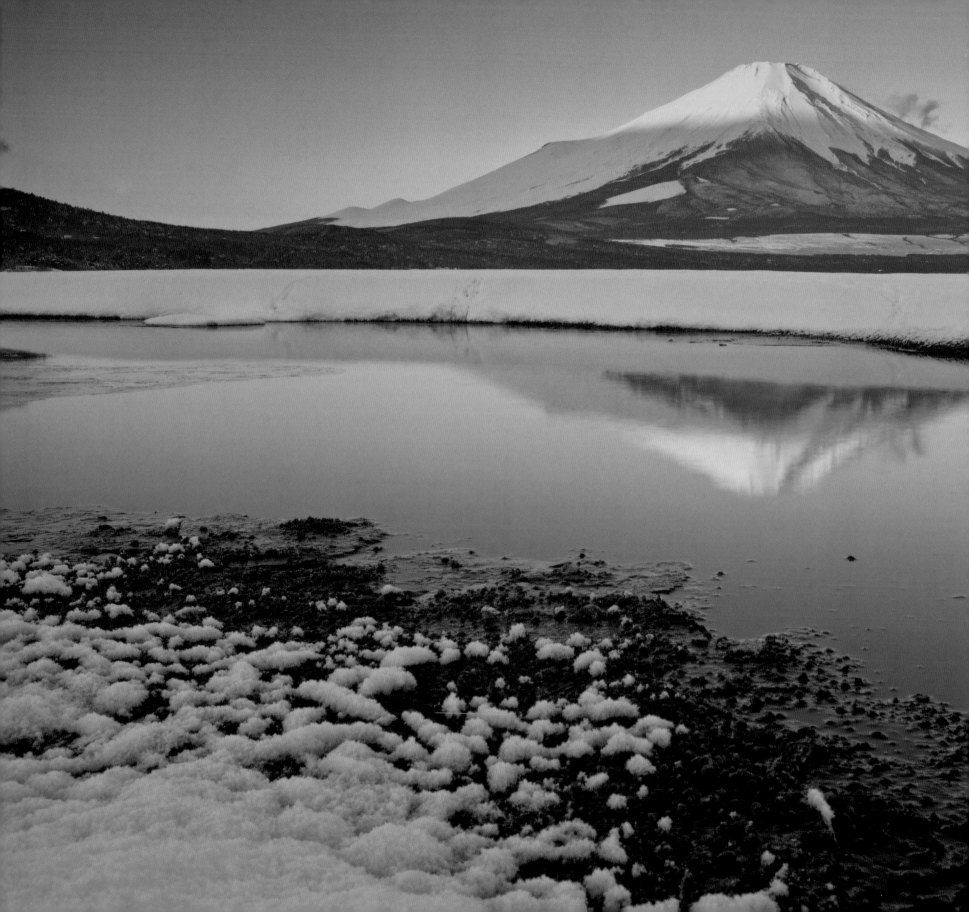

Mount Fuji might be the most recognizable symbol of Japan. It's easy to understand why this eleven-thousand-foot mountain is revered for its ancient slopes and sublime symmetry. This image was shot on a perfectly calm, crystal-clear day in the dead of winter.

In winter the Japanese Alps on Honshu take on an austere and forbidding quality. I was attracted by the thick, curving lines contrasting with the repetitive patterns of the bare trees, each made more graphic by the even tone of the snow. The photograph almost looks like a pen and ink drawing.

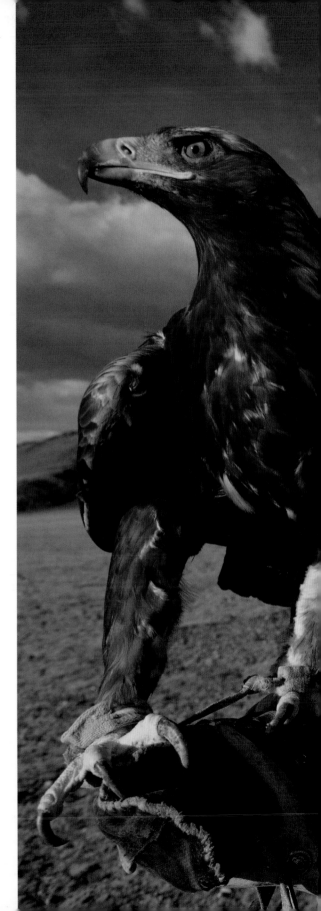

In late afternoon, Kazakh hunters train a golden eagle to respond to commands. For centuries, the Kazakhs, who reside in western Mongolia, have taken eagle chicks from the nest and hand-raised them to hunt foxes, cats, and, in some cases, wolves. The prey's fur provides the Kazakhs with warm clothing in the harsh, but beautiful, Mongolian winter.

MONGOLIA: MOUNTAIN TO STEPPE

Known for its arid steppes, skilled nomadic horsemen, and Genghis Khan, Mongolia retains its traditional culture. At annual *naadam, or* festivals, contestants compete in the centuries-old pursuits of wrestling, archery, and horse racing. We came to Mongolia to find wild horses roaming the steppe; to ride in the mountains with a Kazakh tribesman who hunts with golden eagles; and to catch up with nomadic reindeer herders at their summer camp near the Siberian border.

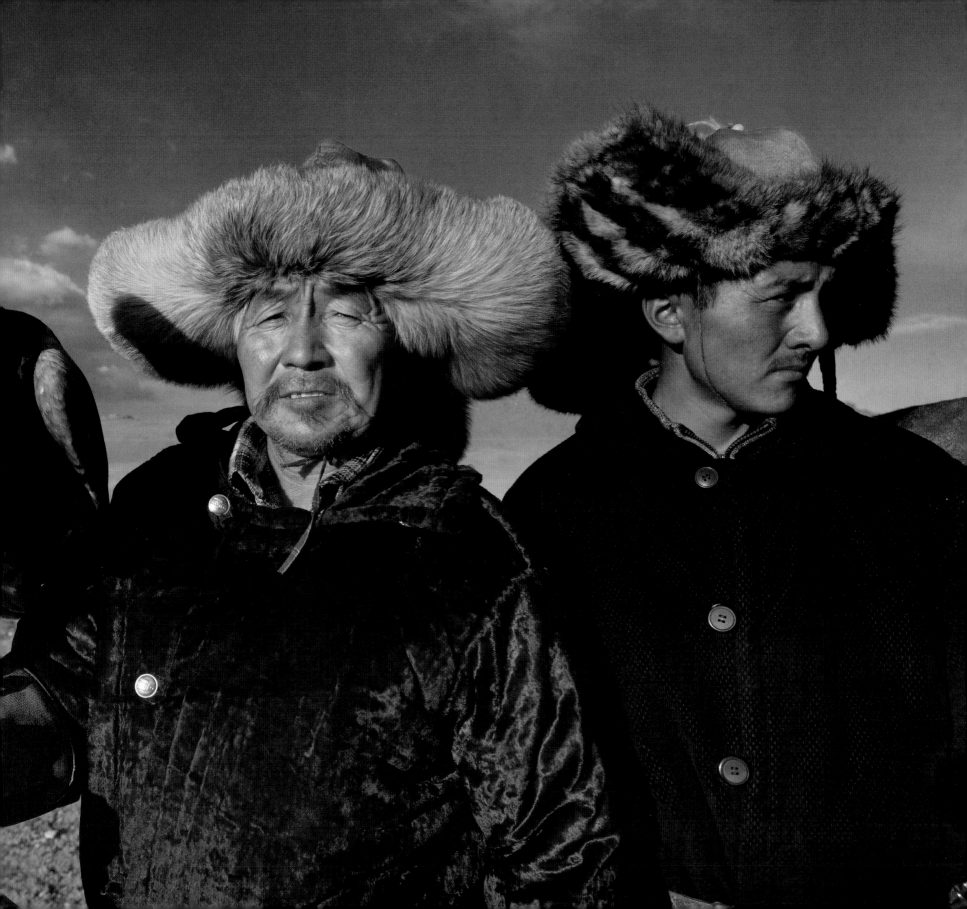

Tsaatan children ride reindeer in the remote mountains along the border of Mongolia and Siberia. "Tsaatan" appropriately translates to "reindeer people," as reindeer provide essential food, clothing, and transportation for this endangered culture.

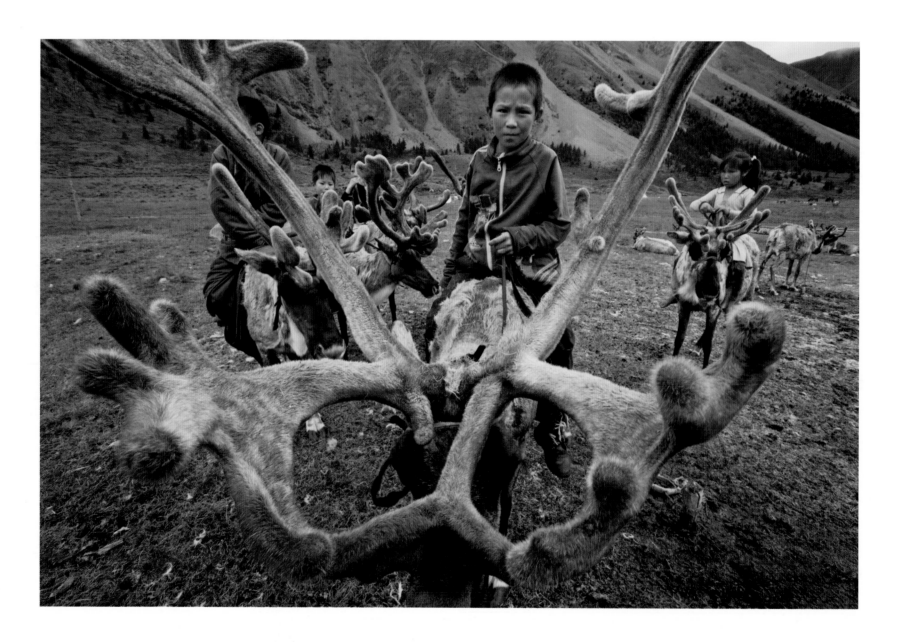

While on a three-day visit to a Tsaatan village, I observed reindeer leaving the village each morning to graze the surrounding alpine tundra. The herd always returned to the safety of the village at dusk. Packs of wolves commonly linger outside the village, waiting to prey on isolated reindeer.

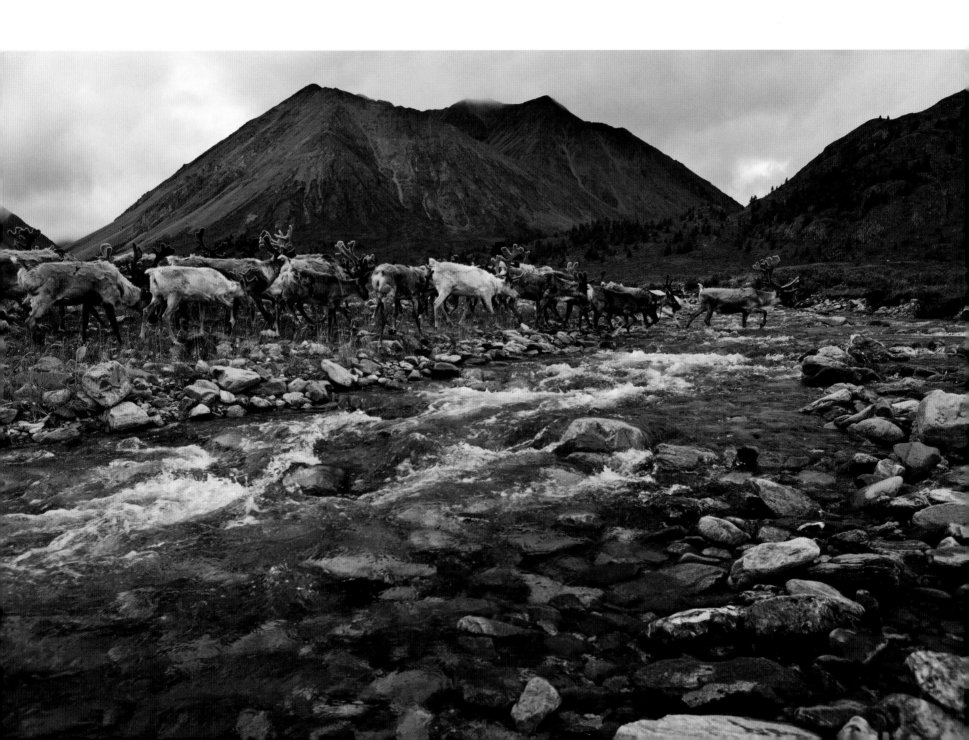

A beautiful rainbow adorns the rugged mountains of northern Mongolia. The southernmost edge of the vast Siberian taiga forest reaches into the land of the reindeer people.

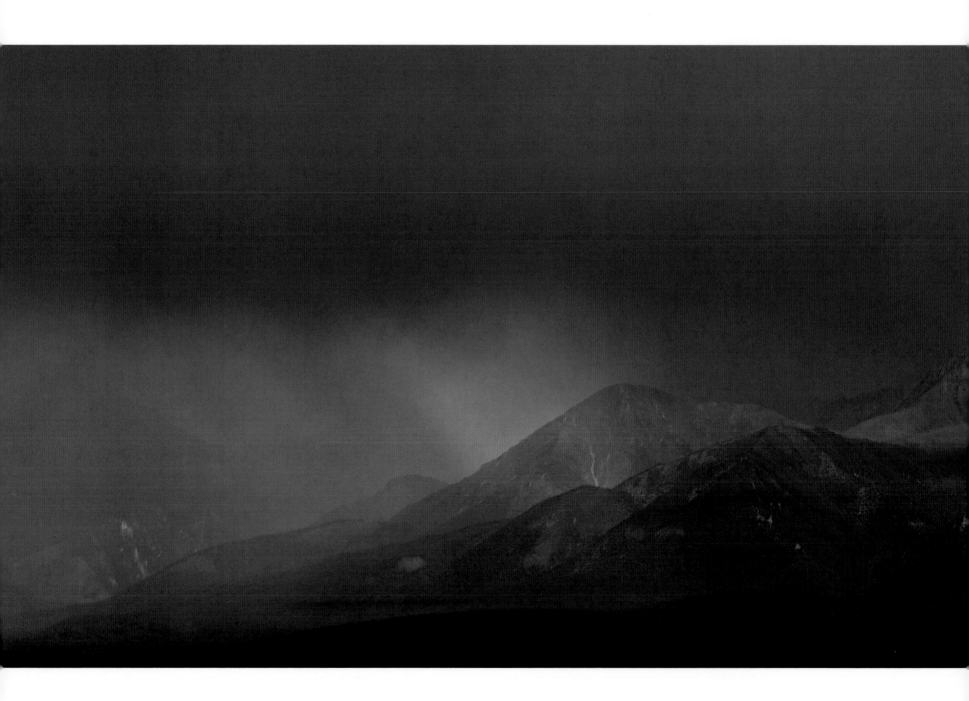

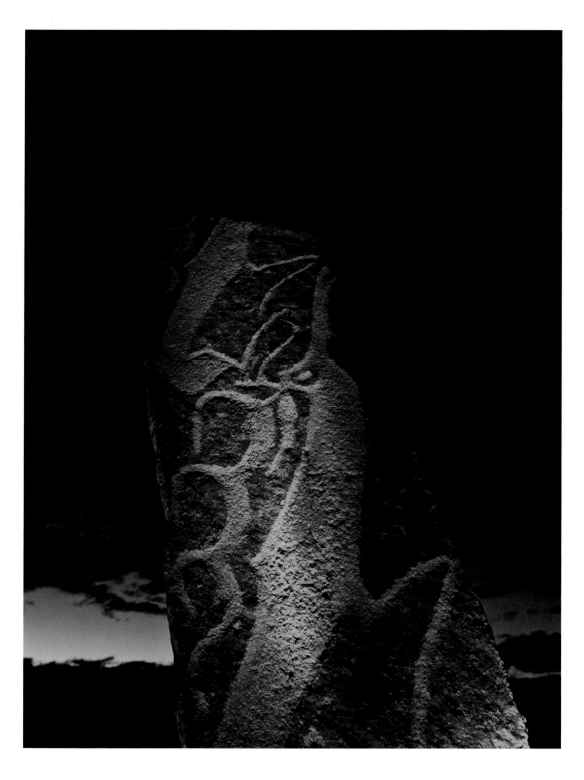

Experts speculate that north-central Mongolian stone engravings, such as this representation of a deer, were created more than three thousand years ago. Originally thought to guide ancient people across the open steppe, these stones are now believed to be grave markers with each engraving echoing a tattoo found on the person buried in the frozen earth below.

I illuminated this engraving with a headlamp to enhance the mystery of these iconic stones. The artificial light brought out the detail of the beautiful lines, highlighting them against the waning light in the western sky.

Following page Children race horses across the steppe in northern Mongolia; a child's light weight allows the horse to run at maximum speed. The annual race is part of the much anticipated *naadam*, which features other events such as archery and wrestling.

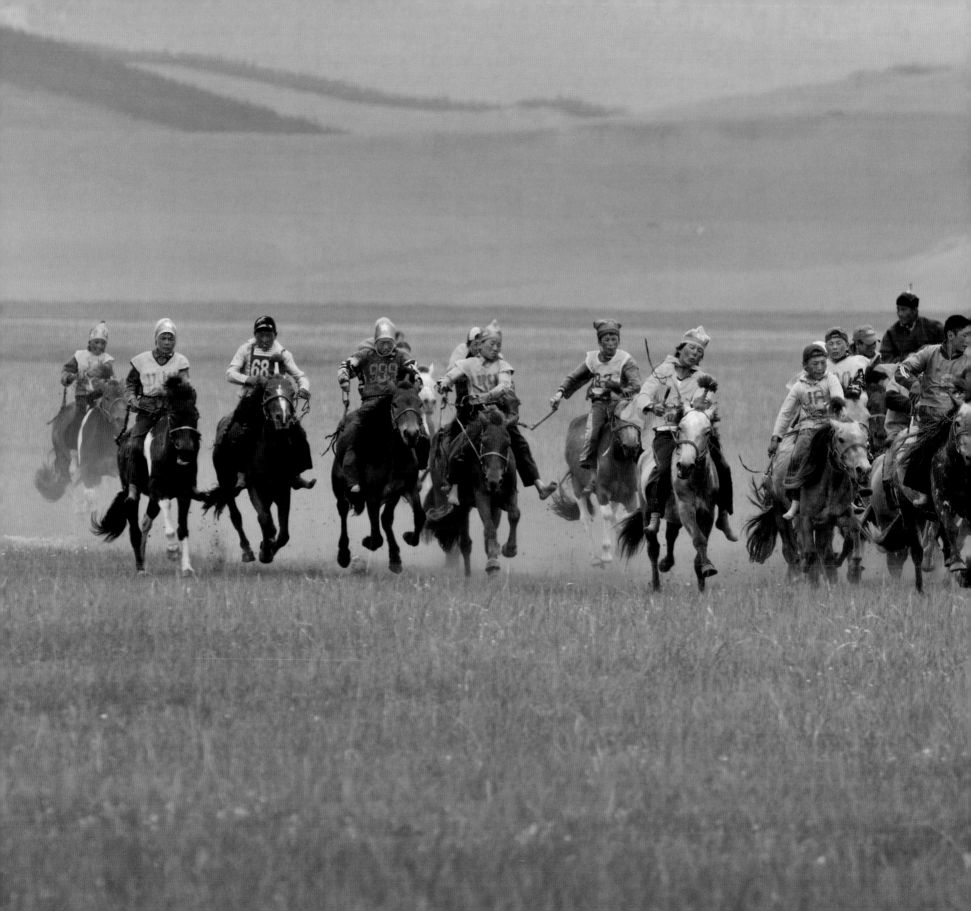

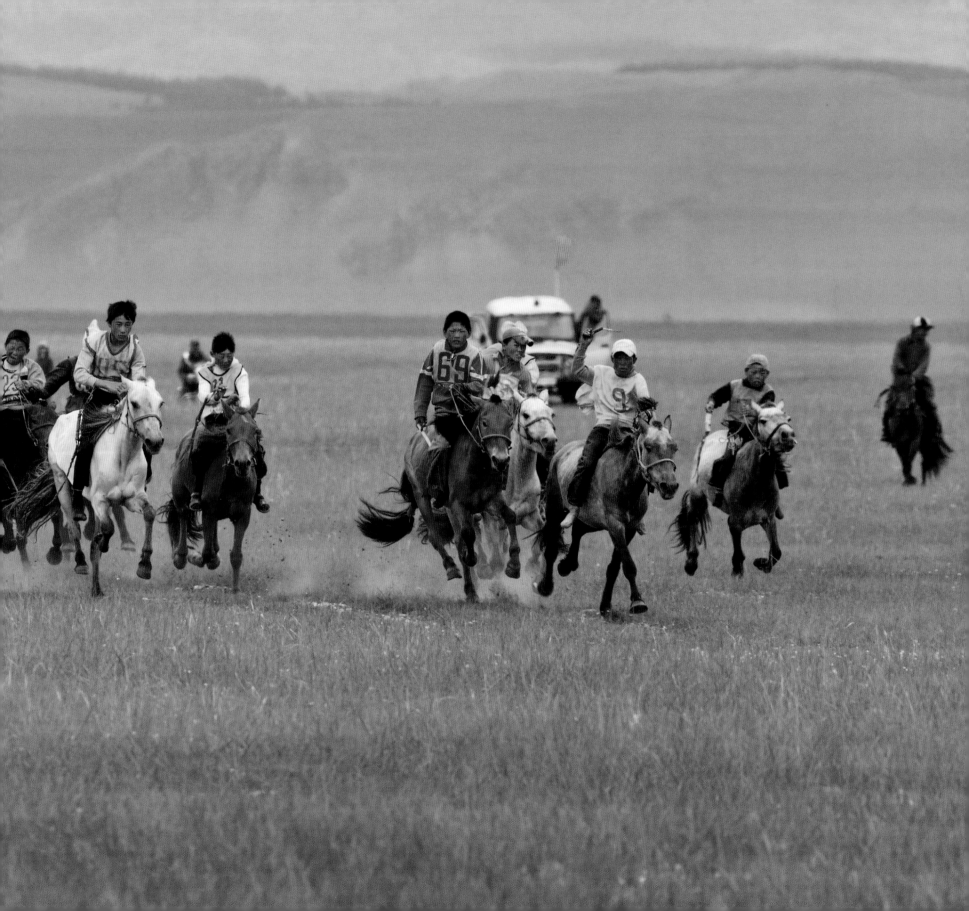

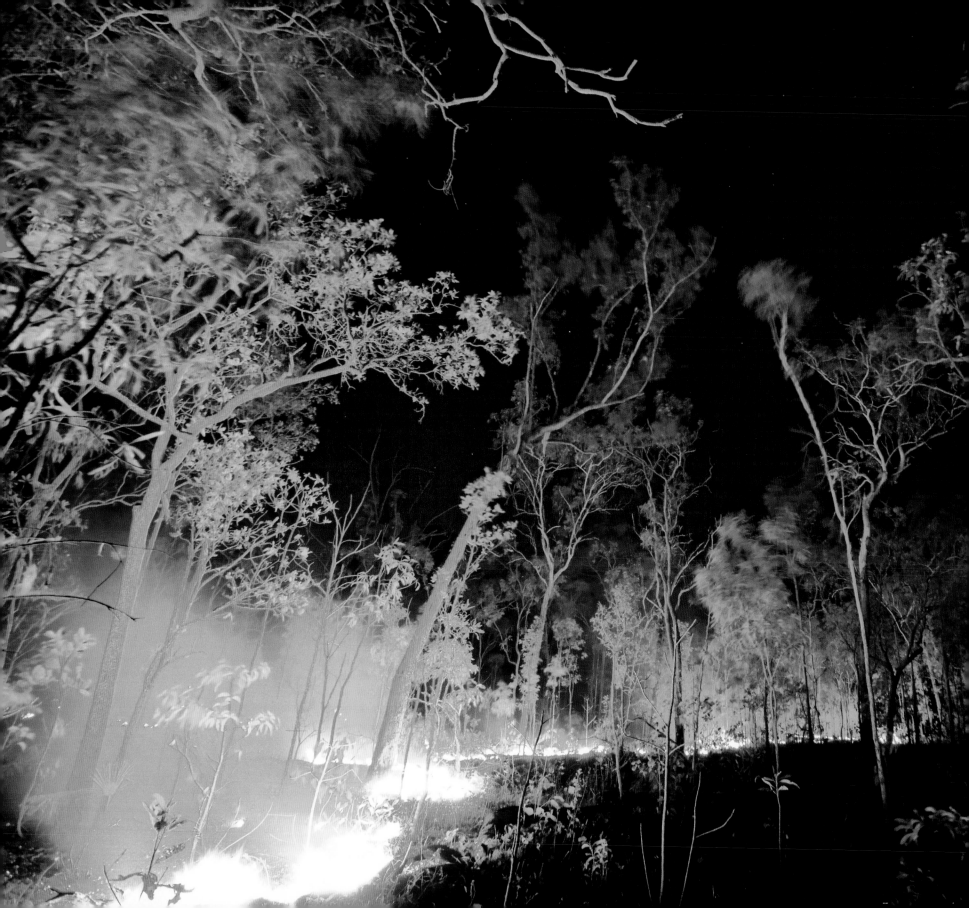

A grassfire rages across the wild lands of northern Australia. Such brushfires may seem destructive, but they actually support the ecological system by burning off dead grass and stimulating regrowth. Trees remain largely unscathed by the swift fires, which appear with astounding frequency across Australia's vast stretches of open country. I photographed this scene just after dusk as blue lingered in the twilight sky.

ARNHEMLAND AND THE KIMBERLEY, AUSTRALIA

The northwest region of Australia is an immense, untamed wilderness as brutal as it is beautiful. For the Aboriginal people, it's the place of the "Dreamtime," where land and story meet. We went in search of rock art, intricately painted thousands of years ago; discovered canyons carved by wind and water; and witnessed an ancient Aboriginal dance emblematic of the connection between the region's first people and the natural world.

Mitchell Falls is in the Kimberley region of Western Australia. The four-tiered falls are sacred to the Aboriginal peoples and the area is rich in ancient rock art. The upper pools are popular swimming holes, but swimmers avoid the lowest pool because saltwater crocodiles can access it.

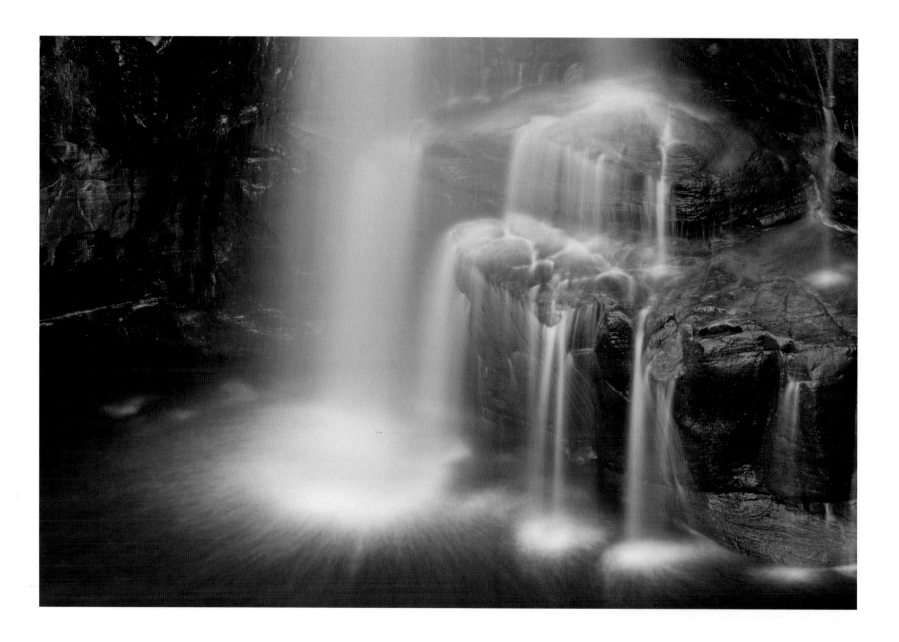

Aboriginal men perform an ancient dance on tiny Elcho Island off Australia's northern coast. A permit is required to travel in this region of Arnhemland, an Aboriginal center.

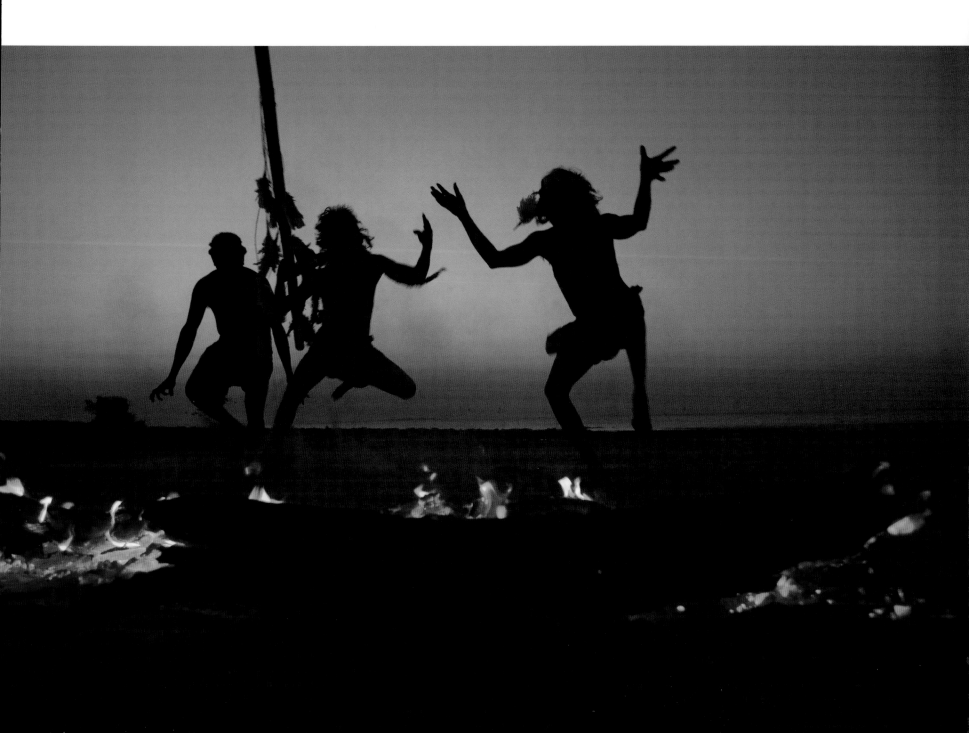

This extraordinary aerial view of beehive-shaped rocks depicts
part of the Bungle Bungle Range in Purnalulu National Park.
Although the region has been a sacred Aboriginal site for tens of
thousands of years, few Europeans knew of this intricate landscape
until the 1980s and the Australian government has permitted only
a few developed trails.

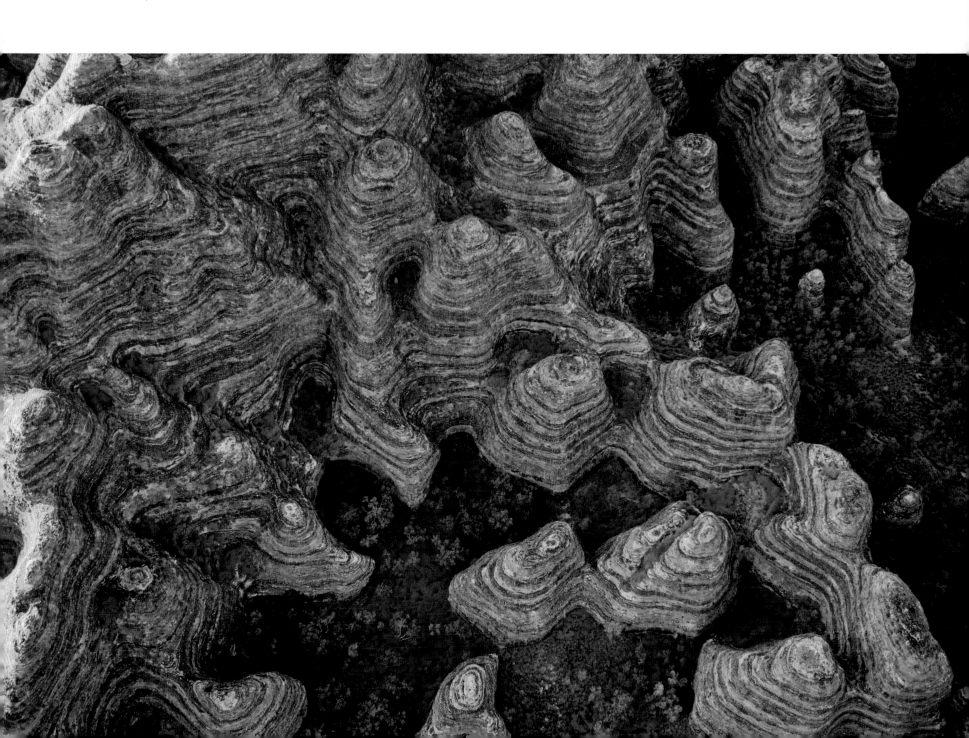

The Chamberlain River estuary is transformed into beautiful abstraction in this aerial shot. Like many photographers, I'm intrigued by how aerial perspectives simplify the land, enabling a clear, abstract composition.

Following page Arnhemland's abundant rock overhangs and smooth rock faces contain an incredible amount of ancient art. The drawings are impossible to date but could be twenty thousand to forty thousand years old. Some of the most interesting sites feature Aboriginal palimpsests, paintings on top of paintings, representing the creative outpouring of many generations.

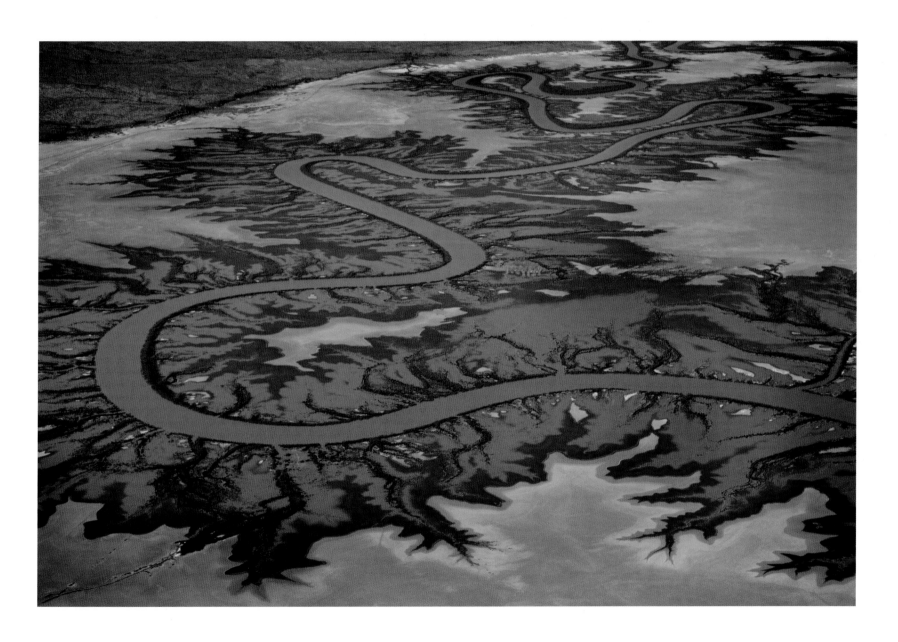

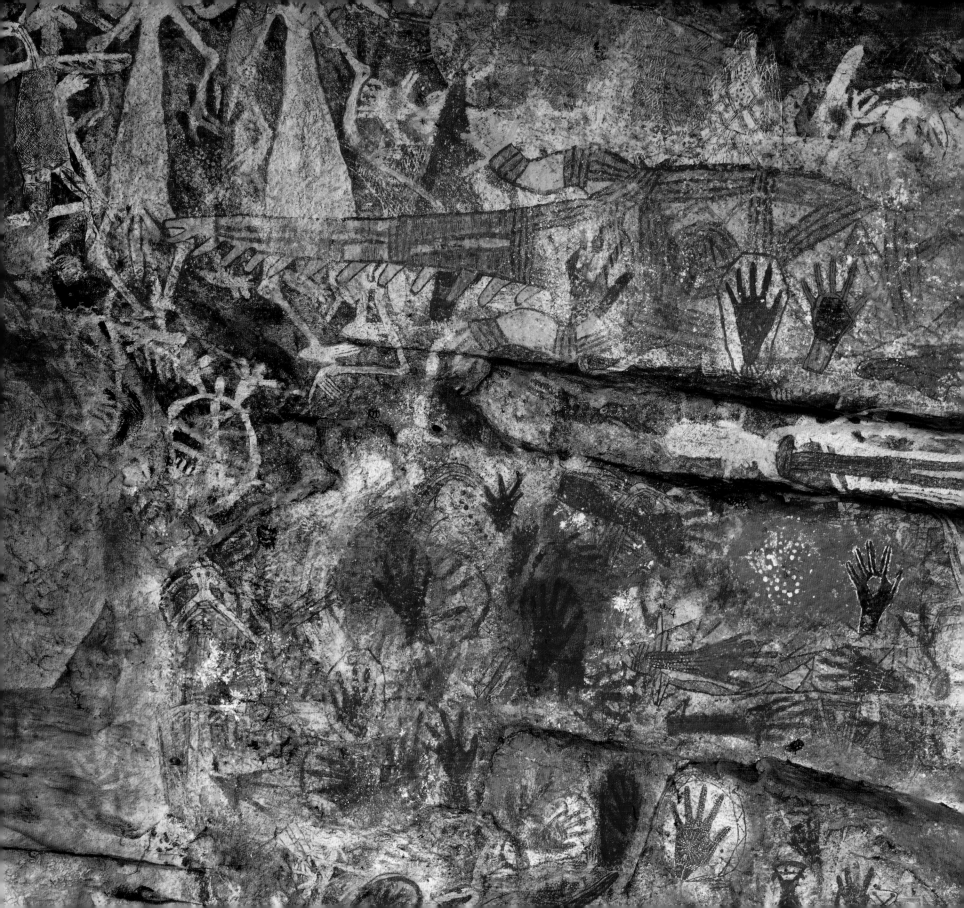

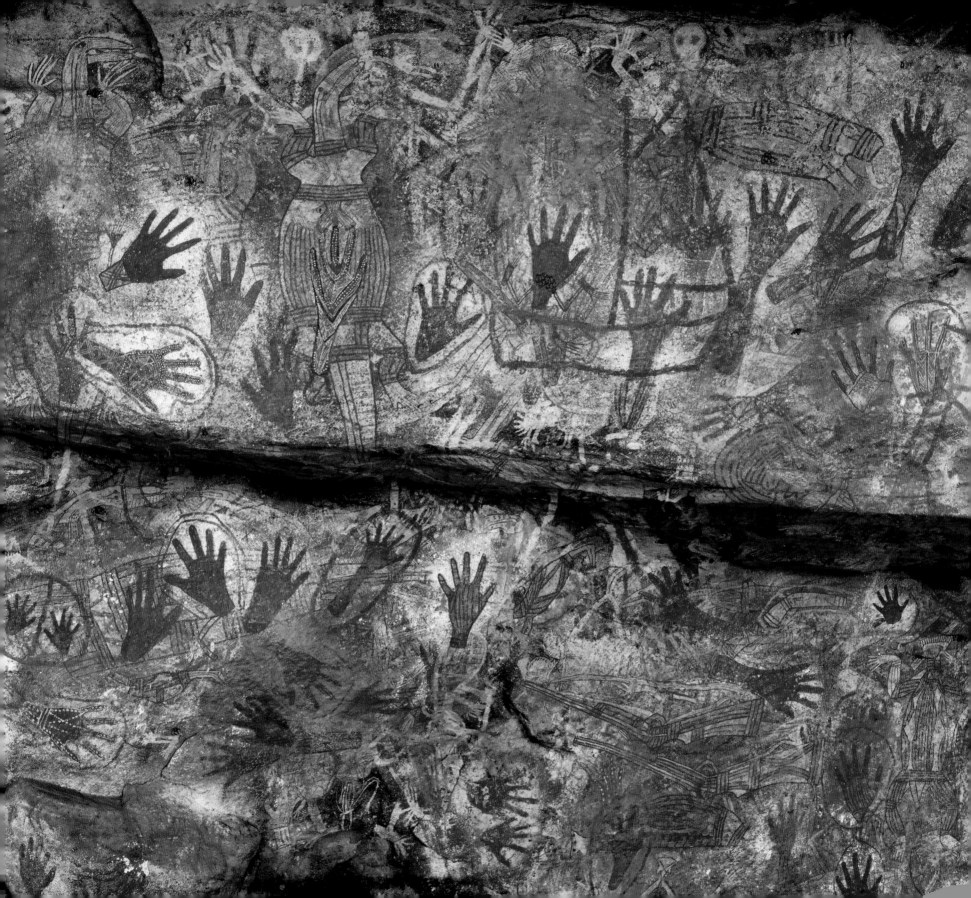

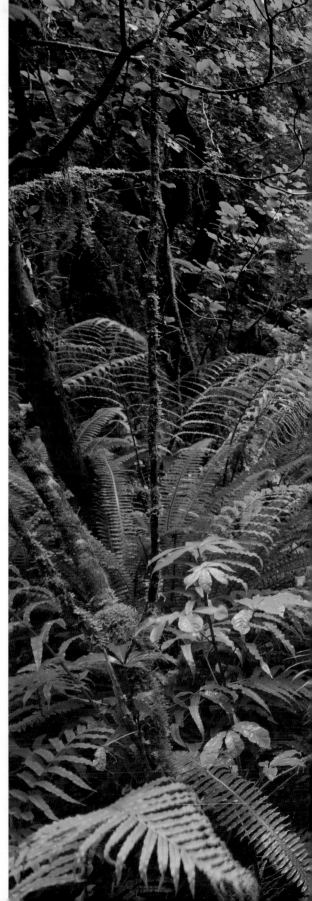

The cold waters of the Tasman Sea roll toward Punakaiki, on the limestone shoreline of Paparoa National Park on New Zealand's South Island.

On the southern slopes of the South Island of New Zealand giant tree ferns rise up to twenty feet in the air; the slopes face west and experience a high annual rainfall. This photograph was taken during a typically rainy afternoon. The soft light of overcast skies combines with dense, moist air to create a glowing landscape.

NEW ZEALAND

New Zealand's dramatic beauty is central to its identity. On the North Island, indigenous Māori people see themselves as guardians of the land. I captured portraits of contemporary Māori artists who wear their stories on their faces in the form of sacred tattoos, and convey their sense of stewardship through their art. On the wild South Island we explored the mountains, forests, and fiords of this pristine and beautifully preserved island nation.

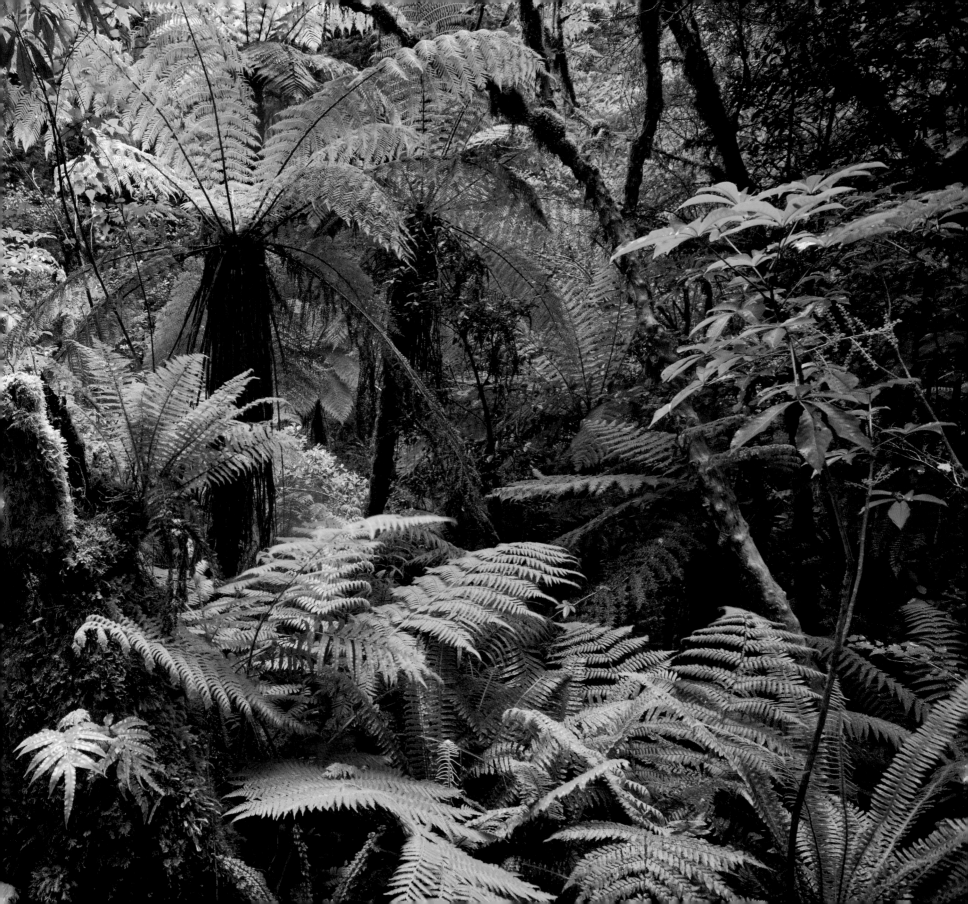

The South Island of New Zealand contains many microenvironments. This mountain forest, high in the Southern Alps, is rich with life. A layer of moss and lichen, which provides food and shelter for the smallest creatures, encases each tree trunk and limb.

The Māori, the indigenous Polynesian people of New Zealand, are renowned for their distinctive tattoos, also known as *tā moko*. The curvilinear tattoos, which are richly symbolic, are facial because in traditional Māori culture the head is the most sacred part of the body.

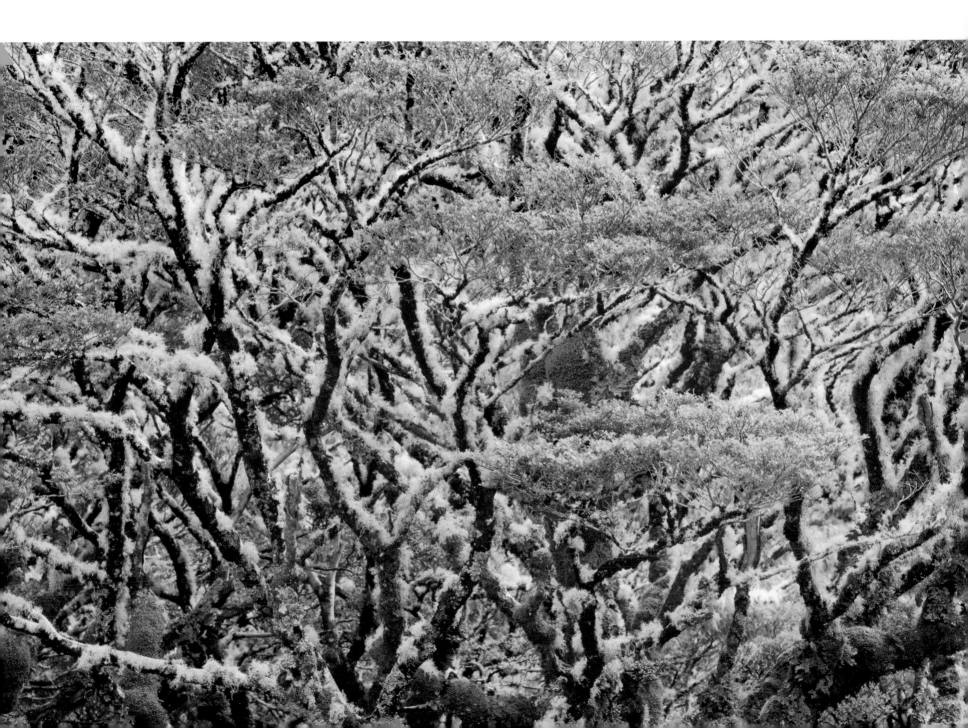

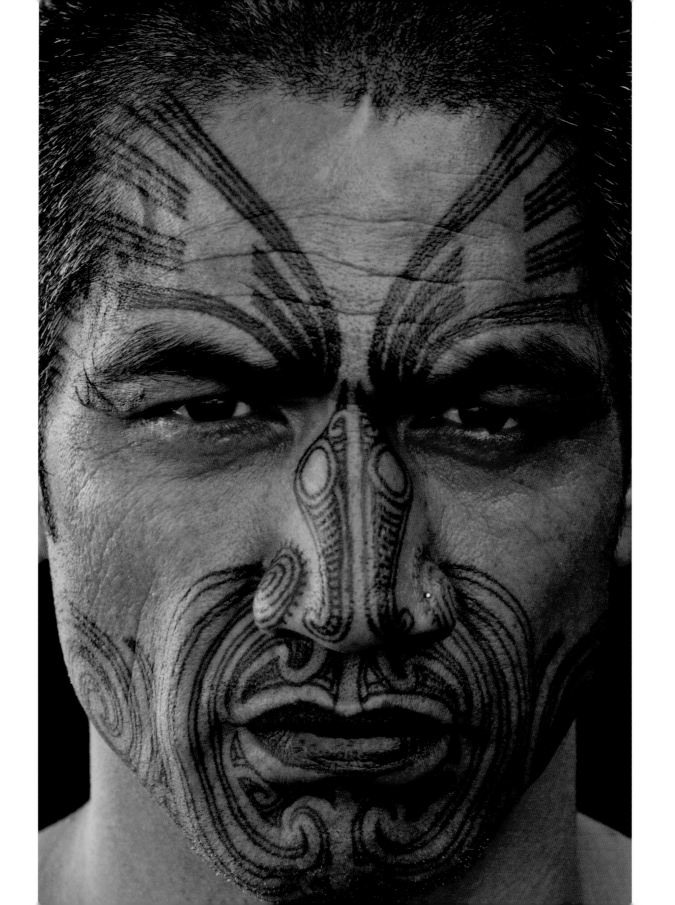

Drawn to the spring salmon run by their need for protein and fat, these enormous brown bears engage in a territorial fight. During spring, the density of bears in this narrow region between the Alaskan mountains and the ocean often leads to ferocious encounters.

When brown bears emerge from their long, winter hibernation, berries are not yet ripe and salmon haven't reached the rivers, so the bears feed on razor clams at low tide and feast on nutrient-rich sedges and grasses. Such vegetation flourishes in the tidal margins of Katmai National Park on the Alaskan Peninsula.

KATMAI COAST, ALASKA

Alaska's Katmai Coast is the largest intact, uninhabited coastline in North America. With the help of a bear expert and a naturalist, I got very close to brown bears in their natural habitat, watching the huge grizzlies graze sedge flats, dig for clams, battle during mating season, and enjoy playful moments below the snowcapped mountains of Katmai National Park.

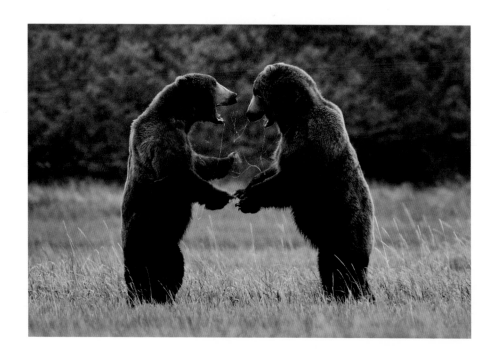

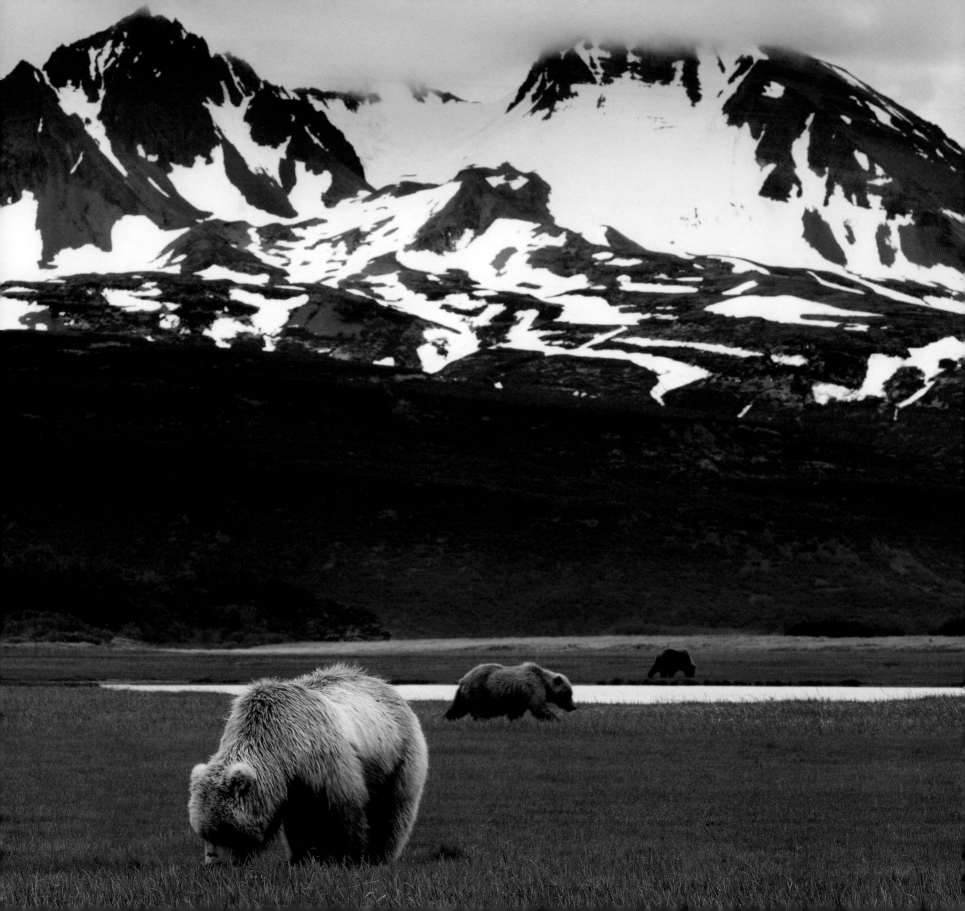

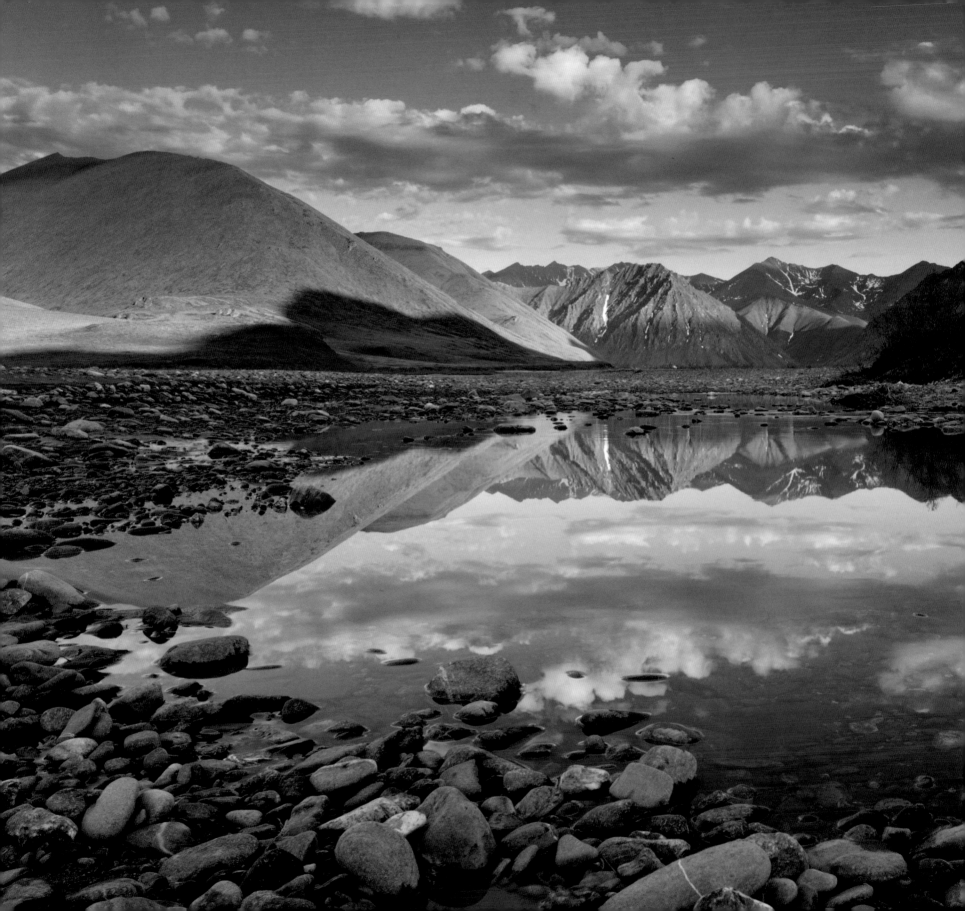

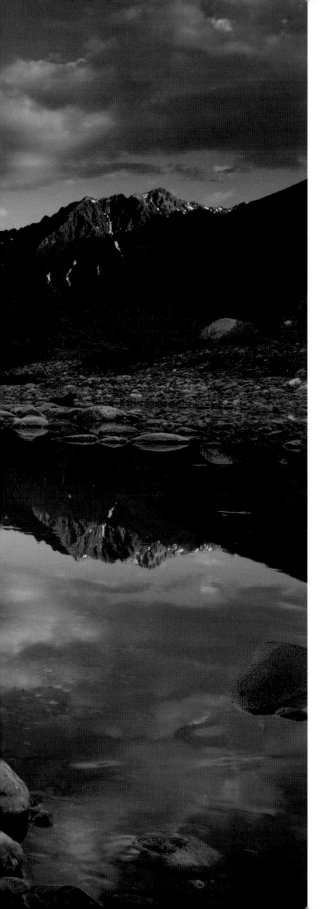

Summer solstice light shines on the bare slopes of the Brooks Range in Alaska. I shot a reflection of the mountains in a pond adjacent to the Kongakut River. At over nineteen million acres, this grand landscape is part of the largest wildlife refuge in North America.

ARCTIC NATIONAL WILDLIFE REFUGE, ALASKA

Flanked by the Brooks Range and the Arctic Ocean, the Arctic National Wildlife Refuge represents some of North America's most remote wilderness. Caribou migrate an average of twenty-five hundred miles a year to give birth in this magnificent region, which is threatened by oil drilling and industrial development. Here we photographed the caribou migration amidst the expansive landscape of one of the planet's most isolated locations.

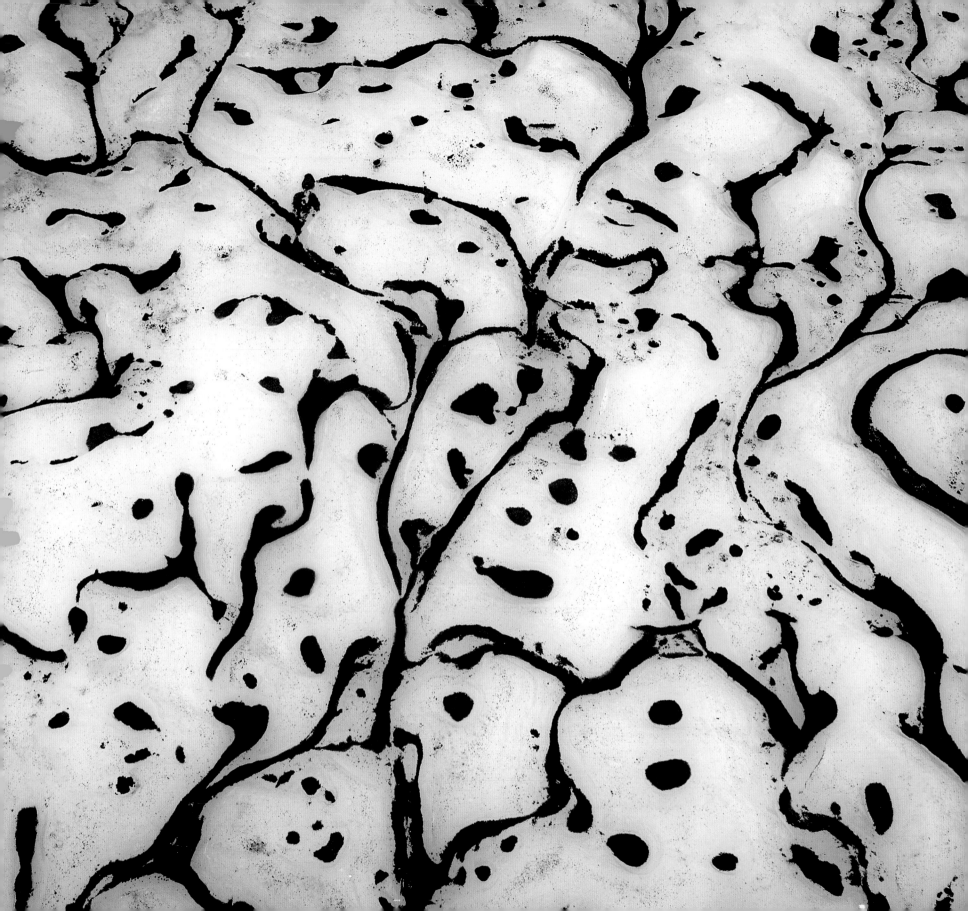

I shot this abstract in the Alaska National Wildlife Refuge. The subject is *aufeis,* German for "ice on top," which forms when groundwater flows over ice in freezing conditions, creating layer after layer of ice. The black shapes are river sand caught in slight depressions on the ice. The image betrays no sense of scale—I shot it straight down from my tripod—and it works as pure pattern.

A small group of Porcupine caribou migrate across the Brooks Range in Alaska's Arctic National Wildlife Refuge. Porcupine caribou have the longest migratory route of any terrestrial mammal in the world. The herd frequently calves on the range's north slope, which has been the subject of much debate over oil exploration and development.

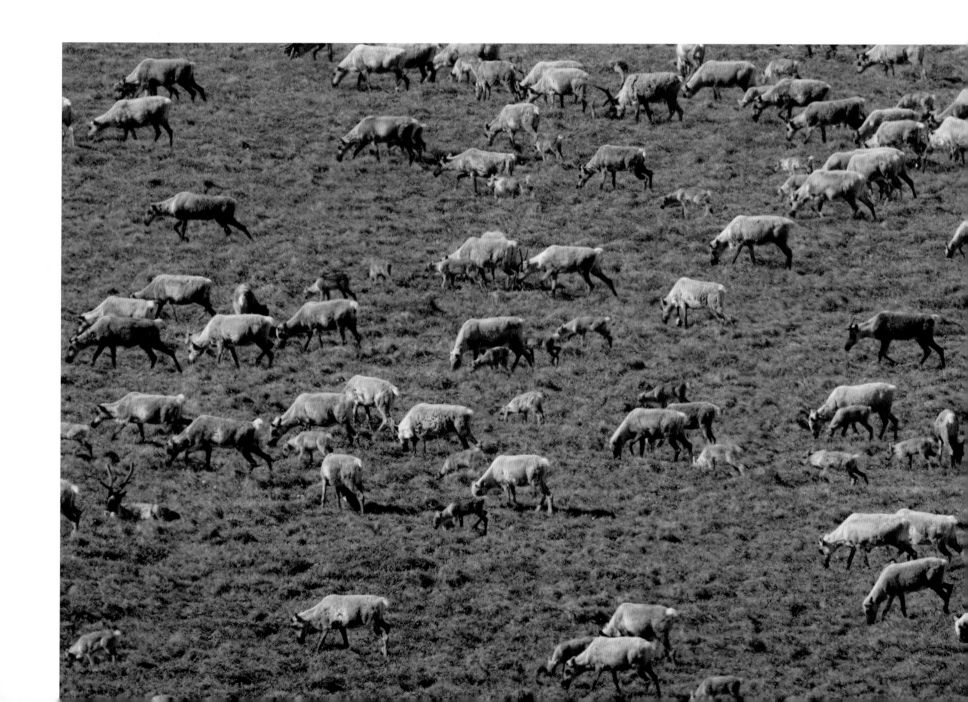

A black bear sow and her cubs feed upon a barnacle-encrusted rock. The barnacles, which were left exposed at low tide, provide vital nutrients to sustain the bears until salmon, berries, and other foods become available in late spring.

A bald eagle in southeast Alaska swoops down to snatch a fish but misses it this time. Bald eagles are the second largest eagle on the continent, behind the golden eagle, and live for up to thirty years.

GLACIER BAY, ALASKA

I love southeastern Alaska. The combination of ancient forest, ice-covered peaks, and iconic wildlife are rewarding subjects. On this trip I photographed black bears on their daily search for food. Nearby, sea lions, gulls, and eagles all vied for the frigid bay's abundant krill. The whites and blues of this icy environment offer as many photographic opportunities as the wildlife, revealing beautiful lines and abstract details.

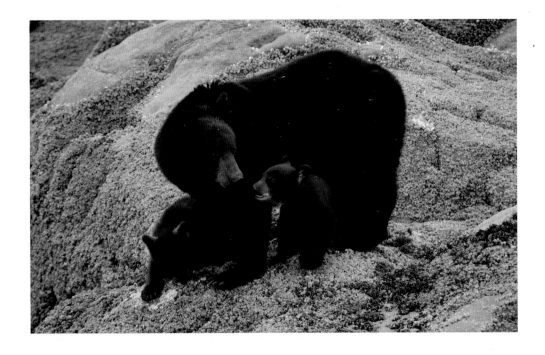

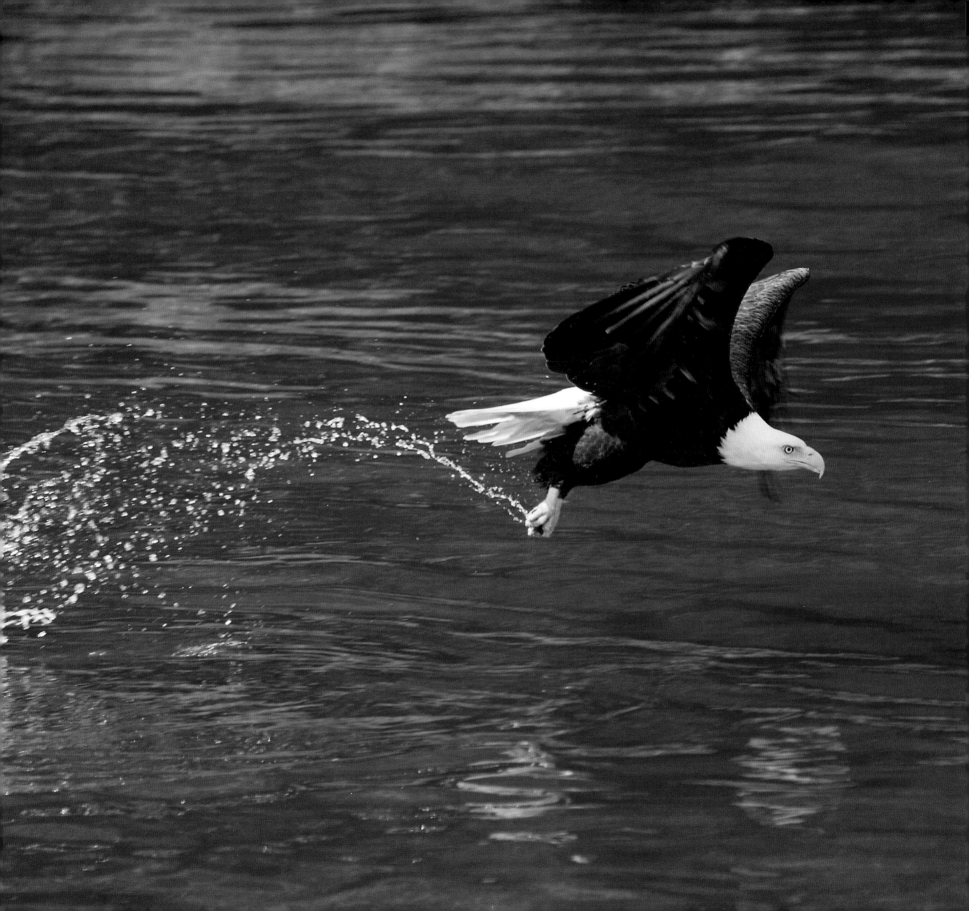

Reid Glacier in Alaska's Glacier Bay National Park has receded as much as a mile in the past twenty years. Few natural phenomena show the evidence of climate change more than receding glaciers.

The tail of a diving humpback—a symbol of the wild ocean—is instantly recognizable.

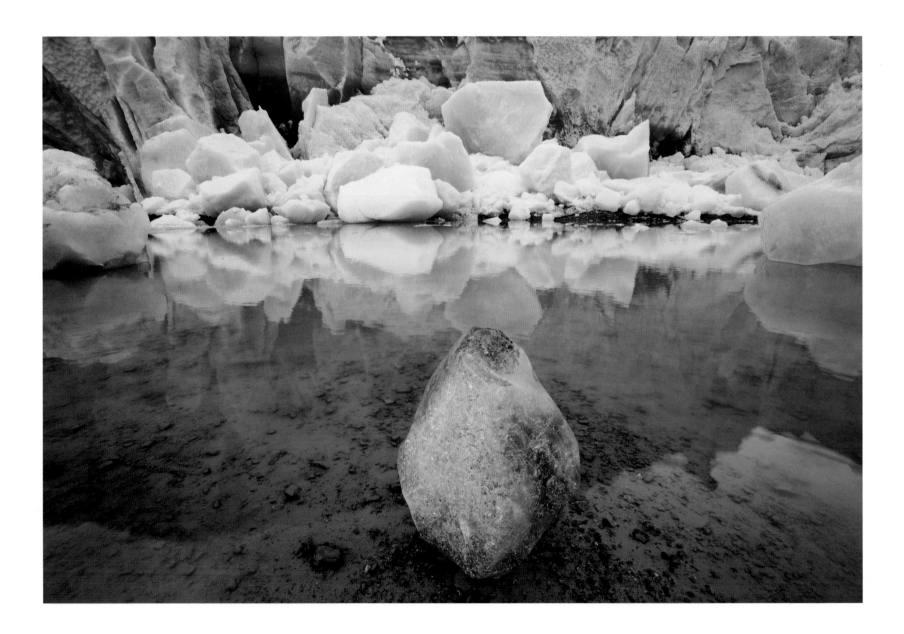

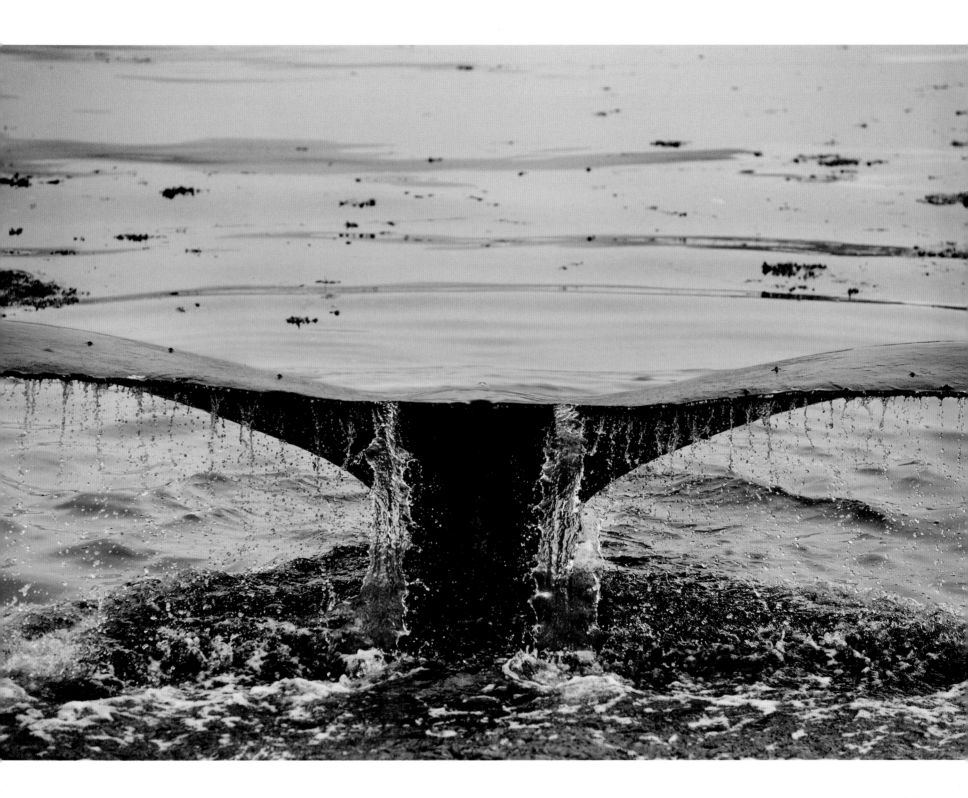

As the moon rises over the horizon, pastel post-sunset tones bathe the buttes and mesas surrounding Lake Powell. This man-made reservoir, although aesthetically beautiful, was a major issue for the early environmental movement. Hundreds of important archeological sites were flooded and lost by the rising waters of the Colorado River behind Glen Canyon Dam. In today's more environmentally aware climate, Lake Powell probably would not have been created.

ZION NATIONAL PARK AND CANYON DE CHELLY, THE AMERICAN SOUTHWEST

The American Southwest conjures images of open buttes and desert landscapes sculpted by great natural forces. We visited the border region of Arizona and Utah, photographing Native American petroglyphs, surreal rock formations, and treasured national monuments and parks. This land, where the earth creates art, is like no other place on the planet.

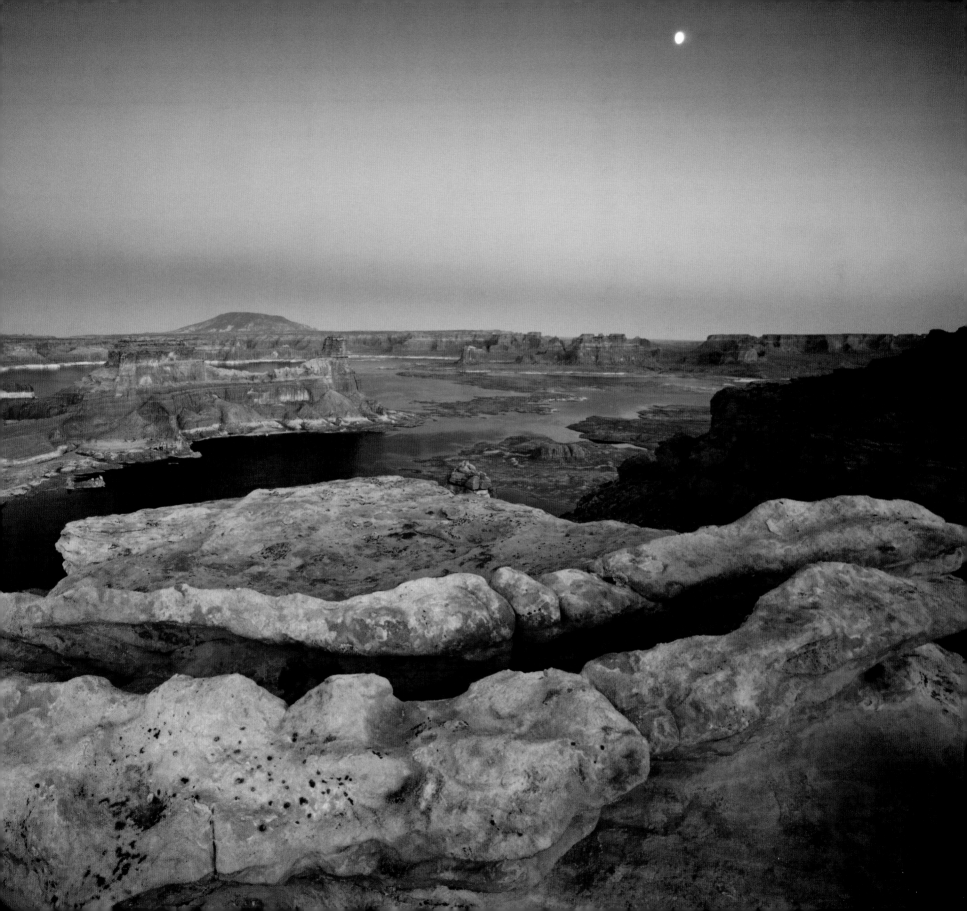

Deep pools punctuate the canyon floor in the Subway of Utah's Zion National Park. For most of the year, the Left Fork of North Creek trickles benignly through this backcountry canyon, but during the short rainy season, flash floods, carrying large amounts of mud and rock, erode the rock surface and cut deep chasms.

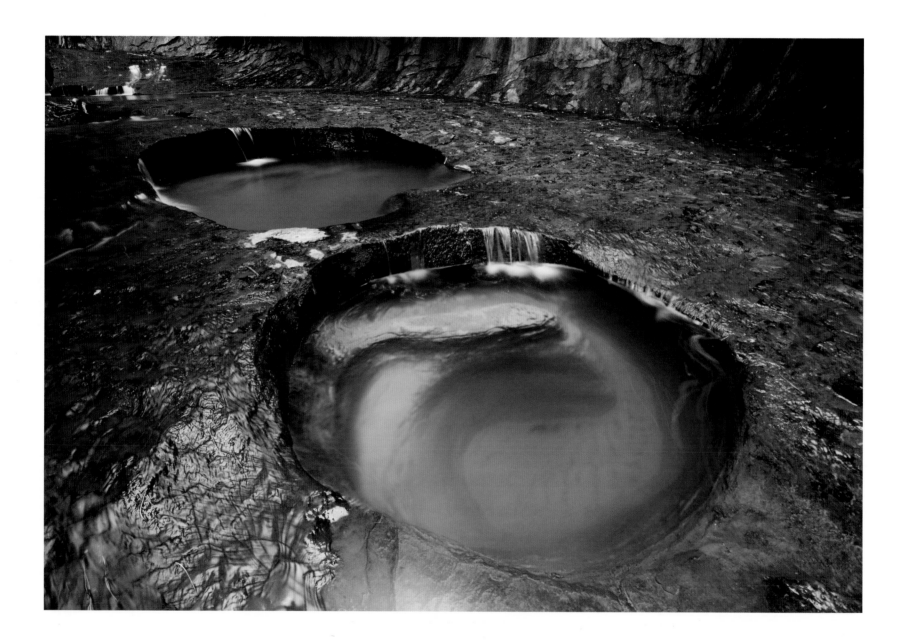

Zion Canyon is a desert Yosemite, replete with tall vertical walls, roaring waterfalls, and dramatic landscapes. This waterfall on the Temple of Sinawava—an imposing sandstone monolith—runs only during rains and snowmelt.

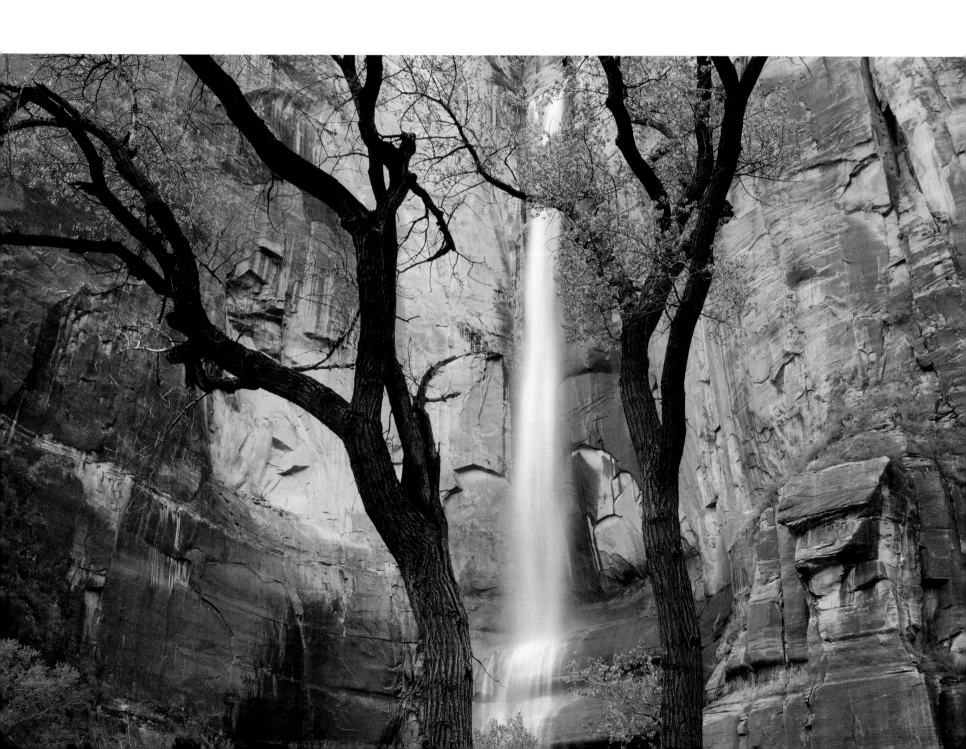

Native Americans left their imprint on the desert Southwest in the form of petroglyphs. Found from California to Colorado, rock carvings such as those shown here depict animals and gods in scenes that range from the highly symbolic to those of daily affairs.

In southeastern Utah, a combination of resistant stone and eroded cliffs create a whimsical, magical landscape known as the Towers of Silence. Dramatic columns of sediment, called "hoodoos," stand near hillsides. Hard rock caps protect the softer rock of the eroded hoodoo.

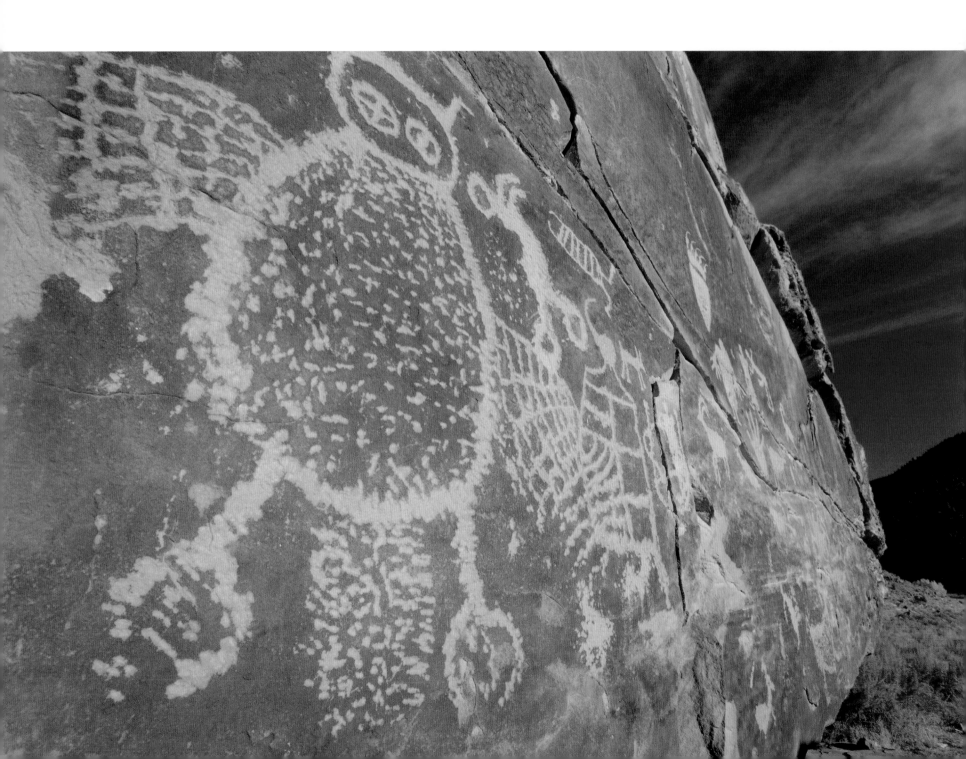

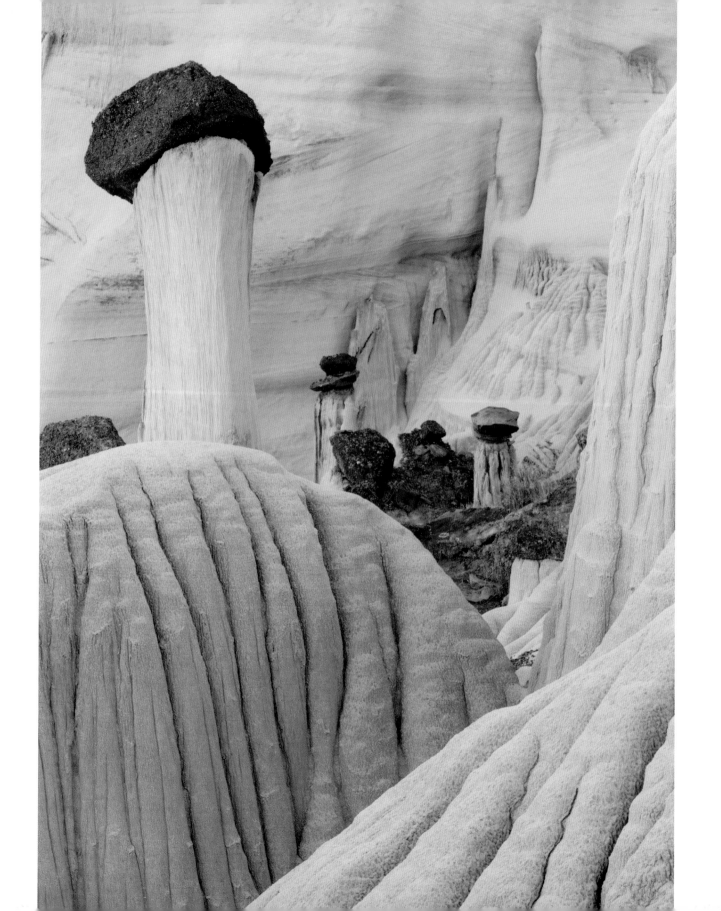

I try to pre-visualize images but sometimes an unimagined opportunity arises. A fin whale surfaced in the placid waters of the Sea of Cortez, creating these pleasing curves and surfaces. The fin whale is a baleen, the second largest species after the blue whale, and the largest specimens grow to eighty-eight feet.

Numbering over five hundred, a school of dolphins plays alongside our boat in the Sea of Cortez. This recreation lasted for well over an hour. The Sea of Cortez receives more sunlight than any other ocean on earth, resulting in one of the world's richest marine environments, rife with dolphins, whales, and birds.

BAJA, MEXICO

Both an ocean oasis and an isolated desert, the northern part of the narrow Baja Peninsula is home to a surprising variety of plant and animal life. After a voyage on the Sea of Cortez in search of migrating whales, we ventured inland through the unforgiving Cataviña Desert and discovered a photographer's playground of light and landscapes.

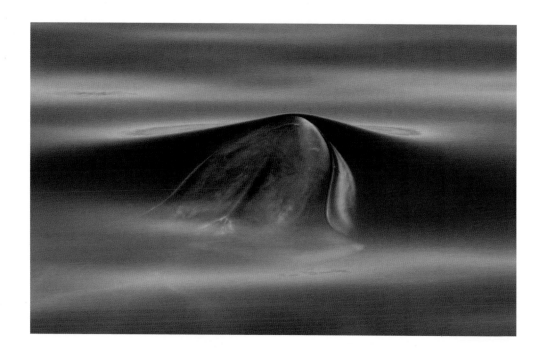

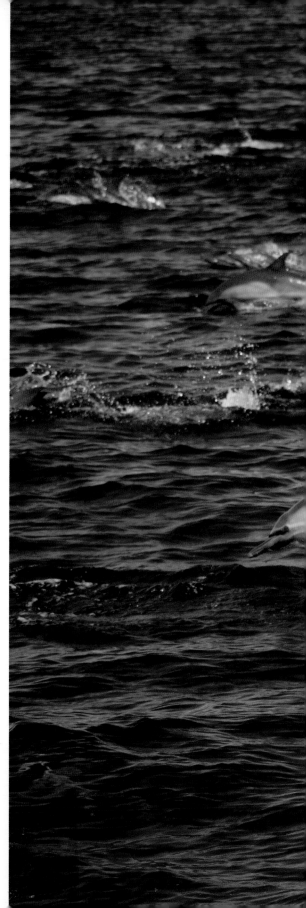

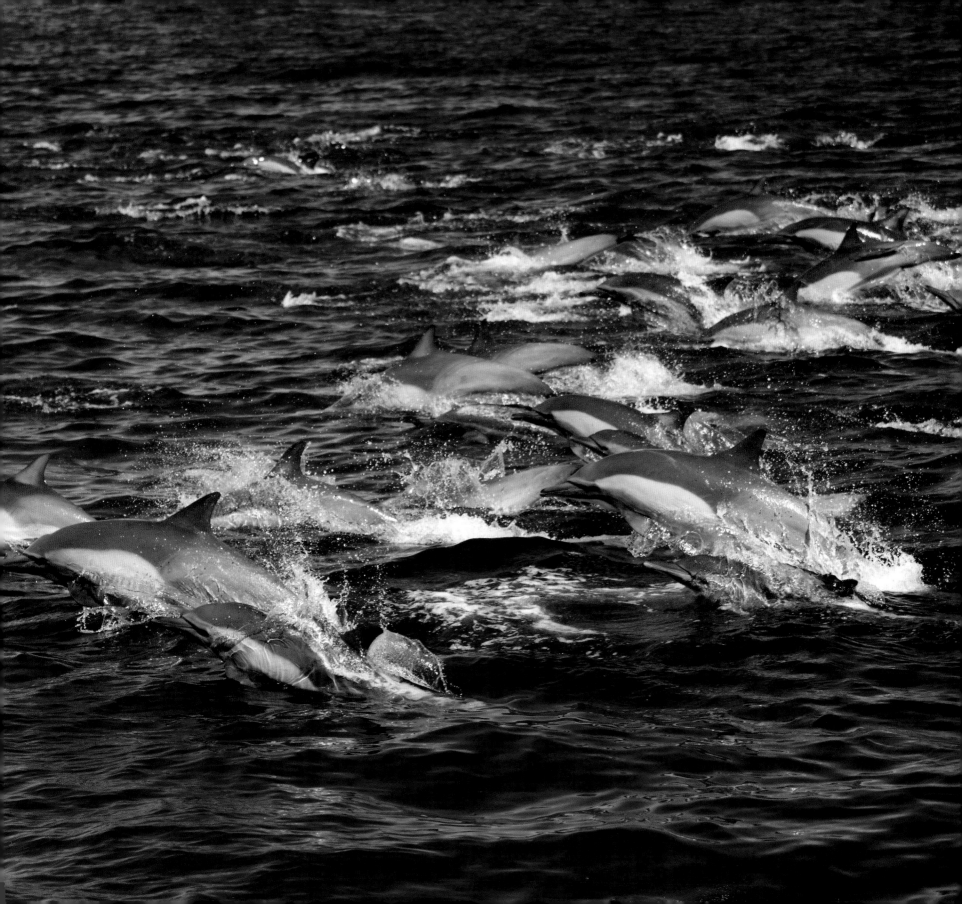

Oblique, low angle light enhances the details defined by vertical ribs of a cordon cactus on a tiny island in the Sea of Cortez. The graceful sweep of arcing limbs makes this cactus one of the region's most striking flora.

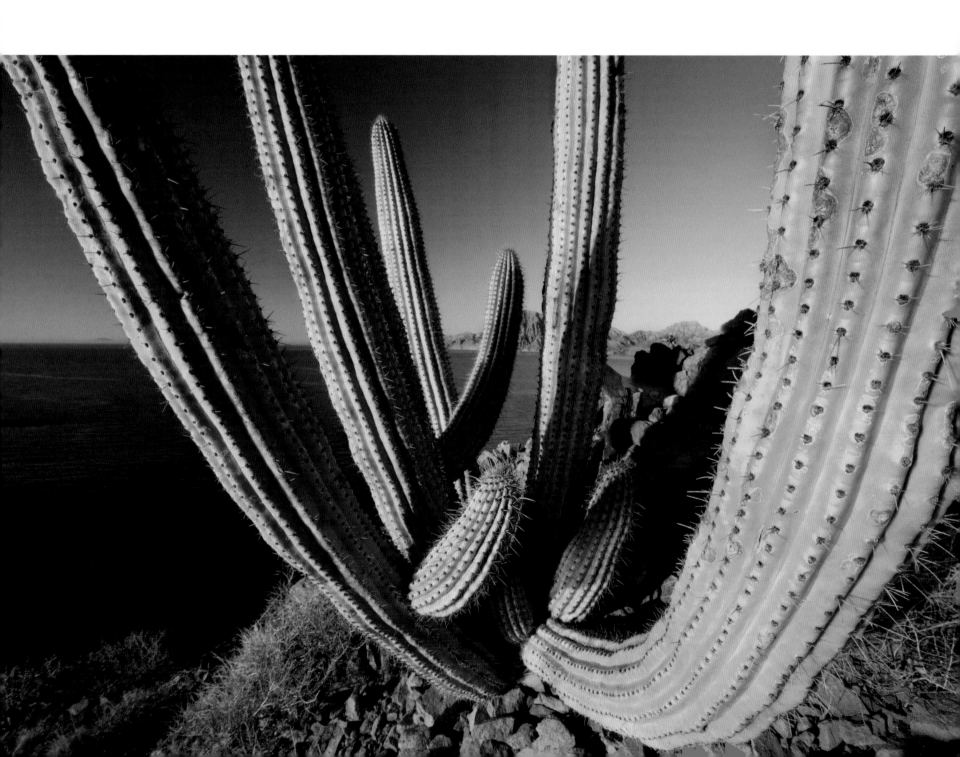

An osprey's graceful wings fan out as it returns to its nest with a fish for its hungry offspring. Ospreys have adapted to many different environments; wherever fish are found, ospreys follow.

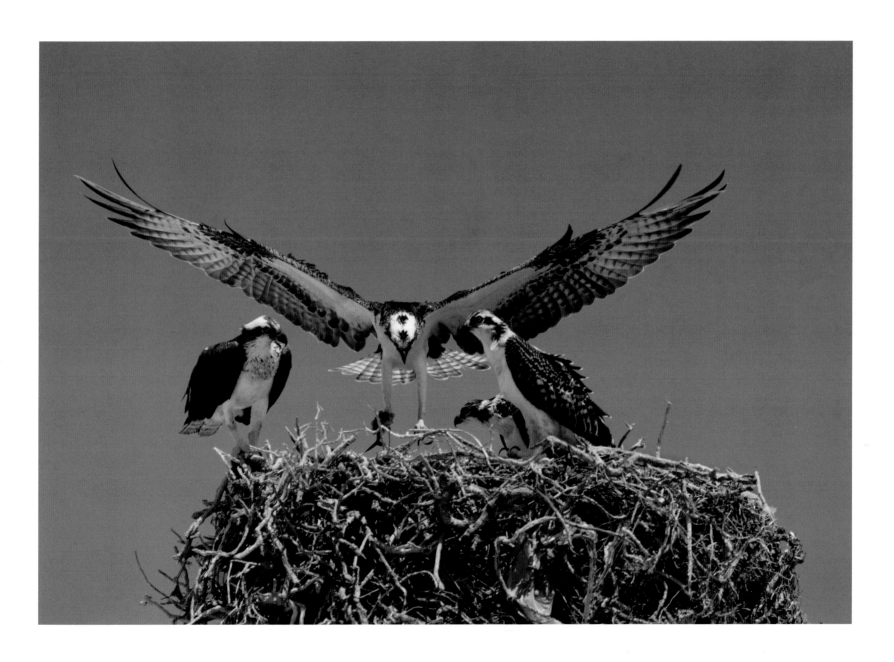

Boojum trees curve gracefully in the highlands of Baja. Relatives of the ocotillo, they are not cacti, but a unique group endemic to the peninsula.

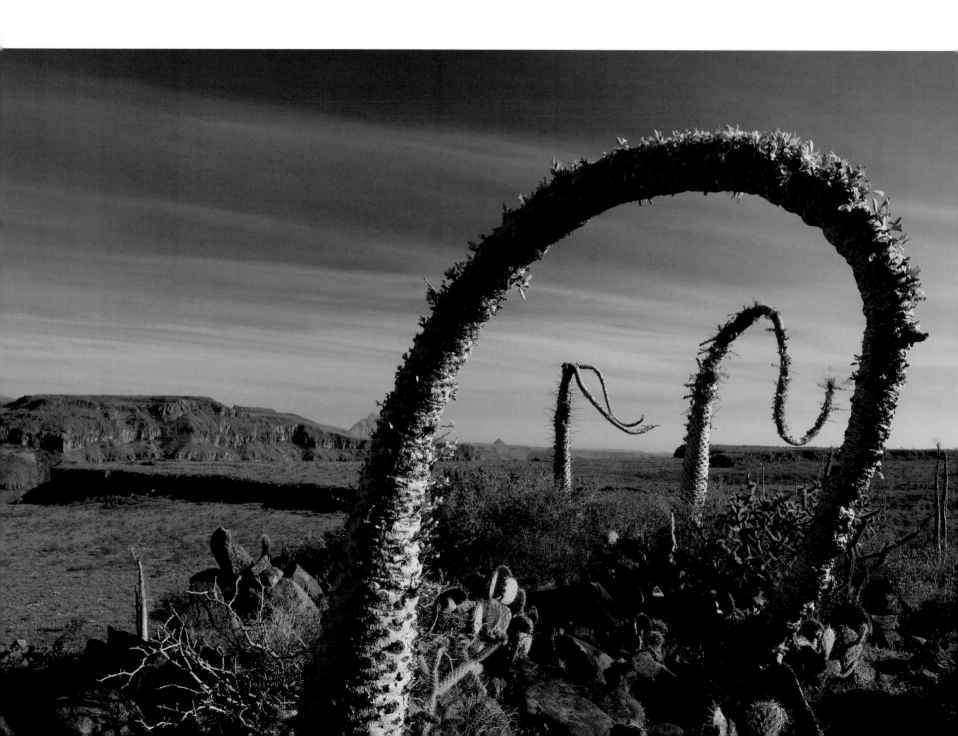

PHOTOGRAPHER'S FIELD NOTES

Page 1
Canon EOS-1Ds Mark III, Canon EF 24-70mm f/2.8L, f/16 at 4 seconds, Gitzo GT3540 tripod, Kirk BH-1 head

Page 2
Canon EOS-1Ds Mark III, Canon EF 24mm f/1.4, f/1.4 at 30 seconds, Gitzo GT3540 tripod, Kirk BH-1 head

Page 3
Canon EOS-1Ds Mark II, Canon EF 70-200mm f/2.8L IS, f/3.2 at 1/1250 second, Gitzo GT3540 tripod, Kirk BH-1 head

Page 6
Canon EOS 5D, Canon EF 70-200mm f/2.8L IS, f/5.6 at 1/1250 second, Gitzo GT3540 tripod, Kirk BH-1 head

Page 9
Canon EOS 5D, Canon EF 70-200mm f/2.8L IS, f/11 at 2.5 seconds, Gitzo GT3540 tripod, Kirk BH-1 head

Page 10
Canon EOS 5D, Canon EF 70-200mm f/24L IS, f/13 at 1/13 second, Gitzo GT3540 tripod, Kirk BH-1 head

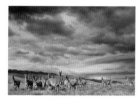

Page 12
Canon EOS-1Ds Mark II, Canon EF 17-40mm f/4L, f/10 at 1/125 second, 2-stop graduated neutral density filter, Gitzo GT3540 tripod, Kirk BH-1 head

Page 13
Canon EOS-1Ds Mark II, Canon EF 17-40mm f/4L, f/9 at 1 second, 2-stop graduated neutral density filter, Gitzo GT3540 tripod, Kirk BH-1 head

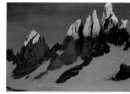

Page 14
Canon EOS-1Ds Mark II, Canon EF 70-200mm f/2.8L IS, f/16 at 1/25 second, polarizing filter, Gitzo GT3540 tripod, Kirk BH-1 head

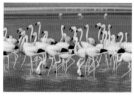

Page 15
Canon EOS-1Ds Mark II, Canon EF 70-200mm f/4L IS, f/13 at 1/2 second, Gitzo GT3540 tripod, Kirk BH-1 head

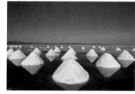

Page 17
Canon EOS-1Ds Mark II, Canon EF 400mm f/4 DO IS, Canon Extender EF 1.4x II, f/14 at 1/400 second, Gitzo GT3540 tripod, Kirk BH-1 head

Page 18
Canon EOS-1Ds Mark II, Canon EF 17-40mm f/4L, f/18 at 13 seconds, Gitzo GT3540 tripod, Kirk BH-1 head

Page 19
Canon EOS-1N, Canon EF 17-35mm f/2.8, f/2.8 at 7 hours, Fujichrome Velvia film, Gitzo G1325 tripod

Page 20
Canon EOS-1Ds Mark II, Canon EF 16-35mm f/2.8L, f/2.8 at 45 seconds, Gitzo GT3540 tripod, Kirk BH-1 head

Page 21
Canon EOS-1Ds Mark II, Canon EF 70-200mm f/2.8L IS, f/20 at 1/320 second, Gitzo GT3540 tripod, Kirk BH-1 head

Page 22
Canon EOS-1Ds Mark II, Canon EF 400mm f/4 DO IS, Canon Extender EF 2x II, f/8 at 1/4 second, Gitzo GT3540 tripod, Kirk BH-1 head

Page 24
Canon EOS-1Ds Mark II, Canon EF 400mm f/4 DO IS, Canon Extender EF 2x II, f/8 at 1/200 second, Gitzo GT3540 tripod, Kirk BH-1 head

Page 25
Canon EOS-1Ds Mark II, Canon EF 24-70mm f/2.8L, f/22 at 1.3 seconds, Gitzo GT3540 tripod, Kirk BH-1 head

Page 26
Canon EOS-1Ds Mark II, Canon EF 70-200mm f/2.8L IS, Canon Extender EF 1.4x II, f/11 at 1/60 second, Gitzo GT3540 tripod, Kirk BH-1 head

Page 27
Canon EOS-1N, Canon EF 400mm f/4 DO IS ,Canon Extender EF 2x II, f/8 at 1/200 second, Fujichrome Velvia film, Gitzo G1325 tripod

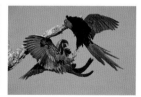

Page 28
Canon EOS-1Ds Mark II, Canon EF 70-200mm f/2.8L IS, Canon Extender EF 1.4x II, f/11 at 1/2500 second, Gitzo GT3540 tripod, Kirk BH-1 head

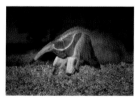

Page 29
Canon EOS-1Ds Mark II, Canon EF 70-200mm f/2.8L IS, f/2.8 at 1/15 second, Canon Speedlite 580EX

Page 30
Canon EOS-1Ds Mark II, Canon EF 500mm f/4 IS, Canon Extender EF 2x II, f/8 at 1/2500 second, Gitzo GT3540 tripod, Kirk BH-1 head

Page 31
Canon EOS-1Ds Mark II, Canon EF 16-35mm f/2.8L II, f/10 at 1.3 seconds, Gitzo GT3540 tripod, 2-stop graduated neutral density filter, Kirk BH-1 head

Page 32
Canon EOS 5D, Canon EF 24-70mm f/2.8L, f/14 at 1/100 second, polarizing filter

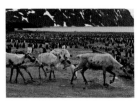

Page 34
Canon EOS-1Ds Mark II, Canon EF 70-200mm f/2.8L IS, f/5 at 1/400 second

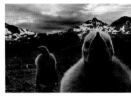

Page 35
Canon EOS-1Ds Mark II, Canon EF 70-200mm f/2.8L IS, Canon Extender EF 1.4x II, f/18 at 1/160 second, Gitzo GT3540 tripod, Kirk BH-1 Head

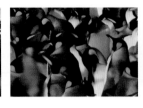

Page 36
Canon EOS-1Ds Mark II, Canon EF 70-200mm f/2.8L IS, f/22 at 1/80 second, 2-stop graduated neutral density filter, Gitzo GT3540 tripod, Kirk BH-1 head

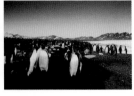

Page 37
Canon EOS-1Ds Mark II, Canon TS-E 90mm f/2.8, f/11 at 1/25 second, Gitzo GT3540 tripod, Kirk BH-1 head

Pages 38-39
Canon EOS-1Ds Mark II, Canon EF 24-70mm f/2.8L, f/10 at 1/8 second, 2-stop graduated neutral density filter, Gitzo GT3540 tripod, Kirk BH-1 head

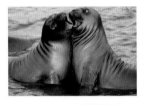

Page 40
Canon EOS-1Ds Mark II, Canon EF 70-200mm f/2.8L IS, Canon Extender EF 2x II, f/5.6 at 1/200 second, Gitzo GT3540 tripod, Kirk BH-1 head

Page 41
Canon EOS-1Ds Mark II, Canon EF 70-200mm f/2.8L IS, f2.8 at 1/500 second

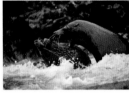

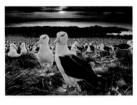

Page 43
Canon EOS-1Ds Mark II, Canon EF 24-70mm f/2.8L, f/22 at 1/125 second

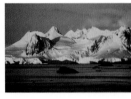

Page 44
Canon EOS-1Ds Mark II, Canon EF 24-70mm f/2.8L, f/9 at 1/50 second, 4-stop graduated neutral density filter, Gitzo GT3540 tripod, Kirk BH-1 head

Page 45
Canon EOS-1Ds Mark II, Canon EF 400mm f/4L DO IS, f/5.6 at 1/640 second

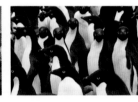

Page 46
Canon EOS-1Ds Mark II, Canon EF 70-200mm f/2.8L IS, f/29 at 1/50 second, Gitzo GT3540 tripod, Kirk BH-1 head

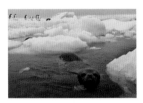

Page 47
Canon EOS-1Ds Mark II, Canon EF 24-70mm f/2.8L, f/18 at 1/160 second, Gitzo GT3540 tripod, Kirk BH-1 head

Page 49
Canon EOS-1Ds Mark III, Canon EF 24-70mm f/2.8L, f/10 at 1/60 second, Gitzo GT3540 tripod, Kirk BH-1 head

Page 50
Canon EOS-1Ds Mark III, Canon EF 16-35mm f/2.8L II, f/14 at 1/5 second, Gitzo GT3540 tripod, Kirk BH-1 head

Page 51
Canon EOS-1Ds Mark III, Canon EF 70-200mm f/2.8L IS, f/14 at 1/8 second, Gitzo GT3540 tripod, Kirk BH-1 head

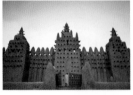

Page 52
Canon EOS-1Ds Mark III, Canon EF 16-35mm f/2.8L II, f/2.8 at 1/5 second, Gitzo GT3540 tripod, Kirk BH-1 head

Page 53
Canon EOS-1Ds Mark III, Canon EF 16-35mm f/2.8L II, f/2.8 at 1/200 second

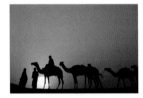

Pages 54-55
Canon EOS-1Ds Mark III, Canon EF 70-200mm f/2.8L IS, Canon Extender EF 2x II, f/8 at 1/500 second, Gitzo GT3540 tripod, Kirk BH-1 head

Page 56
Canon EOS-1Ds Mark III, Canon EF 70-200mm f/2.8L IS, f/22 at 1/125 second, Gitzo GT3540 tripod, Kirk BH-1 head

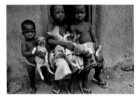

Page 57
Canon EOS 5D, Canon EF 16-35mm f/2.8L, f/9 at 1/200 second, Gitzo GT3540 tripod, Kirk BH-1 head

Page 58
Canon EOS-1Ds Mark III, Canon EF 24-70mm f/2.8L, f/13 at 1/160 second, Gitzo GT3540 tripod, Kirk BH-1 head

Page 59
Canon EOS-1Ds Mark III, Canon EF 24-70mm f/2.8L, f/14 at 1/60 second, Gitzo GT3540 tripod, Kirk BH-1 head

Page 60
Canon EOS-1Ds Mark III, Canon EF 16-35mm f/2.8L II, f/10 at 1/25 second, 2-stop graduated neutral density filter, Gitzo GT3540 tripod, Kirk BH-1 head

Page 61
Canon EOS-1Ds Mark III, Canon EF 24-70mm f/2.8L, f/2.8 at 1/60 second

Page 62
Canon EOS-1Ds Mark II, Canon EF 16-35mm f/2.8L, f/5 at 1/50 second, 2-stop graduated neutral density filter, Gitzo GT3540 tripod, Kirk BH-1 head

Page 63
Canon EOS-1N, Canon EF 500mm f/4, f/22 at 1/60 second, Fujichrome Velvia film, Gitzo G1325 tripod

Page 64
Canon EOS-1Ds Mark II, Canon EF 500mm f/4L IS, Canon Extender EF 1.4x II, f/18 at 1/40 second, Gitzo GT3540 tripod, Kirk BH-1 head

Page 65
Canon EOS-1Ds Mark II, Canon EF 70-200mm f/2.8L IS, f/2.8 at 1/2000 second, polarizing filter

Page 66
Canon EOS-1Ds Mark II, Canon EF 400mm f/4 DO IS, Canon Extender EF 2x II, f/32 at 1/160 second, Gitzo GT3540 tripod, Kirk BH-1 head

Page 67
Canon EOS-1Ds Mark II, Canon EF 24-70mm f/2.8L, f/5 at 1/320 second, polarizing filter

Page 69
Canon EOS 5D, Canon EF 16-35mm f/2.8L, f/8 at 1/125 second, 2-stop graduated neutral density filter, Gitzo GT3540 tripod, Kirk BH-1 head

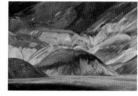

Page 70
Canon EOS-1Ds Mark II, Canon EF 70-200mm f/2.8L IS, f/18 at 1/40 second, polarizing filter, Gitzo GT3540 tripod, Kirk BH-1 head

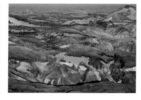

Page 71
Canon EOS-1Ds Mark II, Canon EF 16-35mm f/2.8L, f/5.6 at 1/320 second

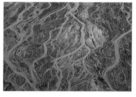

Page 72
Canon EOS-1Ds Mark II, Canon EF 500mm f/4L IS, f/4.5 at 1/100 second, Gitzo GT3540 tripod, Kirk BH-1 head

Page 74
Canon EOS-1Ds Mark II, Canon EF 70-200mm f/2.8L IS, f/5.6 at 1/60 second, Gitzo GT3540 tripod, Kirk BH-1 head

Page 75
Canon EOS-1Ds Mark II, Canon EF 16-35mm f/2.8L, f/2.8 at 30 seconds, Gitzo GT3540 tripod, Kirk BH-1 head

Pages 76-77
Canon EOS-1Ds Mark II, Canon EF 70-200mm f/2.8L IS, Canon Extender EF 2x II, f/51 at 1/15 second, polarizing filter

Page 78
Canon EOS-1Ds Mark III, Canon EF 70-200mm f/2.8L IS, f/16 at 1/125 second, Gitzo GT3540 tripod, Kirk BH-1 head

Page 79
Canon EOS-1Ds Mark III, Canon EF 24-70mm f/2.8L IS, f/5.6 at 1/1000 second, Gitzo GT3540 tripod, Kirk BH-1 head

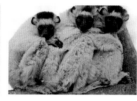

Page 80
Canon EOS-1Ds Mark III, Canon EF 70-200mm f/4L IS, f/4 at 1/320 second, polarizing filter

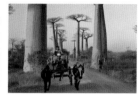

Page 81
Canon EOS-1Ds Mark III, Canon EF 24-70mm f/2.8L IS, f/5.6 at 1/125 second, polarizing filter

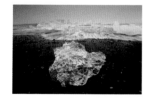

Page 82
Canon EOS-1Ds Mark III, Canon EF 16-35mm f/2.8L II, f/14 at 1/5 second, Gitzo GT3540 tripod, Kirk BH-1 head

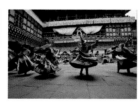

Page 83
Canon EOS-1N, Canon EF 70-200mm f/2.8L IS, f/16 at 1/60 second, Fujichrome Velvia film, Gitzo G1325 tripod

Page 84
Canon EOS-1Ds Mark III, Canon EF 16-35mm f/2.8L II, f/9 at 1/320 second

Page 85
Canon EOS-1Ds Mark III, Canon EF 70-200mm f/4L IS, f/7.1 at .6 seconds, Gitzo GT3540 tripod, Kirk BH-1 head

Page 86
Canon EOS-1Ds Mark III, Canon EF 16-35mm f/2.8L II, f/9 at 1/320 second

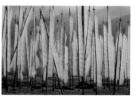

Page 87
Canon EOS-1Ds Mark III, Canon EF 70-200mm f/4L IS, f/18 at .8 seconds, Gitzo GT3540 tripod, Kirk BH-1 head

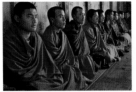

Page 88
Canon EOS-1Ds Mark III, Canon EF 24-70mm f/2.8L IS, f/10 at 1/6 second, Gitzo GT3540 tripod, Kirk BH-1 head

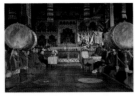

Page 89
Canon EOS-1Ds Mark III, Canon EF 16-35mm f/2.8L II, f/7.1 at 1/15 second, Gitzo GT3540 tripod, Kirk BH-1 head

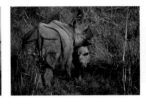

Page 90
Canon EOS-1Ds Mark III, Canon EF 70-200mm f/4L IS, f/5.6 at 1/800 second

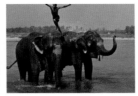

Page 91
Canon EOS-1Ds Mark III, Canon EF 16-35mm f/2.8L II, f/2.8 at 1/1250 second

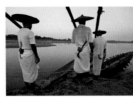

Page 92
Canon EOS-1Ds Mark III, Canon EF 70-200mm f/4L IS, f/4 at 1/1000 second

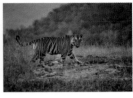

Page 93
Canon EOS-1Ds Mark II, Canon EF 70-200mm f/2.8L IS, f/2.8 at 1/800 second

Page 94
Canon EOS-1Ds Mark II, Canon EF 24-70mm f/2.8L IS, f/18 at 1/25 second, Gitzo GT3540 tripod, Kirk BH-1 head

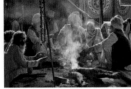

Page 96
Canon EOS-1Ds Mark II, Canon EF 70-200mm f/2.8L IS, f/18 at 1/20 second, Gitzo GT3540 tripod, Kirk BH-1 head

Page 97
Canon EOS-1Ds Mark II, Canon EF 70-200mm f/2.8L IS, f/2.8 at 1/250 second, Gitzo GT3540 tripod, Kirk BH-1 head

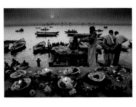

Page 98
Canon EOS-1Ds Mark II, Canon EF 24-70mm f/2.8L IS, f/16 at 1/13 second, Gitzo GT3540 tripod, Kirk BH-1 head

Page 99
Canon EOS-1Ds Mark II, Canon EF 24-70mm f/2.8L IS, f/10 at 1/25 second, Gitzo GT3540 tripod, Kirk BH-1 head

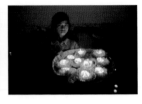

Page 100
Canon EOS-1Ds Mark II, Canon EF 24-70mm f/2.8L IS, f/2.8 at 1/30 second, Gitzo GT3540 tripod, Kirk BH-1 head

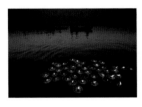

Page 101
Canon EOS 3, Canon EF 17-35mm f/2.8L, f/5.6 at 1/2 second, Fujichrome Velvia film, Gitzo G1325 tripod

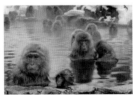

Page 102
Canon EOS-1Ds Mark III, Canon EF 70-200mm f/4L IS, f/20 at 1/15 second, Gitzo GT3540 tripod, Kirk BH-1 head

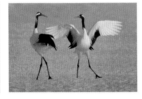

Page 103
Canon EOS-1Ds Mark III, Canon EF 600mm f/4L IS, f/8 at 1/400 second, Gitzo GT3540 tripod, Kirk BH-1 head

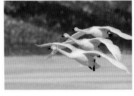

Page 104
Canon EOS-1Ds Mark III, Canon EF 400mm f/4 DO IS, f/6.3 at 1/1250 second, Gitzo GT3540 tripod, Kirk BH-1 head

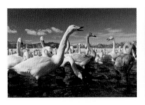

Page 105
Canon EOS-1Ds Mark III, Canon EF 16-35mm f/2.8L II, f/16 at 1/250 second, polarizing filter

Page 106
Canon EOS-1Ds Mark III, Canon EF 70-200mm f/4L IS, f/7.1 at 1/100 second, Gitzo GT3540 tripod, Kirk BH-1 head

Page 107
Canon EOS-1Ds Mark III, Canon EF 70-200mm f/4L IS, f/16 at 1/10 second, Gitzo GT3540 tripod, Kirk BH-1 head

Page 108
Canon EOS-1Ds Mark III, Canon EF 70-200mm f/4L IS, f/4 at 1/25 second, Gitzo GT3540 tripod, Kirk BH-1 head

Page 109
Canon EOS-1Ds Mark III, Canon EF 70-200mm f/4L IS, f/11 at 1/40 second, Gitzo GT3540 tripod, Kirk BH-1 head

Page 110
Canon EOS-1Ds Mark III, Canon EF 16-35mm f/2.8L II, f/18 at .6 seconds, 2-stop graduated neutral density filter, Gitzo GT3540 tripod, Kirk BH-1 head

Page 111
Canon EOS-1Ds Mark III, Canon EF 70-200mm f/4L IS, Canon Extender EF 1.4x II, f/14 at 1/25 second, Gitzo GT3540 tripod, Kirk BH-1 head

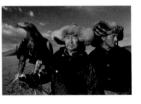

Page 113
Canon EOS-1Ds Mark III, Canon EF 16-35mm f/2.8L II, f/6.3 at 1/500 second, polarizing filter

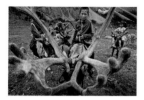 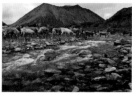

Page 114
Canon EOS-1Ds Mark III, Canon EF 16-35mm f/2.8L II, f/18 at 1/50 second, Gitzo GT3540 tripod, Kirk BH-1 head

Page 115
Canon EOS-1Ds Mark III, Canon EF 24-70mm f/2.8L IS, f/6.3 at 1/250 second, Gitzo GT3540 tripod, Kirk BH-1 head

Page 116
Canon EOS-1Ds Mark III, Canon EF 70-200mm f/4L IS, Canon Extender EF 1.4x II, f/5.7 at 1/125 second, Gitzo GT3540 tripod, Kirk BH-1 head

Page 117
Canon EOS-1Ds Mark III, Canon EF 16-35mm f/2.8L II, f/8 at 4 seconds, Gitzo GT3540 tripod, Kirk BH-1 head

Pages 118-119
Canon EOS-1Ds Mark III, Canon EF 400mm f/4 DO IS, f/8 at 1/640 second, Gitzo GT3540 tripod, Kirk BH-1 head

Page 120
Canon EOS-1Ds Mark II, Canon EF 16-35mm f/2.8L II, f/5 at 10 seconds, Gitzo GT3540 tripod, Kirk BH-1 head

Page 122
Canon EOS-1Ds Mark II, Canon EF 70-200mm f/4L IS, Canon Extender EF 1.4x II, f/22 at 4 seconds, Gitzo GT3540 tripod, Kirk BH-1 head

Page 123
Canon EOS-1Ds Mark II, Canon EF 16-35mm f/2.8L II, f/3.5 at 1/100 second

Page 124
Canon EOS-1Ds Mark II, Canon EF 16-35mm f/2.8L II, f/3.2 at 1/320 second

Page 125
Canon EOS-1Ds Mark II, Canon EF 70-200mm f/2.8L IS, f/4 at 1/400 second, polarizing filter

Pages 126-127
Canon EOS-1Ds Mark II, Canon EF 70-200mm f/2.8L IS, f/4 at 1/400 second, Gitzo GT3540 tripod, Kirk BH-1 head

Page 128
Canon EOS-1Ds Mark III, Canon EF 70-200mm f/4L IS, f/8 at 1/40 second, Gitzo GT3540 tripod, Kirk BH-1 head

 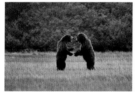

Page 129
Canon EOS-1Ds Mark II, Canon EF 16-35mm f/2.8L II, f/6.3 at 2 seconds, Gitzo GT3540 tripod, Kirk BH-1 head

Page 130
Canon EOS-1Ds Mark III, Canon EF 70-200mm f/4L IS, f/16 at 1 second, Gitzo GT3540 tripod, Kirk BH-1 head

Page 131
Canon EOS-1Ds Mark III, Canon EF 70-200mm f/4L IS, f/13 at 1/15 second, Gitzo GT3540 tripod, Kirk BH-1 head

Page 132
Canon EOS-1Ds Mark II, Canon EF 400mm f/4 DO IS, Canon Extender EF 1.4x II, f/5.7 at 1/250 second, Gitzo GT3540 tripod, Kirk BH-1 head

Page 133
Canon EOS-1Ds Mark II, Canon EF 70-200mm f/2.8L IS, f/16 at 1/40 second, Gitzo GT3540 tripod, Kirk BH-1 head

Page 134
Canon EOS-1Ds Mark II, Canon EF 17-40mm f/4L, f/14 at .3 seconds, 2-stop graduated neutral density filter, Gitzo GT3540 tripod, Kirk BH-1 head

Page 136
Canon EOS-1Ds Mark II, Canon EF 70-200mm f/2.8L IS, f/13 at 1/13 second, Gitzo GT3540 tripod, Kirk BH-1 head

Page 137
Canon EOS-1Ds Mark II, Canon EF 500mm f/4L IS, Canon Extender EF 2x II, f/13 at 1/100 second, Gitzo GT3540 tripod, Kirk BH-1 head

Page 138
Canon EOS-1Ds Mark II, Canon EF 400mm f/4 DO IS, Canon Extender EF 2x II, f/8 at 1/200 second, Gitzo GT3540 tripod, Kirk BH-1 head

Page 139
Canon EOS-1Ds Mark II, Canon EF 70-200mm f/2.8L IS, f/3.5 at 1/800 second

Page 140
Canon EOS-1Ds Mark II, Canon EF 16-35mm f/2.8L II, f/22 at 1/10 second, Gitzo GT3540 tripod, Kirk BH-1 head

Page 141
Canon EOS-1Ds Mark II, Canon EF 70-200mm f/2.8L IS, f/5 at 1/3200 second

 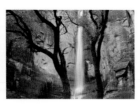 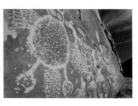 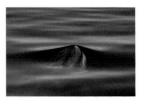

Page 143
Canon EOS-1Ds Mark II, Canon EF 17-40mm f/4L, f/18 at 6 seconds, Gitzo GT3540 tripod, Kirk BH-1 head

Page 144
Canon EOS-1Ds Mark II, Canon EF 17-40mm f/4L, f/11 at 13 seconds, polarizing filter, Gitzo GT3540 tripod, Kirk BH-1 head

Page 145
Canon EOS-1Ds Mark II, Canon EF 17-40mm f/4L, f/18 at 1.6 seconds, Gitzo GT3540 tripod, Kirk BH-1 head

Page 146
Canon EOS-1Ds Mark II, Canon EF 17-40mm f/4L, f/18 at 1.6 seconds, polarizing filter, Gitzo GT3540 tripod, Kirk BH-1 head

Page 147
Canon EOS-1Ds Mark II, Canon EF 70-200mm f/2.8L IS, Canon Extender EF 1.4x II, f/32 at 1 second, Gitzo GT3540 tripod, Kirk BH-1 head

Page 148
Canon EOS-1Ds Mark III, Canon EF 70-200mm f/4L IS, Canon Extender EF 2x II, f/8 at 1/400 second, polarizing filter

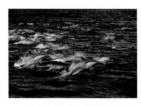 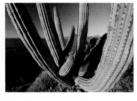 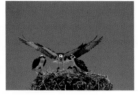

Page 149
Canon EOS-1Ds Mark III, Canon EF 70-200mm f/4L IS, f/5.6 at 1/1000 second, polarizing filter

Page 150
Canon EOS-1Ds Mark III, Canon EF 16-35mm f/2.8L II, f/22 at 1/5 second, polarizing filter, Gitzo GT3540 tripod, Kirk BH-1 head

Page 151
Canon EOS-1Ds Mark III, Canon EF 500mm f/4L IS, Canon Extender EF 1.4x II, f/8 at 1/800 second, Gitzo GT3540 tripod, Kirk BH-1 head

Page 152
Canon EOS-1Ds Mark III, Canon EF 16-35mm f/2.8L II, f/20 at 1/50 second, polarizing filter, Gitzo GT3540 tripod, Kirk BH-1 head

Page 159
Canon EOS-1Ds Mark III, Canon EF 70-200mm f/4L IS, f/4 at 1/800 second

ACKNOWLEDGMENTS

When I first introduced the idea of doing the *Travels to the Edge* television series, four parties stepped up to back us: Oregon Public Television, Conservation International, Canon USA, and the Microsoft Corporation. I am grateful for their support. I would like to thank the individuals at these organizations who put their faith and efforts into helping us bring new, quality programming to public television: David Vaskevitch, Kostas Mallios, Yuichi Ishizuka, Yukiaki Hashimoto, Hitoshi Doi, Peter Tvarkunas, Dr. Russell Mittermeier, Peter Seligmann, David Metz, Josh Weisberg, Charles Westfall, Leonard Musmeci, Kelly Blok, Cheryl Hackert, Jeff Greene, Mike Tedesco, Tim Grey, Laura Bowling, Sterling Zumbrunn, Stephen Bass, David Davis, Tom Doggett, Cheri Arbini, Karen Read, Claire Adamsick, Kayo Lackey, Susan Boyd, and Gabriella Jones-Litchfield. I offer a special thank you to Robert Rotella, Richard Johnson, and Rose Rotella.

I am very fortunate to live in Seattle, Washington, which is home to a wealth of talent and resources. We looked no further than our backyard to assemble a team of top-notch producers, graphic designers, editors, researchers, writers, and sound and film service studios—all magic makers. I'd like to acknowledge Valerie and Simon Griffith, Dan Larson, Steve Cammarano, James Disch, Mikal Gross, Matthew J. Clark, Kyle Carver, Heather Reilly, Eliza Hurlbut, Terrie Bassett, Christine Larsen, Jeff Settle, Peter Barnes, Eric Johnson, Vince Werner, Will Williams, Tim Maffia, Karen Mallin, Lynn Brunelle, Kelley Guiney, John Davidson, Carol Freeman, David Scudder, Matt Lee, Leigh Eckhert, Kris Dangla, Kelli Garces, and Cotton Mayer.

Special thanks are due to Jeffrey Davis and Christine Eckhoff for their tireless work in making the series possible.

The television series has been a marriage of my profession of photography with the very different medium of film. My staff was suddenly enveloped by this new undertaking and rose to the challenge to coordinate and support my best efforts. A heartfelt thank you for all the work on both the television production and this book goes to Julie Sotomura, Deirdre Skillman, Lisa Woods, Carol Flynn, Carol Rother, Craig Angevine, Amanda Harryman, Riko Chock, Libby Pfeiffer, and particularly, James Martin, for guiding this book project.

I thank everyone at the Mountaineers Books for their hard work, tact, and patience in working with our small, but very busy office. It's been a pleasure, in particular, to work with Kate Rogers, Janet Kimball, and Helen Cherullo. Also, much appreciation to Jane Jeszeck for her beautiful design.

ABOUT THE AUTHOR

Art Wolfe is one of the most highly acclaimed and widely published nature photographers of our time. A native Seattleite, he travels nearly nine months of the year on a personal mission to document the natural world on film. His stunning images interpret and record the world's fast-disappearing wildlife, landscapes, and native cultures, and are a lasting inspiration to those who seek to preserve them all. Wolfe's photographs are recognized throughout the world for their mastery of color, composition, and perspective.

Wolfe's vision and passionate wildlife advocacy affirm his dedication to his work. His goal is to win support for conservation issues by focusing on what's beautiful on Earth. Hailed by William Conway, former president of the Wildlife Conservation Society, as "the most prolific and sensitive recorder of a rapidly vanishing natural world," Wolfe has taken an estimated one million images in his lifetime and has released over sixty books, including the award-winning *The Living Wild, Vanishing Act, The High Himalaya, Water: Worlds Between Heaven & Earth, Tribes, Rainforests of the World, The Art of Photographing Nature, Edge of the Earth—Corner of the Sky,* and *Africa* as well as numerous children's titles. *Graphis* included his books *Light on the Land* and the controversial *Migrations* on its list of the 100 best books published in the 1990s. Art's public television series, *Art Wolfe's Travels to the Edge,* garnered American Public Television's 2007 Programming Excellence Award—unprecedented for a first season show.

Art Wolfe has been awarded with a coveted Alfred Eisenstaedt Magazine Photography Award as well as being named Outstanding Nature Photographer of the Year by the North American Nature Photography Association. The National Audubon Society recognized Wolfe's work in support of the national wildlife refuge system with its first-ever Rachel Carson Award. He is an Honorary Fellow of the Royal Photographic Society, a Fellow of the International League of Conservation Photographers, and is a member of Canon's elite list of renowned photographers "Explorers of Light," Microsoft's Icons of Imaging, and Fujifilm's Talent Team.

Wolfe maintains his gallery, stock agency, production company, and digital photography school in Seattle, Washington.

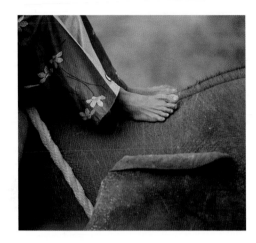

ABOUT *ART WOLFE'S TRAVELS TO THE EDGE* TELEVISION SERIES

Art Wolfe's Travels to the Edge is an intimate and upbeat series that offers insights on nature, cultures, environmental issues, and the new realm of digital photography. Whether Wolfe is journeying from Timbuktu across the sands of the Sahara, trekking in the Himalayan mountain kingdom of Bhutan, or tracking Bengal tigers by elephant-back in India, viewers experience remote and awe-inspiring places through his lens. Throughout this high-definition series, Wolfe shares a contagious enthusiasm for what he has spent a lifetime doing—capturing the beauty and wonder of our unique world.

 Art Wolfe's Travels to the Edge is produced by Edge of the Earth Productions, LLC in association with Blue Moon Productions, Inc. and Oregon Public Broadcasting. It is distributed nationwide by American Public Television.

 Funding for *Art Wolfe's Travels to the Edge* is provided by the Microsoft Corporation and Conservation International.

Cover photograph: Two Tuareg traders warm themselves by a fire, Mali.
Frontispiece: Pathway in a bamboo grove, Kyoto, Japan.
Page 2: Cordon cacti and boonjum trees in the Cataviña Desert on Mexico's Baja Peninsula.
Page 3: Aerial shot of flamingos on Lake Natron, Tanzania.
Page 6: Art Wolfe, Sahara Desert, Mali. Photo @ John Greengo/Edge of the Earth Productions.
Page 9: Art Wolfe photographing caimans, Pantanal, Brazil. Photo @ John Greengo/Edge of the Earth Productions.

THE MOUNTAINEERS BOOKS is the nonprofit publishing arm of The Mountaineers Club, an organization founded in 1906 and dedicated to the exploration, preservation, and enjoyment of outdoor and wilderness areas.

1001 SW Klickitat Way, Suite 201, Seattle, WA 98134
www.mountaineersbooks.org

Distributed in the United Kingdom by Cordee, www.cordee.co.uk
Manufactured in China

Copy Editor: Kathleen Cubley
Cover and Book Design: Jane Jeszeck/Jigsaw, www.jigsawseattle.com
Cartographer: Ani Rucki
All photographs by the author unless otherwise noted.

Library of Congress Cataloging-in-Publication Data

Wolfe, Art.
 Travels to the edge : a photo odyssey / Art Wolfe. — 1st ed.
 p. cm.
 ISBN 978-1-59485-277-0
 1. Nature photography. 2. Travel photography. 3. Landscape photography. I. Title.
 TR721.W657 2009
 779'.3—dc22

 2009011921